PULP ART

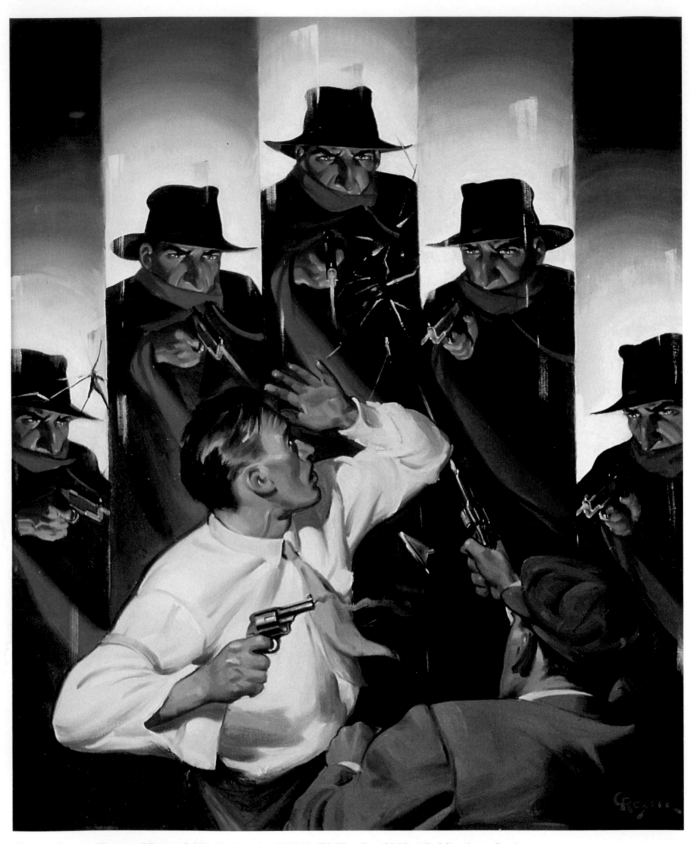

George Rozen: "Room of Doom," *The Shadow,* April 1942 (™ The Condé Nast Publications, Inc.)

PULP ART

ORIGINAL COVER PAINTINGS FOR THE GREAT AMERICAN PULP MAGAZINES

ROBERT LESSER.

WITH CONTRIBUTIONS BY

Roger T. Reed • Fred Cook • Shirley Steeger
Forrest J. Ackerman • Steve Kennedy • Sam Moskowitz
Walt Reed • Jim Steranko • John de Soto
Danton Burroughs • Darrell C. Richardson • Alison M. Scott
John Locke • Zina Saunders • James Van Hise
George Hocutt • Bruce Cassidy • Charles G. Martignette

GRAMERCY BOOKS
New York

This edition is published by Gramercy Books, a division of Random House Value Publishing, Inc., 201 East 50th Street, New York, New York 10022.

Gramercy Books and colophon are trademarks of Random House Value Publishing, Inc.

Random House
New York • Toronto • London • Sydney • Auckland
http://www.randomhouse.com/

Library of Congress Cataloging-in-Publication Data
Lesser, Robert.
 Pulp art: original cover paintings for the great American pulp magazines / Robert Lesser; with contributions by Roger T. Reed [et al.].
 p. cm.
 Includes index.
 ISBN 0–517-20058-9 (alk. paper)
 1. Magazine covers—United States. I. Reed, Roger. II. Title.
NC974.L47 1997
741.6'52'0973—dc21 97-15492
 CIP

8 7 6 5 4 3 2 1

Project and Text Editor: Gregory R. Suriano
Interior and Jacket Design: Helene Berinsky
Production Supervisor: Michael Siebert
Desktop Publishing Assistant: Frank J. Finamore

Acknowledgments

The author wishes to express his unreserved gratitude to the following contributors, pulp-art scholars and collectors, and editors and designers for their help in making this book both possible and very special: Forrest J. Ackerman, Sam Moskowitz, Shirley Steeger, Steve Kennedy, Robert Weinberg, Fred Cook, Walker Martin, James Van Hise, John Locke, Capel N. McCutcheon, Albert Tonik, Jack Deveny, Charles G. Martignette, George Berger, Joseph Gaspari, Carolyn Naporlee, Jim Steranko, John de Soto, Zina Saunders, Danton Burroughs, Darrell C. Richardson, Charles Crane, Robert Barrett, Walt Reed, Roger Reed, Will Murray, Alison M. Scott, Linda Dobb, Rush Miller, Norman Brosterman, Geroge Hocutt, Bruce Cassidy, Ray Bradbury, Tom Lovell, Roger Nelson, John McLaughlin, Tom Johnson, John Gunnison, Frank Hamilton, Tony Goodstone, Richard Merkin, Rafael de Soto, Pierre Boogaerts, Anthony Tolin, Clarence Peacock, Gene Nigra, Mel and Stephen Korshak, Ralph Kaschi, Peter Garriock, Paul Herman, Bob Hyde, Richard Greene, Lyn Hickman, Rusty Hevelin, George Hagenaur, Jerry and Helen de la Ree, Jane and Howard Frank, Randall Hawkins, Phil Weiss, Bruce Bergstrom, Frank Robinson, Jack Juka, Jerry Weist, Thomas Horvitz, Daniel Mark Fay, Cole Springer, Jerry Schattenburg, Grover DeLuca, Leonard Robbins, Ben Chapman, Leon Sevilla, Robert Hammerquist, David Kimball, Russ Cochran, Bill Thailing, Don Hutchison, Beverly and Ray Sachs, Irma Rudin, Herm Schreiner, Peter Manesis, Dino Petrocelli, Bill Morse, Dr. Alfred Collette and Domenic J. Iacono of Syracuse University, David Alexander, Gloria Stoll Karn, Joseph Di Lessio, Dennis East, Jim Gerlach, Bradleigh Vinson, Sheldon Jaffery, Nick Carr, Robert Sampson, Gary Lovisi, Henry Steeger, William Papalia, Mike Avallone, William Feeny, Frederic Taraba, Joe Parente, Ryerson Johnson, Emil Petaja, Norma Dent, Peter Osborne, George McWhorter, Victor Dricks, Frank J. Finamore, Helene Berinsky, and Gregory Suriano.

There is the theory in current political aesthetics that a work authored by only one person is a fascist work of art because it dictates a single point of view; refuses to permit the inclusion of a democratic sampling of important facts

unknown to the single author; and ignores creative insights that could illuminate dark corners and increase the body weight of information. This theory is accepted here. Other voices are happily and proudly included in this book. They are those who should be thanked for having collected, studied, created, and preserved an inheritance of art for future generations to enjoy. Interspersed throughout the text are superb and insightful essays by those who have lived and breathed the pulps for decades.

CONTENTS

INTRODUCTION: POPULIST CULTURE AND PULP ART 3

ESSAYS

The Pulps: Their Weaknesses Were Their Strengths by Roger T. Reed

The Cover Artists and Their Publishers by Fred Cook

Yes, I Was There by Shirley Steeger

SCIENCE FICTION, SCIENCE FACT, AND FANTASY:
PAINTED ANSWERS 24

ESSAYS

When Pulp Art Was in Flower by Forrest J. Ackerman

Collecting Pulp Paintings: Dramatic Imagery and Color
 by Steve Kennedy

The Science Fiction Pulps by Sam Moskowitz

THE NEW KNIGHTS 48

ESSAYS

The Pulps and Their Illustrators: A Brief Survey by Walt Reed

The Lure of the Pulps: An Artist's Perspective by Jim Steranko

Remembering Rafael de Soto by John de Soto, AIA

THE NOBLEST SAVAGE 76

ESSAYS

Important Pulp Paintings in the Burroughs Collection
 by Danton Burroughs

A Conversation with J. Allen St. John, Dean of Fantasy Illustrators
 by Darrell C. Richardson

The Paper They're Printed On by Alison M. Scott

LADIES IN TERROR 97

ESSAYS

Painting the Story by John Locke

The Art That Dared to Be Wild by James Van Hise

Remembering Norman Saunders by Zina Saunders

TO DARE THE DEVIL: AVIATION, WAR, AND WESTERN ART 122

ESSAYS

The Cover Art of the Air-War Pulps by George Hocutt

Editing the Western Pulps by Bruce Cassidy

Where Have All the Paintings Gone? by Charles G. Martignette

APPENDIX I • VOX POPULI: LETTERS TO THE PULPS' EDITORS, 1929–46 157

APPENDIX II • ORIGINAL PULP PAINTINGS: A COLLECTOR'S GUIDE 163

APPENDIX III • ARTISTS' BIOGRAPHIES 167

BIBLIOGRAPHY 175

INDEX 179

What do I ask of a painting?
I ask it to astonish, disturb, seduce, convince.
— Lucian Freud

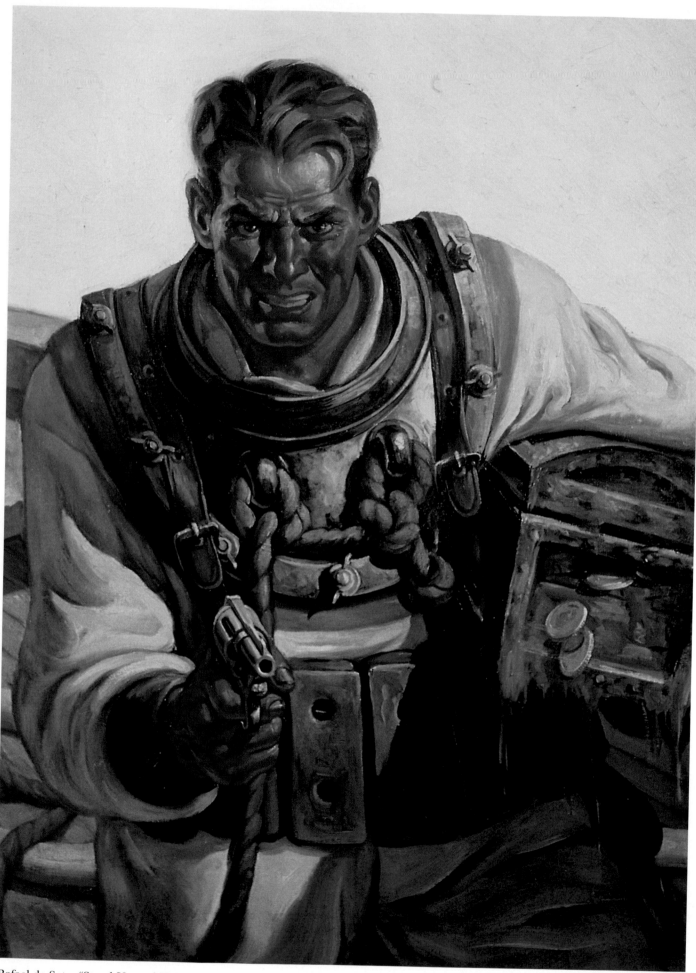

Rafael de Soto: "Stand Up and Fight!" *Adventure*, March 1938

Introduction: Populist Culture and Pulp Art

In the United States of America there never has been and never will be Tyrants of Taste commanding us to like what we don't, to whisper yes when we want to shout no. For hundreds of years kings and queens forced our forebears to bend their knees and shut down their minds, to accept their concepts of high culture and to be ashamed of popular concepts of "low" culture. Inherited titles without the merit to match, enrichment of power derived from laws bought from the political peddlers they put in place, and the capturing of the world's riches enabled this small elite to dictate the absolutes of culture.

But on March 4, 1789, things changed. On March 5, the ink on the Constitution dried and populist culture was born. Now any American was free to sing any song, paint any picture, write any story, pay his money to see, hear, and buy what he liked, without any prince or priest wedged in between. Hidden inside the Constitution's Section 9 was a Declaration of American Cultural Independence and an Aesthetic Bill of Rights. From this extension of liberty, won by war and revolution, we have taken the political permission to be pleased.

Up from this fertile soil of American political liberty has flowered a unique cultural anarchy granting the absolute freedom of anyone to choose anything. All of us are free to pay admission or stay home, to turn it on or turn it off; and we are free to love this or hate that, to collect or reject without a fine-arts professor's permission or the wax seal of approval from the elite of a major metropolitan museum.

This anarchic dimension of liberty has no limits because each new generation is free to begin it all over again, enraging parents, shocking seniors, and allowing things old-fashioned to temporarily wither away by refusing to purchase any of it.

The lot of the Americans is singular: they have derived from the aristocracy of England the notion of private rights and the taste for local freedom; and they have been able to retain both, because they had no aristocracy to combat.

—Alexis de Tocqueville,
Democracy in America

No title of nobility shall be granted by the United States: And no person holding any office or profit or trust under them, shall without the consent of Congress, accept of any present, emolument, office or title of any kind whatever from any king, prince or foreign state.

—The Constitution of the United States of America, Section 9

Europe's elite culture is institutionalized: opera in Italian, ballet à la Russe, classical music in a tuxedo, and paintings of antique faces of the rich and royal of centuries past. But in the United States of America, culture is patronized and chosen with its dollars; beneath it all is the belief that the best will never be because the best is yet to come. Many of us dislike frozen culture because it is always the same. Newness is a major attraction of populist culture: you've never seen it before, never heard it before.

In this nation, art and technology have fallen madly in love and enjoy a happy mixed marriage, and their offspring amaze and delight. And with startling speed this union has produced a materialist extension of democracy: the anarchy of ownership. Just a few years ago Hollywood had all the movies clutched in a tight fist and might release a classic once every few years. But with the invention of the VCR and videos, anarchy has been extended into ownership, and now all of us own all of it. Soon the finest art from the finest museums in the world will be ours by pressing a fingertip on a computer key. The entire corpus of world culture, past, present, and deep into the future will be owned by the poorest man in the smallest home.

One belief of Cultural Anarchy is that Art is Art: any kind, whether it's a Rembrandt self-portrait, some caveman's scrawls of a sabertooth tiger in a cave in southern France, or even Junior's kindergarten sketch of a chicken, pasted on the refrigerator door. All art has at its very center the same impulse of creation: a wage payment to the artist in the rare money of spiritual satisfaction, and a wage payment to the viewer in spiritual pleasure.

Cultural Anarchy believes that any picture painted by the hand of man, woman, or child anywhere, anytime on the planet, is art. Not fine art or commercial art, not high art or low art, not populist art or museum art—just Art. It can be characterized as good or bad, genius or worthless, I like it or I hate it, worth a million bucks or not a dime, but it's all art.

Commercial art? Inside our system all art is manufactured for money or the hope of money. How can there be a difference between fine art and commercial art when the motive for creation is the same? Alexis de Tocqueville in *Democracy in America* renamed the commercial arts the *useful arts*: this crystal-clear insight into our national pragmatic character provides a better name for us to use.

Cultural Anarchy believes that values and the means to measure quality are nonhostile and can enhance understanding, but they cannot become a weapon used by the Tyrants of Taste to impose limits. The creative imagination has no natural limits; therefore, the artist's complete freedom is a necessity. He has a friend in the words of the Constitution. The value of his work is to be determined by the people making a democratic choice, voting yes with their dollars or no with their feet.

The best is yet to come.

One example of one of the best is a single page. This entire book is about that single page: the front cover of the pulp magazines from the 1930s and 1940s. These covers were created from magnificent paintings by artists who refused to see that magnificence. They created a Golden Age of American Art, most of this work still unknown and unrecognized—each a painted nightmare superb in form, unique in content. American Nightmare Pulp Art is our lost inheritance.

Frederick Blakeslee: "Death Rides My Wings!" *Fighting Aces*, December 1942

The pulp-magazine industry flourished during the Great Depression's low bottom. Some publishers got rich, and the industry's army of writers, artists, printers, and workers had jobs: steady work, away from bread lines, soup kitchens, and apartment evictions.

Printed on the cheapest paper—hence the name—manufactured for two cents, wholesaled for a nickel, and retailed on the newsstand for a hard-times dime, they were bought by the millions. "They looked like a defeated army returning home," the novelist Herbert Gold wrote, about workers on the subway at night. Just by turning a page, weary men without hope and their fantasy-hungry children could escape into an enticing world filled with excitement and adventure. Just by looking at the covers, they could enter a universe of distant planets with creatures more intelligent, and beasts more dangerous, than any they knew of.

Imagine yourself, then, as a reader of pulp magazines in those years of depression and war. Become part of a cover painted by Frederick Blakeslee and climb into the cockpit of a World War I Spad and engage in a dogfight over France with the infamous Von Richtoven in his red triplane Fokker. Or look at a cover of *Battle Birds* and picture yourself in that Douglas divebomber:

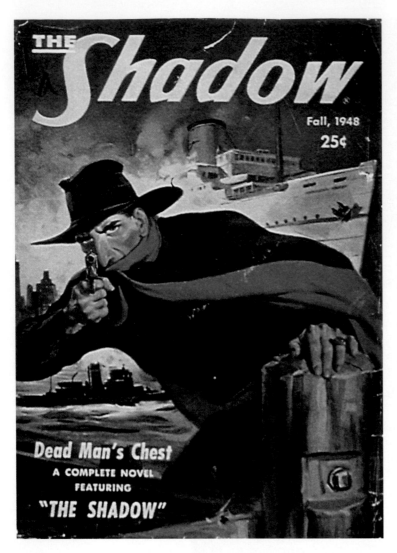

The Shadow, Fall 1948 (©/ ™ The Condé Nast Publications, Inc.; cover art by George Rozen)

all the torpedo bombers have been shot down, and you, only you, can hide in the clouds and then dive down to place your five-hundred-pound bomb right onto the deck of that enemy carrier. Or, dressed in your natty Edward G. Robinson suit, shoes shined to a mirror and a .45-caliber bulge under your armpit, seek out crime in the streets, at the office, in a penthouse, at the warehouse. Become The Shadow, Doc Savage, The Spider, or Operator #5 and fight the "yellow peril" and ruthless gangsters—evildoers that can only be stopped dead in their tracks by American heroes just like you.

Cover art presold the magazines visually, often with flesh-creeping, brain-haunting pictures of men in pain and women in terror of what was about to happen to them. Pulp cover fought pulp cover on the crowded newsstands of the Depression thirties—and those with the most fright, excitement, and senses-pounding colors per square inch won...one thin dime.

Approximately two hundred different titles and thirty years of time comprised this factory for making art. Most of the pulp artists were taught and trained just past the turn of the century in the classical mode of representational painting. As with the old masters, oil paint on canvas and board, paintbrush and palette were their tools. The originals were about twenty by thirty inches in size, mounted on stretch frames with room at the top for the later entry of titles, price, and story information. They would be photographed down in size for color separations. After the magazine was printed, very often the painting, having served its purpose, was trashed. The artists did not request their return since they had no monetary value and their attitude then was somewhere between indifference and shame. Often the next month's painting for a new cover was painted directly over the previous one; the canvas and the stretch frame had a cash value.

When the Popular Publications warehouse in the Bronx burned to the ground, hundreds of pulp paintings were destroyed. In 1961, when Condé Nast bought Street & Smith and moved to high-rent uptown and were cramped for space, they called the artists: "Do you want your artwork returned?" The answer: "No!" Street & Smith had saved their art and it was a large collection of the very best. A small auction was held but there were no bids, no bidders. Then the paintings were offered free to their employees; even at that price, there were no takers. A tragedy in American art: the largest collection ever saved was put on the street for Iron Mike, the sharp-spiked roller-crusher at the back of a New York City garbage truck, to cut and rip to pieces. The best of the best were lost forever.

Is it possible that an artist could be the worst judge of his own work? John Newton Howitt created approximately three hundred of the very best pulp cover paintings for Popular Publications between 1933 and 1939. He was called the Dean of Weird Menace Art, the Premier Illustrator of Modern Horrors. He painted human nightmares and imagined scenes from inside hell: *Horror Stories, Terror Tales, The Octopus, The Scorpion, The Spider, Operator #5,* and *The Whisperer* cover art sold out the magazines as quickly as they hit the newsstands. Howitt was trained at the Art Students League and was born to paint. His paintings were carefully planned, with much sharp detail; still, he produced as many as seven covers in a single month. Despite praise, despite demand and a top reward of nine hundred dollars a cover, he despised his own work. In his own words: "Honest and finely executed paintings constitute 'Fine Art.' Occasionally it becomes 'Great Art.' But Good Art is not eccentric, does not attempt to shock people nor to copy or rehash what has been good, but is an honest expression of the basically well-trained artist."

Some believe the story that most of Howitt's paintings were returned and he had them stored in a barn, that on one black night in a prudish rage of growing hatred against pulp art he torched the barn. Perhaps the proof of the story's truth is that almost none of his paintings seem to have survived.

At the first science fiction convention held in Manhattan in 1939, beautiful cover paintings from the imaginations of Frank R. Paul, Virgil Finlay, and Wesso were auctioned. The auctioneer began: "Ten dollars? Do I hear ten dollars, anyone?... Five dollars?... Two dollars?... A quarter?... No bidders?" So the auctioneer in anger threw them high up into the air over the audience—and whoever caught them owned them for free!

Frank R. Paul, "The Spore Doom," *Wonder Stories,* February 1934

Midtown Manhattan/Lexington Avenue was pulp publishing's geographical pinpoint. The artists and writers were there because their publishers were there; the publishers were there because the printers were there; and the printers bankrolled the publishers to get presswork. Sometimes the artists would take their paintings to Wagner's Photos and Prints on East Forty-second Street and Pop Wagner would try to sell a cover painting for ten bucks; he'd take five, or even two.

Some of the authors went uptown and upward to the slick magazines and then to Hollywood and fame: Dashiell Hammett, Earle Stanley Gardner, Edgar Rice Burroughs, Raymond Chandler, Ray Bradbury, and Isaac Asimov, among others, all became well-known and respected writers.

But hardly known at all were the pulp artists: J. Allen St. John, Virgil Finlay, Frank R. Paul, George and Jerome Rozen, Norman Saunders, Rafael de Soto, Walter Baumhofer, Rudolf Belarski,

The Pulps: Their Weaknesses Were Their Strengths

ROGER T. REED

The glory that was the pulps is gone, and too often, forgotten. It may sound strange to put these publications on a pedestal; after all, they were created by hack writers and just-out-of-art-school illustrators; they were generated by formula and printed on below-newsprint-grade "pulp" paper. They were cheap in every meaning of the word.

Yet their weaknesses were also their strengths, and the raw excitement of working at the rough-and-ready frontier of American popular culture is evident in every issue. In trying to appeal to the common man, the pulps streamlined and punched up the content, and in so doing left the subtle intricacies of Henry James or Edwin Austin Abbey behind forever. The pulps' contents tap directly into our primal nervous system: the fight-or-flight reflex, the pleasure center, the gut and the tearducts—places where violence, power, awe, sex, horror, hero worship, and xenophobia stir our impulses. For the pretelevision reader, this wild fringe of the print media was highly entertaining and bolstered by occasional flashes of genius.

Are such initially fringe phenomena as Elvis, King Kong, or Googie-designed "atomic" restaurants representative of our culture? No. But they are definitive, which is far more interesting. Precisely because these phenomena were at the edges of culture, they helped define its overall shape. After all, which is more sought-after today, the Oldsmobile or the Kustom Kar of Ed "Big Daddy" Roth? Pulp magazines (and their successors, the paperback "originals"), dwelling in this outer niche, have occasionally been footnoted as having brought to the attention of the public such writers as Dashiell Hammett, Edgar Rice Burroughs, Max Brand, H. P. Lovecraft, Jim Thompson, and others. But it was the art on the covers, as the publishers readily acknowledged, that sold the magazines in the first place. By contrast, little attention has been paid to the artists.

Why has this art been neglected? For one thing, the paintings were generally trashed after they served their purpose. Of an estimated fifty thousand paintings made for all pulps, only about 1 percent has been recorded to survive today. Second, books written about the pulp era so far have consistently downplayed the art. Even the best artists of the format—Walter Baumhofer, Rudolph Belarski, Norman Saunders, Earle Bergey, J. Allen St. John, George and Jerome Rozen, to name a few—are completely unknown in art-historical circles and are only pursued by a cult following. Their original paintings were never seen by, or exhibited for, the public. It is only recently that the very first public exhibit featuring pulp art we're aware of was held at Bowling Green State University in Ohio. Relatively few artists (such as Tom Lovell) "graduated" from the pulps to more mainstream illustration circles.

But these are only symptoms of the pervasive ignorance of pulp art, not reasons for it.

The constraints on pulp cover art required a bracingly direct, fresh painting style, without contrived artsiness. Born of the need to attract attention at the newsstand, artists developed dynamic, complex compositions and silhouettes, quickly describing the action. For it was action, above all, that sold the pulps. A gun going off was always more exciting than one merely pointed. Colors came right out of the tubes, shadows were "awakened" with mysterious green or purple reflected light, and backgrounds were most effective when they were solid, saturated color. Diligent artists would try to craft their cover images to adhere to the text of the lead story within. Often, the cover art would mislead the reader about the story; in some cases it had nothing to do with anything inside. Sometimes the story was written to suit an artist's sample.

After almost a hundred years of proto-pulps, the true form came into maturity with the publication of the pulp tale "Tarzan of the Apes" in 1912. The runaway success of Edgar Rice Burroughs's Tarzan and Martian stories spawned many magazines (and imitative writers) and turned up the competitive heat on established ones. In that year, *Cavalier* magazine became a weekly, and circulation of the Munsey magazine chain mushroomed. In the teens, *All-Story*, *Argosy*, and *Popular* contained every kind of romantic adventure fiction. Twenty years later, the field was so widely popular that even very small-niche magazines like *Prison Stories*, *Ranch Romances*, and *Terrence X. O'Leary's War Birds* could flourish (at least for a while).

Editors from *The Saturday Evening Post* and other magazines patronizingly considered the pulps to be great training ground for their publications. With these "slick" magazines luring away the best and most mainstream writers and artists, the pulps were pushed to ever more extreme niches to survive. *Spicy Detective*, for example, had to be sold under the counter. *Horror Stories* purveyed torture inside and outside the magazine. By the mid-1930s, many pulps had reached the point of offending a substantial portion of the American newsstand-gazing public, and New York's Mayor La Guardia cracked down on the publishers, imposing a code of decency. For this and numerous other reasons, few pulp magazines survived the Second World War; but their spirit has been reincarnated into other magazines, paperbacks, and movies.

Naturally, what we pine for today is that universe that is *Spicy* and *Amazing*, that is hard-drinking, that is the fastest draw, that feels like the ragged end of nowhere, and that truly knows the hearts of men—the glorious era of the pulps!

Roger T. Reed is the director of Illustration House, a gallery in Manhattan dedicated to the paintings and drawings of illustrators. He has written several articles on the subject, is a member of the Society of Illustrators Permanent Collection Committee, and is an authority often consulted by institutions regarding identity, authenticity, and quality of original illustrative art.

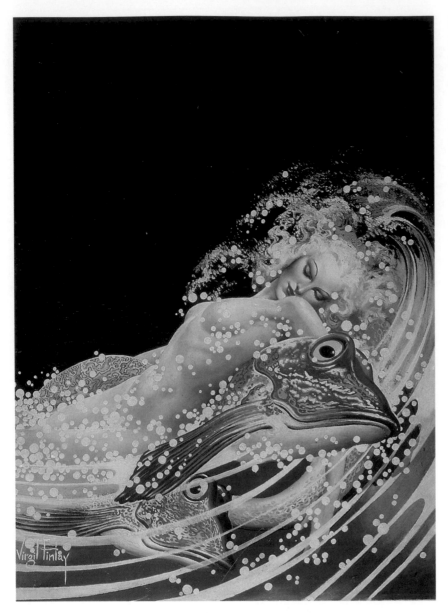

Virgil Finlay: "Creep Shadow," *Famous Fantastic Mysteries,* August 1942 (Capel McCutcheon Collection)

Frederick Blakeslee, H. Ward, Tom Lovell, Paul Stahr, John Coughlin, H. W. Scott, Herbert Morton Stoops, and many others.

Why wasn't this art saved? Why is it so hard to find today? Because pulp art is, to many, offensive art. Its pictures are filled with pain, torture, violence, and the threat of sexual violation and death in motion. Your spouse and other family members would balk at hanging it in the house: the neighbors might see it, and it's not *nice*. Landscapes, seascapes, a bowl of fruit, a vase of flowers, a dog or a cat or a horse, an emotionless canvas of abstract colored shapes, and Norman Rockwell's *Saturday Evening Post* paintings are *nice*.

Pulp art is hard whiskey: men's art fueled on testosterone. Unknown and unrecognized, without a deep anchor sunk into the marketplace, it has remained—until the very present—a unique American heritage that burned brightly on newsstands for two decades, a lost inheritance future generations might never see or be able to claim. Its neglect has been an American cultural tragedy.

Why wasn't it saved, or at least acknowledged? Because of a single word: *pulp*. Prejudice of the cultural variety is perhaps the strongest kind because it sneaks into the language and stays forever in speech and print. Here the insult is the cliché: "It is as worthless as pulp fiction!" Such characterizations have served the literary elite as a sword to cut down books it doesn't like. An entire genre of American art and literature has been condemned by a single word.

Who created this climate of disdain that resulted in artist and writer surrendering to self-hate? What Tyrant of Taste had the nationwide power to put a permanent stain on the cloth? For one answer, we can plunge back in time to August 30, 1935, and open to the editorial page of the *New York Times,* where there is a essay entitled "Fiction by Volume."

But there is another publishing world little known and certainly officially unrecognized in which volume of production is more important than literary quality. The pulp magazines, month in and month out, regardless of season and almost without concern for the economic depression, go on pouring an endless stream of fiction to the newsstand trade. Their readers want variety, and a nucleus of half a dozen strong firms, each publishing from four to over a dozen pulp magazines, give them westerns, detective

stories, adventure, spy stories, love stories, tales of war in the air, railroad stories, and mysteries....

Millions of words are written every month for the pulps.... A pulp editor will get [out] as many as half a dozen magazines a month. The result of this production system is inevitably an emphasis on quantity rather than quality. Fiction writers who have "been in the game" for a number of years and who are favorably known to their editors are harried and spurred to turn in their thousands of words a month. They receive perhaps an order for a novelette of 20,000 words involving a scene: "Illustrated by front cover, enclosed herewith." Invention and industry come into play. The pulp writer probably has two or three stories already on the fire, but he immediately starts on the new order, piling murder on intrigue, words upon words.

If he began his writing life with any feeling for style, it is washed out of him by the flood of words in a few years. Still, a handful of writers may be expected to graduate from the pulp world. Just as some of the more popular comedians of the stage have come from the burlesque wheel.

Reading between the lines, we may discern some jealousy. In 1935, the book business was poor and getting poorer; the pulp business was rich and getting richer. A fighting-mad reply was written by A. A. Wyn, owner of Ace Publications.

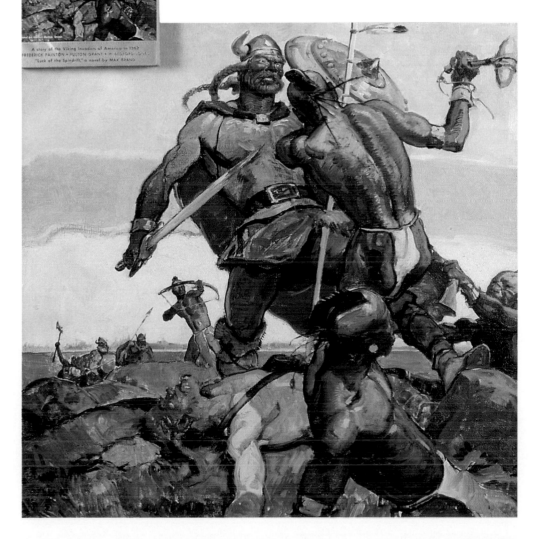

Herbert Morton Stoops: "A Story of the Viking Invaders of America, 1362," *The Blue Book Magazine,* April 1941

The Cover Artists and Their Publishers

FRED COOK

I vividly remember a visit, several years ago, from a local artist who specialized in painting scenes from our rural Amish country. He was dragged, kicking and screaming, into the house by a fellow pulp-magazine collector who wanted him to see some of the pulps in my collection. After taking a look at several cover illustrations by J. Allen St. John and Walter Baumhofer, he got a bewildered look on his face and gasped, "This—this is *art!*"

He hadn't expected to see, on what he and others considered cheap, pulp-paper throwaway magazines, illustrations by competent, trained artists. These, and other excellent artists, during the Depression turned to the only outlet for their paintings and created the covers that ultimately sold the magazines to the public. Whether or not the cover illustrated one of the tales contained in the magazine, it had to be attractive, colorful, and tell a story by itself—and make the prospective purchaser "want" to pay his ten or fifteen cents and take the magazine home with him.

Harry Steeger, president of one of the most successful magazine chains of the thirties and forties, Popular Publications, personally approved and bought all the cover art that appeared on his magazines. Mr. Steeger built and installed a replica of a newsstand in his offices and would purchase rival magazines and place them on the stand with his own, as they would appear to the public, and determine whether his magazines or his competition caught his eye. He felt that, with all the pulps displayed on the newsstand at one time, the buyer had about three to five seconds to have his eye attracted to a cover that would lead him to spend his hard-earned dime.

Mr. Steeger also had a theory about using color to lure buyers to his products. He felt that yellow and red were colors that attracted the male eye and that blues and greens attracted females. His *Dime Detective, Dime Western,* and *Dime Mystery* all featured distinctive yellow backgrounds on virtually every cover; red was the dominant color on *Star Western* and others. The bestsellers of the Popular line were the love-story magazines, which featured the green and blue backgrounds.

Rafael de Soto, one of the most prolific of the cover artists, began work at Street & Smith in the late twenties, doing interior illustrations for a very low rate of pay. He had received his artistic training in both Spain and Puerto Rico and decided to present a painting to Mr. Blackwell, who bought the covers for the company. He had to wait in Blackwell's outer office, which had many oil paintings originally used for covers framed on the walls. De Soto looked at a Wyeth, a Schoonover, and other famous artists' work and decided not to show what he considered inferior art to Mr. Blackwell.

Instead he showed some unfinished pieces, and Blackwell showed some interest and asked that de Soto do some finished art and bring it around later. In the process of leaving, de Soto changed his mind, walked back into Blackwell's office, and showed him his original painting; he sold it. For some time Blackwell called de Soto "the fastest artist in New York."

Walter Baumhofer, an excellent, trained artist, told me in a letter how he broke into Street & Smith's cover group. It was in the early thirties and close to the end of the month, when the rent was due, and Walter had only enough money to either hire a model for a western painting that he could show to Blackwell, or pay the rent. He hired the model, painted the classic "Stand and Deliver" stagecoach robbery, and got the job.

John Newton Howitt, who worked for Popular Publications and painted beautiful action covers for *The Spider* and *Operator #5*, became an award-winning landscape artist in his later years. He kept all his pulp paintings, and when he passed away, his wife burned them all, because she wanted him to be remembered as an "artist" rather than as a "pulp painter."

Popular Publications kept all the original art for their covers in a loft somewhere in New York City. Periodically, it became crowded, and the artists were called to pick up their paintings, if they wanted them. Norman Saunders, one of the artists, received that call and climbed into the loft where the paintings were stored and saw quite a few of Walter Baumhofer's paintings stacked against the wall. He asked if Baumhofer had claimed his paintings yet; he was told that he had, and that he'd left those he did not want. Saunders, who admired Baumhofer's work, left several of his own paintings and took the Baumhofers in their place.

Who are my favorite cover artists? For the Fiction House group, I consider the paintings of Rudolph Belarski, George Gross, Norman Saunders, and Allen Anderson to be outstanding: Belarski for his great air-war paintings, Gross for his paintings of beautiful women for *Jungle Stories*, Saunders for his Far North covers, and Anderson for his wild science fiction art.

For Popular Publications, my favorites were Rafael de Soto for his wonderful, action-packed covers for *The Spider, Dime Detective,* and *Black Mask,* Frederick Blakeslee for his powerful air-war paintings, and John Howitt for his covers that adorned *Operator #5*.

Earle Bergey stood out among the Standard Magazines artists. He could paint covers that looked so real you could almost reach into them. He was great on the science fiction, detective, western, and love-story magazines. Robert Harris specialized in the company's western magazines; years ago, I didn't read the westerns, but I bought and saved all of Harris's covers. In the forties, Rudolph Belarski painted spectacular covers for Standard featuring beautiful women.

Street & Smith had Tom Lovell, Walter Baumhofer, Robert Harris, Gayle Hoskins, and George Rozen. For the detective magazines, Tom Lovell painted sensational action covers that told a story. Baumhofer was unsurpassed as the cover artist for *Doc Savage,* as was Rozen for *The Shadow,* and Hoskins for *Western Stories.*

There were three great cover artists at the Munsey chain: Paul Stahr, Charles Graef, and Emmett Watson, and many excellent covers were painted by Rudolph Belarski. Watson did most of the contemporary covers for *Argosy*, Stahr did the western and adventure covers, and Graef did most of the science fiction.

As can surely be implied from some of the paintings reproduced in this book, it was the cover art that sold a pulp, more often than a big-name author. The pulp era was responsible for hundreds of excellent paintings— those that caught the eye, those that told a story in a second or two, and those that should be displayed today as examples of fine art. Here's to the great pulps and to the cover artists who made them great!

Fred Cook is a senior executive for a major midwestern manufacturer; he resides in Ohio. He has spent a lifetime in pursuit of what very well might be the country's largest and best collection of pulp magazines and populist culture artifacts.

To the Editor of the *New York Times*:

Your editorial about pulp magazines headed "Fiction by Volume" in the *Times* was so typical of the attitude of the partially informed and misinformed that I cannot resist the temptation to answer it. As publisher of approximately ten western, detective, flying, spy, and mystery magazines, I am particularly amused by your characterization of this publishing world as "little known and officially unrecognized." Little known by whom? Officially unrecognized by whom? Certainly the 10 million who go to their newsstands each month to buy pulp magazines know and recognize this publishing world. When you consider that these 10 million buyers in usual computation make over 30 million pulp readers, you have an astounding percentage of the entire American literate public.

Monthly newsstand sales—the unerring acid test of circulation— clearly demonstrate the preference of the American reading public, not that small coterie which is faintly amused and slightly incredulous of the existence of the pulps and totally ignorant of their importance and purpose....

We all know that plenty of bankers and brokers, lawyers and doctors, salesmen and senators are addicted to reading the pulps. How often we have heard them say, "Pulps? Um, yes—I read them myself once in a while—they help put me to sleep." The sly liars! Imagine our blood-and-thunder stories, sweated out to provide the utmost in spine-chilling, blood-tingling fiction, being used as a sedative!...

You may laugh at the stories we use; you may laugh at the paper we use.... But you can't quite laugh off the 10 million Americans who plunk down their hard-earned cash each month for their favorite magazine.

And who knows what some future historian may say about the relative merits of the forests of pulp that go into the magazines and books of today?...

But I should be the last one to think about the verdict of the future. I've got a western pulp, a detective pulp, and a mystery pulp all going to press. There is a foot and a half of manuscript to be read with bang-bang and rat-

tat-tat and corpses galore, the number of corpses per story having gone up since the depression.

A. A. Wyn

New York, August 30, 1935

Soon more anti-*New York Times* letters to the editor poured in, and the pulp flames got hotter.

To the Editor of the *New York Times:*

One further word about those lowly pulp magazines—a point or two not covered by your recent editorial and which pulp publisher A. A. Wyn failed to mention in his letter of defense....

Unless a first glance at his work proves him to be an unmistakable genius, what chance has an unknown writer to break into the bigger magazines? Even genius can be hesitant about showing itself at first; besides, I doubt very much that the general magazine-buying public readily takes to an unmistakable genius at first meeting. Isn't it essential, therefore, that the new writers be provided with an outlet for their first efforts? Call the pulp magazines a proving ground then, if you like, or call it the author's amateur show; the fact remains that innumerable writers have their beginnings in it.

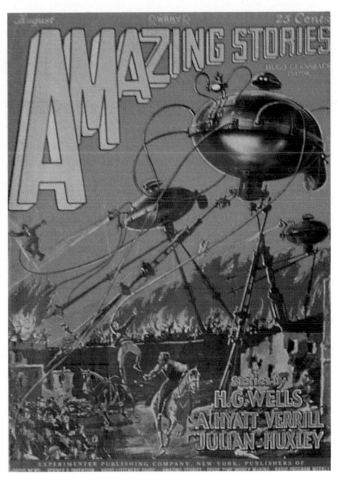

Amazing Stories, August 1927 (cover art by Frank R. Paul)

And yet the pulp magazine is not an amateur show. Though dozens of writers lift themselves out of the pulps annually and into the slicks, they seem to retain a certain loyalty to their earliest publishing medium. Thus it is that in addition to the names of Max Brand, Earle Stanley Gardner, Robert Carse, T. T. Flynn, and Allan Elston there are...dozens more who continue to publish in both pulps and slicks simultaneously.

Don't dare tell me that as writers all these men have split personalities!...

No! Slick-paper magazines and pulp-paper magazines are not the worlds apart that you imagine them to be....

Frederick Clayton
Editor, *Argosy*

New York, September 4, 1935

The cover art of the magazines was also ridiculed, and intense letters of dislike were sent to the pulps' editors. Many newsstand operators would tear off the covers in order not to offend prospective buyers or the passing police—as attested to by editorial comments in the November 1928 issue of *Amazing Stories*. A reader from New York wrote:

I want to join others in the criticism of your covers. You seem to find it impossible to believe that one could be so sensitive as to tear off the covers to uphold their pride. Can you not recognize the right to possess an aesthetic sense! I always tear off the cover of my copy for I feel sure that to exhibit it would be a detriment to my prestige among my friends and shame if seen by my neighbors.... Surely a gaudy, poster-like cover is not conducive to lend dignity to Science Fiction.

The *Amazing Stories* editor responded:

We have given a good deal of thought to letters similar to the above, but so far we have not been convinced by them....

The fact remains, however, that the gaudy covers do sell the magazines, and that this is the most important thing any publisher considers. The publishers are fully convinced of the fact that the covers are not artistic or ethical but this does not affect them in their decision at all, for the simple reason that experience has taught us that only "flashy" covers are easily seen when displayed on newsstands.

The next time you step up to the newsstand on which are displayed 150 or more magazines, all of which are fighting to be seen, make this test: step ten feet away from the newsstand and scan the magazines rapidly for not more than three seconds. The idea of this test is to see which magazines impress you the most. You will find that only the magazines with flashy and loud colors will attract you at all, and that is a good test for these reasons: you walk by a newsstand, and at best, you have no intention of buying a magazine. Your attention will be focused for not more than three seconds. If one or two magazines don't flash into your consciousness and make you stop and at least look upon one cover all has been lost and you move on....

It will be found that the magazines with the quietest covers are usually the poorest sellers.... We venture to say that most of the readers who are dissatisfied with the loud covers were themselves attracted to *Amazing Stories* by these same covers. And we have on file thousands of letters from readers admitting that they were attracted to the magazine by its cover.

The policy must be right because the circulation is increasing month by month and the publishers are convinced that this growth could not be effected by printing an Ethical Cover.

Ethical cover? The editors opened their own veins to let the deadly germs of misguided criticism come in. They accepted the guilt, providing a valiant defense from a commercial standpoint, but leaving their products wide open to criticism from the cultural guardians throughout the 1930s. President Herbert Hoover, concerned about the pulps, formed the Committee on Recent Social Trends to investigate them for "attitude indicators" that would reveal approval or disapproval of such matters as old-fashioned religion, morality, and radical stories favoring communism. Much to the committee's surprise, despite the political and literary critics, they found the pulps to be devoid of damaging influences. In 1933, with hatchet sharpened, *Vanity Fair* published "The Pulps: Day Dreams for the Masses," which contains this rather nasty characterization: "Chicago soda-jerkers living in tenements with their mothers and three sniveling little sisters are transformed into dare-devils of the sky reading *War Aces*. Cheap girls in Pennsylvania hosiery mills and Kansas City ten-cent stores find their handsome lovers in *True Confessions*. The pulps manufacture daydreams, on a wholesale scale." And in 1936 *American Mercury* magazine published "A Penny a Word" by an anonymous pulp writer, unnamed because he was still taking money from the hand he was biting.

The pulps, I learned, dispensed daydreams to hordes of Americans too unimaginative to dream for themselves. Some 5 million of these morons paid willingly each month for their canned dreams.... If a writer's product sells the

magazine his stuff is bought. If the stories don't appeal to the morons, he is out of luck. The check-up on the writer is immediate and final.

My colleagues are a servile, pitiful lot. Some have become embittered and, deliberately layering their souls with calluses, are striving to get all they can out of it while they last. Others have distorted themselves into an unhealthy adaptation, deluding and reviling themselves. They defend their positions fanatically against outside attack and bemoan their fate among themselves.

I myself have become a dependable purveyor to those 5 million morons who pay a few nickels each month for their mechanized dreams. I am one of the camp followers of the pulp-writing profession, the ragtag and bobtail of the fiction parade who, for bare subsistence, scavage in the garbage heaps of literature.

In the present, things are still going badly for the pulps. Anna Quindlen (who most likely has never read or seen a pulp magazine), in a 1993 op-ed piece for the the *New York Times*, reiterated the old saw by calling something "as worthless as pulp fiction." In that newspaper's Letters column in 1996, a reader wrote: "These libraries make available not the latest pulp fiction but scientific,

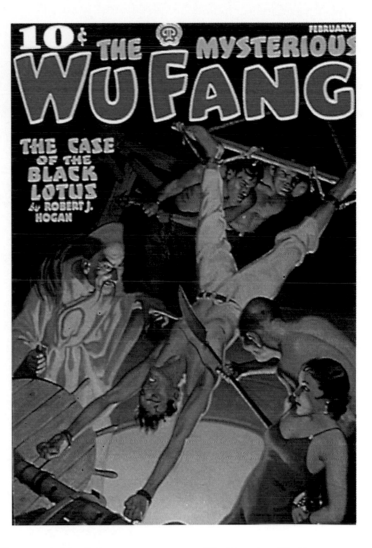

The Mysterious Wu Fang, February 1936 (cover art by Jerome Rozen)

social, and political information." In a *New York Times* article of the same year ("Disciples Pay Homage to a Guru of Gumshoes"), it was related that a president and publisher of adult trade books asked if Raymond Chandler's pulp novels deserved to be called literature. "Literature is whatever people read," replied Mickey Spillane.

Pulp in the form's heyday meant trash. *Pulp* still, apparently, means trash, a concept embedded in the American language. It is a stain of cultural injustice that remains. The cover art and the stories inside were Siamese twins joined at the hip; one was ignored, the other despised. Tyrants of Taste leading an army of Philistines damned the art and poisoned the minds of pulp painters against their own work. Blinded by prejudice, they never looked *really* critically and closely, never saw beauty where there was beauty, never saw magnificence. But there *was* magnificence: a unique and marvelous American populist art had been created.

Hopefully, a future generation of Americans with free minds will look at the few survivors not as pulp illustrations but as paintings, just paintings. And each time they hold a pulp magazine in their hands and look at the cover, perhaps they will realize that once upon a time it was a large and daring oil on canvas.

Looking at it with fresh and appreciative eyes, then, we should finally ask, What is pulp art, and what makes it unique? It is storytelling art in motion, like a still photograph taken from the middle of a movie, stop-action at the crisis point. It is not one painting, but three. You see the center painting, not the

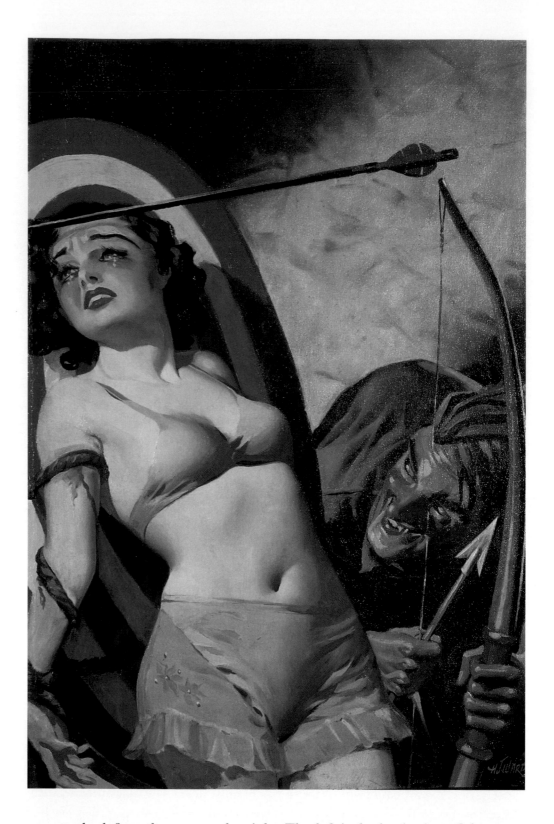

H. J. Ward: *Spicy Mystery Stories,* August 1936 (Book Sail Collection/John McLaughlin)

one on the left or the one on the right. The left is the beginning of the story, what came before the crisis; on the right is the resolution. You can see the center painting: it is physical paint on canvas, but the missing two are conceptual. It's like walking into a movie in the middle. Of course, this was the commercial intention—to create sufficient curiosity to get your dime.

The twentieth-century Italian philosopher Benedetto Croce, in his *Guide to Aesthetics,* provides an entrance. The Crocian aesthetic suggests that one should read a painting. As much time as the artist took in its creation, the reader of the painting should spend in study: lavish time on each stroke of the brush; it is a process in logic applied to the painting, it is the inductive form

of reasoning from the particulars to a general conclusion. Suddenly an aesthetic intuition occurs and the conceptual art appears; the paintings on the left and right become visualized.

The usefulness of this method can be demonstrated by imagining a conversation between two art collectors viewing a particular—and particularly grisly—pulp painting, the one created by H. Ward for a 1936 *Spicy Mystery* cover.

"Why the objections? It's really a very good and typical *Spicy*," offers one collector. "Certainly it has all the elements. The victim is a beautiful girl being tortured. The arrow in her hair suggest a 'William Tell' scenario of danger. The villain is a leering monster, enjoying his evil and preparing the next arrow."

His companion might reply: "As a mid-1930s sexual fantasy it's a marvelous invention, but I just can't believe it. In her face the pain is posed, not real. That's what I see."

"Then you don't see enough. You read the painting but skipped a whole page. Look in the lower corner at her hand. Her wrist is broken."

"You're right. It *is* broken, and there is blood. I missed that."

"And that detail makes it real, not posed, because..."

"Because the terror on her face might seem posed, but the broken wrist means she is feeling real pain."

"And on the invisible left?"

"I can see how it began. He had broken her wrists, removed some clothes, and tied her to the target."

"And on the invisible, yet-to-come right?"

"A pulp nightmare! He'll remove the rest of her clothes and bring his symphony of unspeakable acts to their logical conclusion. The invisible left and right, prelude and postlude, are readable extensions of the 'center' scene. Ward saw all three elements of the story in his mind."

"And if he had painted them, the publisher would have thrown him down a flight of stairs and called the police!"

Pulp art is nightmare art. Unlike inside the human mind, there is no release at dawn. The scene of terror is recorded in permanent paint on canvas. The best of pulp art is nightmarish, reflected from the rear wall of the mind; it is our midnight side.

In the realm of art history, certain paintings and themes seem to point the way, or serve as sources, for the best of the pulp covers. There is, in particular, one universally recognized painted image that Everyman will see forever in bright colors and clear focus. It can still be seen everywhere, as the subject of giant stained-glass cathedral windows as well as of pint-sized postcards. It is the Crucifixion of Christ.

This often-painted scene represents the collective nightmare of the human race. Perhaps a secular interpretation of a religious painting can widen its horizon of importance, bring it into the present—and in its newest translation provide sights, and insights, unseen. How can we look at it afresh, and

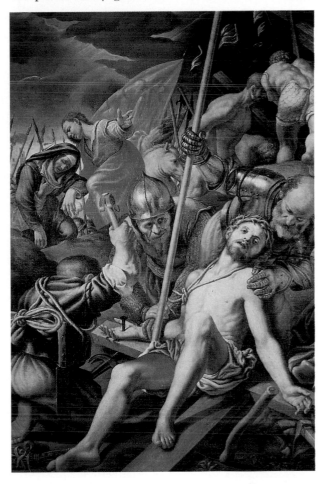

Vincenzo Campi: *Christ Nailed to the Cross*, 1577 (The Prado, Madrid)

Yes, I Was There

SHIRLEY STEEGER

Yes, I was there when Popular Publications was only a crazy dream for two ambitious young editors—Harold Goldsmith from Ace Publications and Harry Steeger from Dell. Starting a new publishing venture in 1930 in the pits of the Depression was lunacy. But they did it. I remember one of the planning sessions with them, when I suggested that in order for a magazine to be successful it had to be popular. Bingo! There was the company name, Popular Publications, and incidentally, that familiar little colophon. With $10,000 of borrowed money they managed to get about $125,000 worth of credit to start four magazines. The first office was a minuscule space: two desk-size offices and a one-person staff. Harold Goldsmith was the business-man and Harry the publisher, editor, art director, and recruiter of talent.

Of the first four books—*Battle Aces, Detective Fiction, Gang World,* and *Western Rangers*—only one sold enough to warrant continuation. As if that were not daunting enough, the distributing company went bankrupt, owing several months' collections from newsstand sales. It almost wrecked the com-pany but not the resolve to push on, which the partners did by evading bill collectors and talking their way out of a padlocked door.

Harry always thought that the cover sold the book. The stories kept them coming back for more. He knew what appealed to the male public in the stories and what visual magnets made them stop as they passed by a newsstand. He had a prescience about what the readers would want many months ahead, from manuscript to newsstand sale.

All pulp fans are familiar with the names, work, personalities, and spe-cialties of the various cover artists so vital to the success of the magazines: Lovell, Reusswig, Howitt, Saunders, de Soto, Blakeslee, and Baumhofer, among them. Harry worked closely with all of them, pouring in his own cre-ative energy and critical judgment, which elicited the best from each one. He designed the simple, bold lettering in the upper left-hand corner of the cover. The emphasis was on strong, masculine colors—red, yellow, black. He devised a grid on a scale of an inch dividing up the entire painting. With careful study, this determined the exact area with the strongest impact.

He had a special easel built in his office at 205 East Forty-second Street. It had ample natural light as well as focused lightbeams. There with artist, editors, and art director, he told his powerful story. While not explicitly drawn from any of the issues' contents, it was always relevant in feeling to the material in the book. A painting went back many times to be reworked until everyone was satisfied.

He was a stickler for accuracy. The right gun for the purpose, infinite details for each plane, correct clothing, badges, features—all had to be verified. Nevertheless, there were occasional slips and criticism, which only assured Harry that his readers were "there," knowledgeable and caring. His glass-covered mini-newsstand in the waiting room was a popular spot.

While the themes were time-honored—air, crime, mystery, westerns, adventure, and later horror—shifting tastes were reflected in the material as well. One example was the Bermuda Triangle story. It was born in a skull session in Harry's office from news bits about downed planes in the Caribbean. He pointed out that the location of the lost planes formed a triangle. The Bermuda Triangle has become history.

Many of the cover paintings were destroyed in a disastrous warehouse fire during the 1960s—a terrible loss. However, there have been exhibits, one in New York under the sponsorship of Bob Lesser, and a lovely show at Bowling Green State University under the guidance of Bob Lesser and Fred Cook. In 1994 there was also a retrospective show of the work of John N. Howitt in Port Jervis, New York. Howitt was a consummate artist who painted several hundred covers for Popular during the 1930s. He always deplored this work, though meticulously done, regarding it as junk. The fact was that he had to do it in order to eat—until such time as he could move on to more prestigious employment. Most of his pulp paintings were simply destroyed.

Among my closest friends were the artists Fred Blakeslee and Walter Baumhofer. As a matter of fact, Harry and I were en route to dinner with the Blakeslees when we heard of FDR's death on the car radio. As for Walt, we knew his studio well. It was his telephone cord that did him in, not old age. It was an endless extension cord running under his desk, across the floor and on top of a scatter rug. He tripped over it several times, injuring himself badly. He could no longer stand straight but bent over at the waist, working in pain at a tall easel in his studio. Walt's ill-health did not impair his workmanship, and all of his artwork remains as a testament to his memory.

Over the years there has been a scornful view of the pulps as connoting something lurid and cheap. This disregards the fact that it was the starting point for now-famous authors and great art. The fan organization and convention Pulpcon has done a heroic public-relations job, bringing together collectors, dealers, experts, and loyal supporters. It has established a real value and respect for this treasure trove of historic art and literature. Recognition is now burgeoning in the younger generation and is being memorialized in well-selling, newly published books. Having outlived so many of the pulp-era greats, I am thrilled with this devotion at long last, and happy to say I was there.

Shirley Steeger was a force in the founding of Popular Publications, a venture started by her husband in 1930. She knew and advised many of the pulp cover artists.

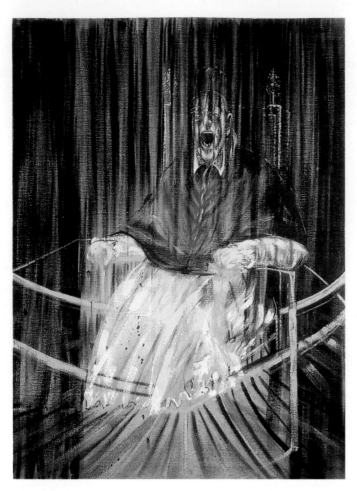

Francis Bacon: *Study after Velasquez's Portrait of Pope Innocent X,* 1953 (Des Moines Art Center, Coffin Fine Arts Trust Fund)

discover the new from inside the old? Perhaps the answer rests again with the methods of Croce.

The Crucifixion is an image *in media res*—the "middle painting." Where is the painting on the left, the beginning of the story? Five centuries ago, works of art often *physically* consisted of all three parts of the story, and these were called triptychs. One such masterpiece, painted by Vincenzo Campi in 1577, is entitled *Christ Nailed to the Cross.* Lionello Puppi, in *Torment in Art,* has written: "The positioning of Christ and the gesture of the executioner remind one of the wheel as it was applied in Lombardy: the victim was stretched out on the ground before his limbs were broken with an iron bar."

It was common practice in such Roman-era executions to break the arms and legs. The spikes could be driven into flesh easier than through bone. In art, this reality, the truth of Christ's physical pain, has seldom been depicted; Crucifixions are unfinished paintings.

The crown of thorns? Sister Wendy Beckett, famed for her brilliant television series on religious art, undertook a Crocian journey to the Middle East to pluck some real Palestinian thorns. She was horrified: they were very sharp-pointed, three inches long, with a wide base and so strong she couldn't break them. A crown of these, hammered into Christ's head, was an especially evil invention of torture.

But where is the Cry of Christ? Surely the combination of a crown of Palestinian thorns, broken arms and legs spiked to the cross, and a spear cutting his side would produce terrible screaming, but in all of the paintings of the Crucifixion the expression of Christ is painless and beatific.

One might, in a search for completion, for true depictions of this theme with readable "right" and "left" stories, wish to compare paintings from centuries past with some from the modern era. To start, against a classic Crucifixion hold up Francis Bacon's *The Screaming Pope.* Bacon, the modern master of nightmarish "fine art," has captured the genuine Cry of Christ, and the lending of it to the Crucifixion makes the scene of Christ's death more complete.

Now imagine a painting of a true crucifixion: the victim in screaming pain under a crown of formidable thorns; spikes smashed through broken arms and legs; a spear stabbing into his side; and the bad guys playing dice below. Imagine such a scene on the cover of a pulp magazine at a New York City newsstand, circa 1935. On one side of that magazine is *Horror Stories,* on the other, *Terror Tales.* Would it have been noticed next to these neighbors and the 150 lookalikes on the newsstand? No; because this image, whether on museum-housed canvas or dime-magazine cover, would have fit in among the pulps since it can be said to have the same essence, the same elements as pulp art—

qualities that have also made it the strongest and most disturbing picture in the world.

Finally, include among the hallowed relations of twentieth-century American pulp art "classical" and religious art depicting the saints and martyrs: Goya's *Saturn Devouring His Children* and *Woman with Her Throat Cut,* Poussin's *Massacre of the Innocents,* Caravaggio's *Judith and Holofernes,* Brueghel's *The Triumph of Death,* and pulp art by Tintoretto, Dürer, Rubens, Rembrandt, Manet, and Hogarth. The elements of pulp paintings have always been a part of our aesthetic culture, and will remain so until the end of art.

Science Fiction, Science Fact, and Fantasy: Painted Answers

The entire human race down to the last man, woman, and child shares a fanatic's faith strong as steel and intolerant of dissent. We seldom permit doubt to be voiced or printed anytime, anywhere, asleep or awake. We don't want to hear the question—we just want to see answers.

The answer is yes—there is life in outer space. Fred Hoyle, the cosmologist, came to the mathematical conclusion that not only is there life in outer space but there must be a cricket team that can beat the Australians. Enrico Fermi was another true believer. He would walk into the engineering room at the Institute for Nuclear Studies, smile, look straight up and ask: "Where is everybody?"

So where is everybody? When are our outer-space guests coming to visit the planet Earth, or are they here already? When they come, will they love us or eat us? Will they look like us or nothing like us?

The purpose of science fiction art is to paint all the answers we don't yet have. All that is required is the infinite human imagination and a paintbrush. From the earliest scratches on a cave wall of the moon and stars to the latest computer-generated mind enhancement that can plunge one down onto a strange, dangerous planet, the factory of the human mind has continued to manufacture, in glorious Technicolor, all the answers.

Any real alien from the stars would have a serious problem: how could this visitor possibly live up to his competitors—visible to all, years before his arrival—on the 1930s covers of *Amazing Stories, Astounding Stories, Wonder Stories, Science Fiction, Future Fiction,* and other sci-fi pulps? The pictures painted from the imagina-

Virgil Finlay: "Minos of
Sardanes," *Fantastic Novels,*
November 1949

tions of Frank R. Paul, Rudolph Belarski, Virgil Finlay, Wesso, Howard
Brown, and J. Allen St. John are tough acts to follow. Is it possible that what
we have already achieved in paint and print here is more magnificent than
the reality of those who are still undiscovered out there? These are two dif-
ferent "realities": science fiction art was painted in the golden age before sci-
ence-fact art entered with space camera and computer to measure truth and
demand belief. After Sputnik it became more science and less art, more up-
close photos from outer space than magnificent paintings from the inner
space of the human imagination.

Before NASA, artists and writers could tell pen-and-paint lies—they were
never limited by facts, because there weren't any. Anything was possible
because nothing could be proven impossible, and even observed truth could
be embellished. Lowell had the most powerful telescope of his time and saw
long, huge canals on Mars. Delightful liars embraced this observation and cre-
ated in print and pictures the strange race that carved them, the machines
they used, their cityscapes and setting suns. But now, such creativity is strictly

When Pulp Art Was in Flower

FORREST J. ACKERMAN

I was born in 1916. The first magazine I remember noticing was the October 1926 issue of *Amazing Stories*. I was nine years old and amazed by the cover by the pioneer "scientifiction" (as it was known before it became "science fiction" or "sci-fi") artist, Frank Rudolph Paul of Austria, transplanted to America a decade or so earlier.

I believe I had seen a circus shortly before I saw that pulp-art cover and had been astonished by the life forms one did not ordinarily see on the streets of Los Angeles: lions, giraffes, hippos, rhinos, zebras, and a variety of other jungle beasts. On the cover of that *Amazing* was a creature I hadn't seen in the circus, some kind of incredible crustacean about three times the size of the human being who was looking at it in awe. I too stood looking at it in awe, when suddenly the magazine jumped off the newsstand, grabbed hold of me, and shouted (magazines spoke in those days) in my ear, "Take me home, little boy, you will love me!"

I fell in love with sci-fi pulp art that day. For a while there was only the one monthly magazine that featured it, but then there came an annual edition, followed by a quarterly, and by the turn of the decade there were eight sci-fi publications and I had also discovered *Ghost Stories* and *Weird Tales*.

To be a sci-fi fan in the 1920s and early 1930s was to be like a man in a burning desert, dying of thirst and grasping at every precious drop of water. The next thing I knew I was buying copies of *Argosy* and *Blue Book* and *Popular* and *Excitement!* and *Top-Notch*, lured inside by their portrayals in blazing colors, straight out of a volcano, of rocketships and giant insects and futuristic cities and earth-shaking catastrophes and extraterrestrial aliens. Paul dominated the field for ten years with his paintings of genius (I'm thrilled to own three of them), but other names began to make their mark: "Wesso" (Hans Waldemar Wessolowski), Leo Morey, Elliott Dold Jr.—and Margaret Brundage, with her titillating pulchrinudes on the covers of *Weird Tales:* naked ladies being sacrificed, semiclad heroines being menaced by all manner of monstrous beings. Wow! We didn't have *Playboy* yet to appeal to the prurient interests of young boys burgeoning into manhood, and I was just a little too young to buy the behind-the-counter copies of *Terror Tales, Horror Stories, Spicy Mystery,* and *Spicy Adventure,* but at least I could catch a glimpse of their erotic covers.

While seeking out science fiction in mundane magazines, I couldn't help noticing the dashing covers of cowboys and Indians, diving aeroplanes, surfacing submarines, and masked bandits, and although these were not my cup of glee, I appreciated them only a little less than did the aficionados they were aimed at.

I have an eighteen-room home in Hollywood with hundreds of paintings in every room, including the kitchen; and the majority of them are from the 1920s—when pulp art was in flower, as I have titled this memoir. The art of the late twentieth century may be said to have superior craftsmanship, but give me the 1920s and 1930s for visions that could make the heart pound and the pulse race, that could bring a smile of satisfaction to the face. With the joy and wisdom of eight decades behind me, I salute these pioneering pulp-art practitioners, thank them for the thrills of my youth, and clasp their hands in gratitude for the wonderful works that still survive, as preserved in this priceless volume.

Forrest J. Ackerman is possibly the twentieth century's greatest and best known science fiction and horror fan. His vast collection in this genre is only exceeded by his encyclopedic knowledge: he is recognized worldwide as an authority on science fiction and horror films in particular. He has won a number of sci-fi's international Hugo Awards, and is perhaps best known as the creator and editor of the legendary magazine of the 1950s and 1960s Famous Monsters of Filmland.

limited. No more H. G. Wells Martian monsters at war against the world, finally defeated by Earth's germs; and no more Orson Welles Martians scaring the hell out of New Jersey. After Viking Lander, science fact will not permit our minds to wander; Mars, seemingly, houses no army of space invaders. Science fiction art was painted in the colors of the unknown, in the shapes of nightmares and daydreams and adventurous explorations deep into the lost jungles of the mind. Science-fact art is a prison inside the ghetto of truth.

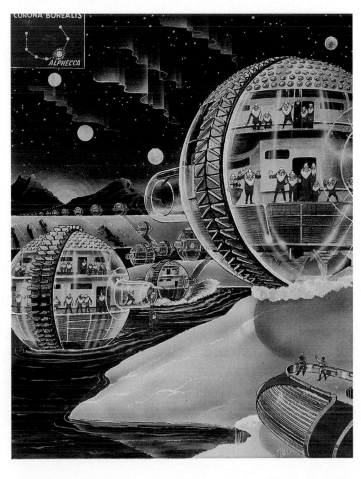

Frank R. Paul: "Stories of the Stars—Alphecca," *Fantastic Adventures*, 1946 (back cover)

Once upon a time one magazine artist was granted the freedom to paint pictures from his imagination, not covers needed to sell the stories inside and not with firm suggestions from a paying boss. The back covers of *Amazing Stories* and *Fantastic Adventures* became his art gallery. And amazing and fantastic they were. Pure science fiction art at its best: multicolored skies filled with the strange and exciting, towering buildings embedded into cities filled with twisted shapes and inhabited by incredible life forms. And inside the magazine, a bit of print attempted to explain what Frank R. Paul had painted.

Paul's back covers, such as "Golden City of Titan," "Quartz City on Mercury," and "Stories of the Stars—Alphecca," are masterpieces of science fiction art. The artist's training in architecture

Frank R. Paul: "The Vanguard to Neptune," *Wonder Stories Quarterly,* Spring 1932

shows in all his work, but the style is unique. There is a two-dimensional flatness, as if the Italian Renaissance had never introduced perspective. Paul's paintings border on primitive art; they are charming, and almost childlike in their imagination and sense of wonder.

Paul was paid forty-five dollars each for his slowly produced illustrations, but he had steady work in hard times for a lifetime. In 1926 Hugo Gernsback began the first science fiction magazine, *Amazing Stories.* Paul painted the covers and the black-and-white interiors. Letters were written to the editor praising his work; his fans begged for and bought the original art and waited impatiently for the next month's magazine to appear at the newsstand. Paul loved his work, as is obvious from his comments published in the August 26, 1938, issue of *Family Circle.*

"I get a tremendous kick out of my work. When I run into a story so bizarre that it seems to have too much of a muchness, I remind myself that our great-great-grandfathers would have pooh-poohed prophecies of radio, television, and aviation.... One of the things I enjoy about the yarns I illustrate is the ingenious way in which they go from fact to frightfulness without a struggle.... The beauty of fantasy is that there is no place that the characters can't go.... Far be it from me to say that anything is impossible.... Illustrating that sort of thing may not be art, but believe me, I never get bored. And sometimes when I'm absorbed in working out some author's idea, I catch myself thinking that maybe it could happen."

Paul's joyous approach to his art never waned, and toward the end of his career his style changed as he discovered the airbrush. Black-and-white interiors, gouache with delicate coloring, and incredible flights of imagination comprised his final, triumphant period. One of his best back covers was his last: *Amazing Stories* published a twenty-fifth-anniversary issue in 1961, and the venerable sci-fi artist created a magnificent farewell. Great artists often lose their first names and a work of art becomes "a Monet," "a Picasso," or "a

Rembrandt." Today aficionados of the genre say: "Where can I find a Paul?" and "I have to have a Paul in my collection."

There is a difference between Frank Paul and near-genius Hannes Bok; it's called night and day. Bok had the mysterious ability to find within himself the forms and colors of fantasy and then paint them in a surreal style that blended the sinister with humor. He created a body of work that cannot be easily labeled. His was genius that failed to flower. Never permitting art editors to correlate his painting on the outside of a pulp with a story on the inside, he went his own way.

And one of these ways was almost unbelievable. Recent expert analysis of three of his larger paintings reveals that he had developed the skills to replicate the High Renaissance technique of multiple glazing; Leonardo da Vinci used this technique on the *Mona Lisa.* The result, if successful, creates the optical effect of depth, pushing the background back and the foreground forward. Each coat of linseed oil mixed with colors takes a long time to dry; it is estimated that six months was required for Bok to create his private works *Martian Picnic, Out of the Storm,* and *Lunar Moonscape.*

With the 1939 issue of *Weird Tales,* Bok began providing the cover painting and interior black-and-whites. Here started his stylization of humans, machines, and objects seen through a glass darkly. "I like to make pictures...showing things not as they are...which we all know too well...but pictures of things as they might be," he stated.

Bok was a student of paint. He sought knowledge about the oldest known pigments surviving in ancient Greek ruins and Egyptian tombs, about glazing techniques from the masters of High Renaissance art to Maxfield Parrish, and he experimented with the new fluorescent

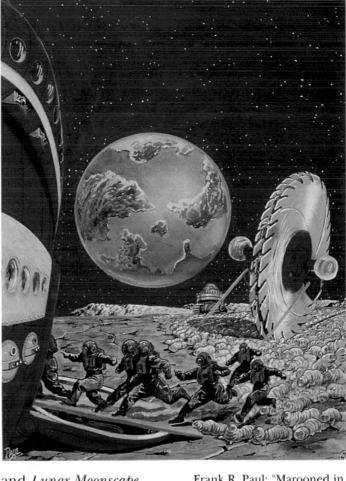

Frank R. Paul: "Marooned in Andromeda," *Wonder Stories,* October 1930

Frank R. Paul: "The Moon Era," *Wonder Stories,* February 1932 (black-and-white interior illustration)

Collecting Pulp Paintings: Dramatic Imagery and Color

STEVE KENNEDY

The pulp cover paintings, spanning over three decades, have been forgotten, neglected, and largely lost. It has been through the efforts of a few collectors that we have a vestige of this remarkable genre of American art.

The last great movement of painters of illustration, trained in the rigors of classical painting, existed in the early twentieth century. In fact, many of the fine-art painters, such as John Stuart Curry, Rockwell Kent, and N. C. Wyeth, contributed to the pulps.

There were many other artists of talent that painted fantastic pulp covers. The most widely regarded painters of the pulps were Walter Baumhofer, Rafael de Soto, Norman Saunders, John Newton Howitt, Gerald Delano, Tom Lovell, R. G. Harris, Herbert Morton Stoops, and Nick Eggenhofer. Others of noted talent were Rudolph Belarski, Graves Gladney, George and Jerome Rozen, Richard Lillis, Ernest Chiriacka, Sam Cherry, H. W. Scott, and Leslie Ross. There were other pulp illustrators that produced terrific covers, yet we know very little about them—artists such as H. J. Ward and J. W. Scott.

In a recent interview, Tom Lovell discussed the dramatic approach that went into painting a pulp cover: these covers had an impact on the newsstand that appeared as a "blaze of color...a highly colored circus in which everything was pushed to the nth degree." Tom Lovell also pointed out the effective use of warm and cool colors.

Not since the Fauve movement and the German Expressionists has there been such a striking combination of warm and cool colors from the artist's palette. The pulp paintings combine this extreme palette with action depicted to the absolute extreme. The red-hot flame from a .45 and a woman screaming, her face glowing in orange, violet, and green, would describe a good pulp image with its fantastic colors, its orchestra of warm and cool tones. This is where pulp-painting imagery becomes quite unique. The cover art of a pulp has a hard edge to it that all other forms of painting have dare not tread. Most pulp imagery of the 1930s and 1940s would not be allowed today. The pulps' action scenes and garish colors are totally dramatic and direct. Most viewers of the past or present would agree that pulp imagery "grabs you"—and this is what it was meant to do at every newsstand of yesteryear.

Pulp images derive from a different time and place, in which a great depression and a world war were part of every American's life. The stories and imagery from the pulps reflected those extraordinary events, at the same time providing temporary escapism from them.

Television, films, and computer graphics have completely replaced the extreme fixed images of the pulps. However, I don't believe anything conveyed by modern technology comes close the impact of a good pulp cover painting.

Steve Kennedy is a leading New York art dealer and an authority in the fields of American art and illustration. His understanding, love, and encyclopedic knowledge of pulp art is only matched by his determination and devotion to uncover and discover these paintings from the past.

paints and black light. Before World War II, and before the term *popular culture* was invented, Bok was a sci-fi fanatic inside the same saucer with Ray Bradbury and Forrest Ackerman. He went to sci-fi and horror films to listen to the music: he was especially enthusiastic about the marvelous film scores that Max Steiner composed for *King Kong* and *She*.

Hannes Bok: *Lunar Landscape,* 1944

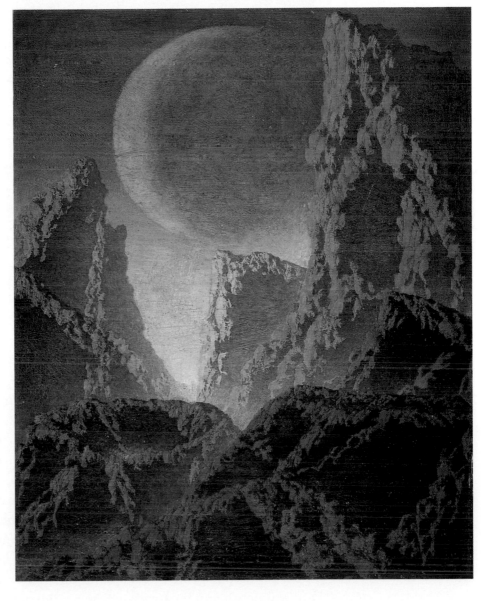

In Bok's paintings content was devoid of the recognizable: no real people here, no machinery, rocket ships, or planets seen before. Form was depicted in a free-flowing style, and a study of his use of color reveals that the color of one object became the underlay of the next, creating a subtle visual unity.

His best works were the large, personal paintings meant to be considered his masterpieces. *Martian Picnic* is not science fiction or fact but pure science fantasy and yields easily to the Crocian spyglass. Like Gustav Klimt of the Secessionist movement he considered the frame to be part of the picture; for *Picnic,* he painted it with large polka-dots, suggesting a circus clown's costume. One's first reaction

Hannes Bok: *Out of the Storm,*
1944

to the painting is to smile automatically at its humor. Mother Martian, son,
and dolly-dragging daughter—looking very pixieish—are going on a picnic.
The strange trees and leaves mark the entrance to the park. High on the hill
is a dynamic rectangle—their windowless apartment-house, strong and safe
against some Martian menace, but confining; hence the picnic is a both a
treat and a necessity for Mom and her two kids. The children walk upright,
but the mother walks on all fours, similar to our own forebears. Mother has
her son on a leash and is holding her daughter's hand: danger is about! Mars
may be an alien world, but life-forms are life-forms, and all families have the
same problems; a picnic is a picnic, and sometimes you just have to get the
kids out of the house. As the Crocian pieces come together, it becomes obvi-
ous that this Martian picnic is fun and very funny—and a great painting.

In complete contrast is Bok's more serious masterpiece, *Out of the Storm.* It
was painted in one color only—a composition in brown with lighter and
darker variations. All elements of the painting become related by one color;
three-point perspective, combined with extensive glazing, increases back-
ground depth and the focus on foreground detail; light and shadows become

a harmony of differences and balance. Here, in this one painting, all of Bok's natural talents, vivid imagination, and learned techniques are centered like the bright beam of a flashlight. An interpretation could be: man looking up into the face of God, smiling and secure in the grasp of those large, gnarled hands.

Whether he was required to produce a cover for a pulp magazine or the jacket art for a small science fiction publisher, Bok read every story, planning carefully before painting. They paid him slowly...and poorly. Bok lived in poverty and died in poverty of a sudden heart attack at the age of fifty. That his art is seldom seen and now largely forgotten is a tragedy. He was a great pulp artist, and among the first leaders of an American renaissance of populist art.

Is there a place where we can say science-fact art begins, and meets science fiction art? Yes, in one painting. This convergence can be seen in Virgil Finlay's cover for the August 1957 issue of *Fantastic Universe*. It could be given a simple title: "Flying Saucer from Mars Meets Soviet Sputnik from Earth." It's fact versus fiction: the cover is half and half. The saucer, with its little green men with large heads, scared at their first sight of the satellite, is pure science fiction art. The Sputnik is an accurately detailed depiction of the real thing. From this point forward the art had to change, imagination had to compromise with fact. NASA, Apollo, Viking, satellites, and accurate photos and measurements from outer space could not be artistically denied.

It was this one amazingly talented artist who combined fiction, fact, and fan-

(Left) Virgil Finlay: *Fantastic Universe*, August 1957

(Right) Virgil Finlay: "Minos of Sardanes," *Fantastic Novels*, November 1949 (black-and-white interior illustration)

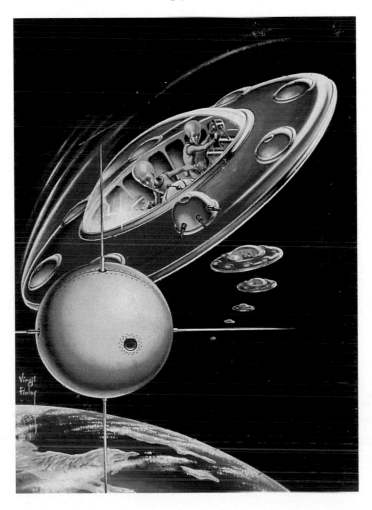

The Science Fiction Pulps

SAM MOSKOWITZ

The science fiction magazines almost started out not being pulps at all. They were actually reluctant converts to the standard pulp size and paper. Following their format conversion, they literally became a symbol of the pulp magazine.

When Hugo Gernsback issued the first science fiction magazine, *Amazing Stories,* dated April 1926, it was closer to the size of the "slick paper" magazines like *Cosmopolitan* and *Redbook,* only he used a very thick book paper to bulk the publication up and give the impression that the reader was getting a big physical value for his twenty-five cents. *Amazing Stories Annual* in 1927 and *Amazing Stories Quarterly* in 1928 followed, and these companions more closely resembled a telephone book in thickness and size than a pulp magazine.

After losing his company in 1929 due to an involuntary bankruptcy, he started a new one, issuing *Science Wonder Stories, Air Wonder Stories,* and *Science Wonder Quarterly,* all in a large size with thick paper. Even the off-shoot of his science fiction magazines, *Scientific Detective Monthly* (January 1930), adopted the same format.

It wasn't until Clayton Publications issued *Astounding Stories of Super Science* (January 1930) that science fiction could legitimately have been said to enter the realm of pulp magazines. *Astounding Stories* was a pulp not only in format—even down to the untrimmed edges—but also in its care-free story policy that made no pretense of worshipping at the shrine of science, as did the Gernsback magazines.

It was only after the stock market crash of 1929, when the nation hit hard economic times (which was reflected in the dipping circulation of his magazines), that Gernsback entertained the notion of having his publications "become" pulps. *Science Wonder Stories,* now combined with *Air Wonder Stories* (June 1930) became *Wonder Stories* and converted to pulp format with the November 1930 issue. This may have been done in the mistaken belief that *Astounding Stories* was selling better because of a pulp presentation.

Clayton had thirteen titles, only two of which were not pulps, *Field & Stream* and *Miss 1930.* Harry Bates, the first editor of *Astounding Stories,* later claimed (in *A Requiem for* Astounding) that Clayton used to print their covers four at a time, and one grouping had only three covers, so to reach four, *Astounding Stories* had to be published pulp size.

A short-lived science fiction magazine, *Miracle, Science, and Fantasy Stories* appeared as a pulp (April/May 1931), probably because all the other magazines in that chain (Harold Hersey) were pulps. Gernsback returned to the large size with the November 1931 *Wonder Stories,* then went back to a pulp format with the November 1933 issue; the magazine and all its companions remained pulps for the rest of their publishing life.

Amazing Stories assumed pulp format almost at the same time with the issue of October 1933. With the pulp *Wonder Stories, Amazing Stories,* and *Astounding Stories,* the science fiction segment took its place as an integral part of pulp publishing. Soon, whenever an illustration depicting the pulps in a book, magazine, or newspaper was required, science fiction covers—the most colorful, far-out, and action-packed images—were selected to provide emphasis.

During the years 1938 to 1941 there was an unprecedented spate of new science fiction titles, curtailed only by the fact that most of them were bimonthly or quarterly. Then occurred two events that are only linked by history. When the war was brought home to the United States by the bombing of Pearl Harbor, many items went on ration as plants that produced them were converted to war work. One of the items that was rationed was pulp paper. The rationing was set up by quotas based on how much paper the individual magazines had used in the period immediately preceding the onset of rationing. Obviously, the publishers had gotten advance notice of this, because with its January 1942 issue, *Astounding Stories* went large size, giving an incredible value for the monthly; *Amazing Stories* began to add pages, increasing to a pyramid of issues with 276 pages—if not the largest pulp in history, certainly a legitimate contender. These two magazines had enlarged their respective publications in anticipation of the rationing rules. Both used different methods to stretch their paper supply. *Astounding Science Fiction* went digest-size with its November 1943 issue. This was the first digest-size science fiction magazine in history and would herald the end of the standard pulp. *Amazing Stories* cut back its pages and gradually went quarterly. That way an issue would stay on sale for three months, and the publisher had only one bill.

Eight science fiction magazines kept publishing right through the war and paper shortages, but only *Astounding Science Fiction* maintained a monthly schedule. When the war ended and paper became more readily available, the science fiction pulps began coming back, but many of the new leading publications like *Galaxy* and the *Magazine of Fantasy and Science Fiction* were digests; these were more economical to print and distribute and required less artwork. By 1955 all of the pulps had succumbed to changing times. The paperbacks were coming in strong, and the readers regarded the digest-size science fiction magazines as really serial paperbacks. The end of the pulps had come abruptly. They were doing fine through 1952, but by 1955 they were virtually all gone; but the science fiction digest, however, held on and is still with us today.

Sam Moskowitz was a pioneer in the area of twentieth-century science fiction. A consummate scholar, he has written sixty books on the subject. In the 1930s he served as managing editor for renowned Amazing Stories *publisher Hugo Gernsback and worked closely with artist Frank R. Paul; he has a fine collection of Paul's art. He was the chairman of the first World Science Fiction Convention in 1939, and in 1972 he received the Science Fiction Hall of Fame Award. Sam Moskowitz truly deserves the title of World Scholar of Science Fiction.*

Virgil Finlay: *Fantastic Novels* cover sketch, mid-1940s (Book Sail Collection/John McLaughlin)

tasy and brought this art to its highest level of quality. Virgil Finlay began illustrating at the age of sixteen and continued at it until the end of his life, producing a corpus of approximately twenty-five hundred works of art. He was first published in Weird Tales in the early 1930s. Before Finlay, readers objected to interior art, complaining that the art was taking up space that could be devoted to more story. After Finlay arrived, they didn't complain: they screamed for more.

Certainly, Finlay was a genius in black-and-white art. But the reproduction of these illustrations on rough pulp paper conveyed only a fraction of their beauty. He mastered three techniques that resulted in the best interior illustrations and color covers ever created for science fiction and fantasy:

Stipple art consists of hundreds of tiny black dots in precise clusters. Finlay used a 290 lithographic pen with a point so fine that most artists would never employ it, dipped the pen into india ink, allowed only the ink to touch the surface of the white board, and then wiped the penpoint clean after each dot. It was time consuming and required much patience, but the result was almost photographic. Stipple art was popular a hundred years ago, practiced by such masters as Winsor McCay, Gustave Doré, and Aubrey Beardsley. Finlay's technique is so detailed that it requires a magnifying glass to see it in clear focus—and thus fully comprehend the artist's hours, days, weeks of work. He was paid eight to eleven dollars for each illustration.

Scratchboard art was another of Finlay's precise graphic techniques. With it he was able to achieve an illusion of dimensional depth and the look of a wood engraving. A layer of india ink would be laid down on white scratchboard. Then with a thin, knifelike instrument he would cut and scratch through the black ink, and a picture full of highlights and shadows would emerge from the darkness.

The medium of *egg tempera* was invented during the Middle Ages and practiced by Raphael and his Renaissance contemporaries with such mastery that their work has never been equaled. The combination of egg and paint produces a surface strength that eliminates the need for a final coat of varnish for protection and prevents age-cracking. The viscosity of the paint permits fine-line detail and creates the illusion of depth. As Finlay's popularity grew he moved from interiors to covers. By 1937 he began to paint the covers for *Weird Tales*. He wanted to achieve the same effects in paint that he obtained with dot and scratch and india ink. A close examination of his masterpiece, the cover for "Burn, Witch, Burn!" (*Famous Fantastic Mysteries,* June 1942), suggests the use of egg tempera and a very successful transfer of his talent to the front page. In fact, there is no other way such detailed painting could be accomplished. The two levels of paint push the background back and the foreground

forward, creating the illusion of depth and the casual viewer's impression that it must be some kind of photograph.

Finlay prepared several watercolor sketches for each painting, roughs for the art editor's approval and to judge how the illustration related to the story inside. There was much preparation work and talk before the painting began. A *Weird Tales* cover illustrating H. P. Lovecraft's "Hallowe'en in a Suburb" (September 1952) reveals an advanced use of the tempera technique. The red eyes of the ghouls in the graveyard are painted thickly and almost round, creating the fear that they are alive and intelligent and evil: the ghouls rise up from their graves in a storm of fiery ectoplasm. "Burn, Witch, Burn!" and "Hallowe'en in a Suburb" share the same egg tempera technique but are very different from each other—one almost photographic, the other nearly surrealistic. Finlay experimented with paint and its applications to achieve dazzlingly different results. He painted with the courage and curiosity of an inventor; with dot, scratch, and egg he succeeded.

Paul Stahr: "The Hothouse World," *Argosy,* February 1931

There were many other talented science fiction and fantasy artists, most of whom could produce great pulp art in other genres as well: Belarski, St. John, Fuqua, Brown, Lawrence, Smith, Wesso, Morey, Brundage, Cartier, Finlay, Bok, and Paul were not alone, but in the Golden Age of Science Fiction Art, they were the best.

These are the painted an-swers of the past, all that we knew or could imagine we knew. But in the far future, beyond the concepts of our fact/fiction/ fantasy creations, humankind will fulfill its destiny to explore and populate the universe. Amazing technology will transmit pictures that will transcend the widest dimensions of our imagination and our very willingness to believe: all of space, one canvas.

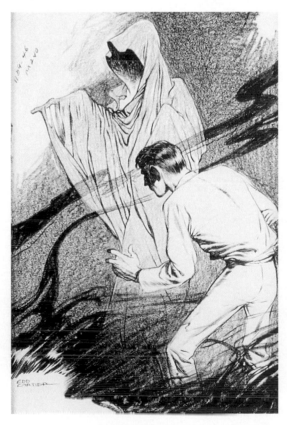

Edd Cartier: "Death's Deputy," *Unknown Fantasy Fiction,* February 1940 (black-and-white interior illustration)

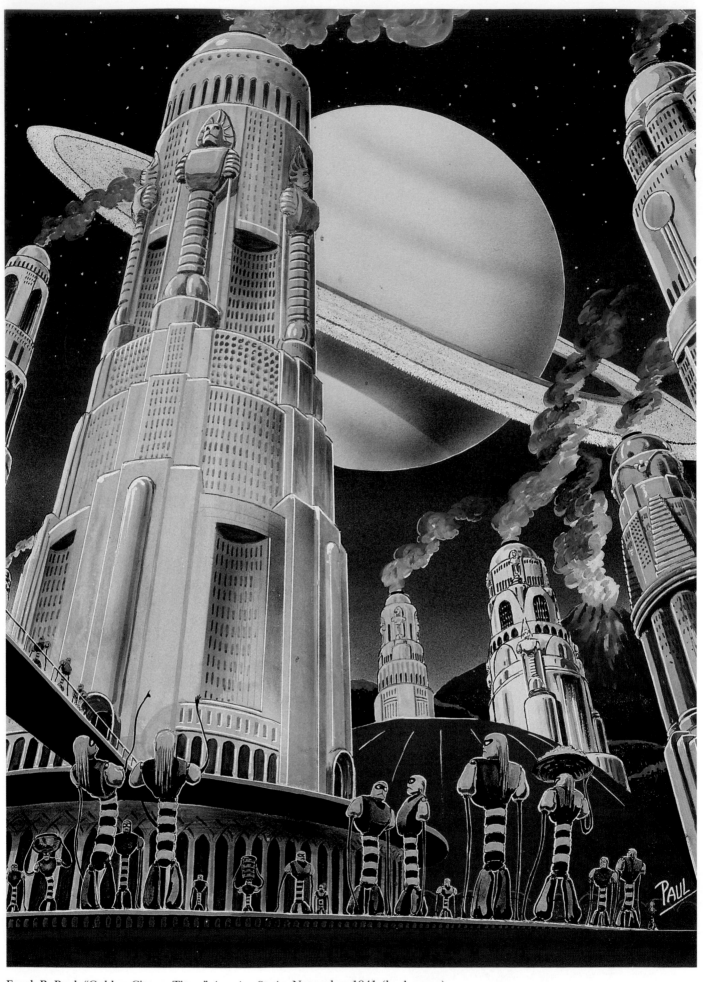

Frank R. Paul: "Golden City on Titan," *Amazing Stories*, November 1941 (back cover)

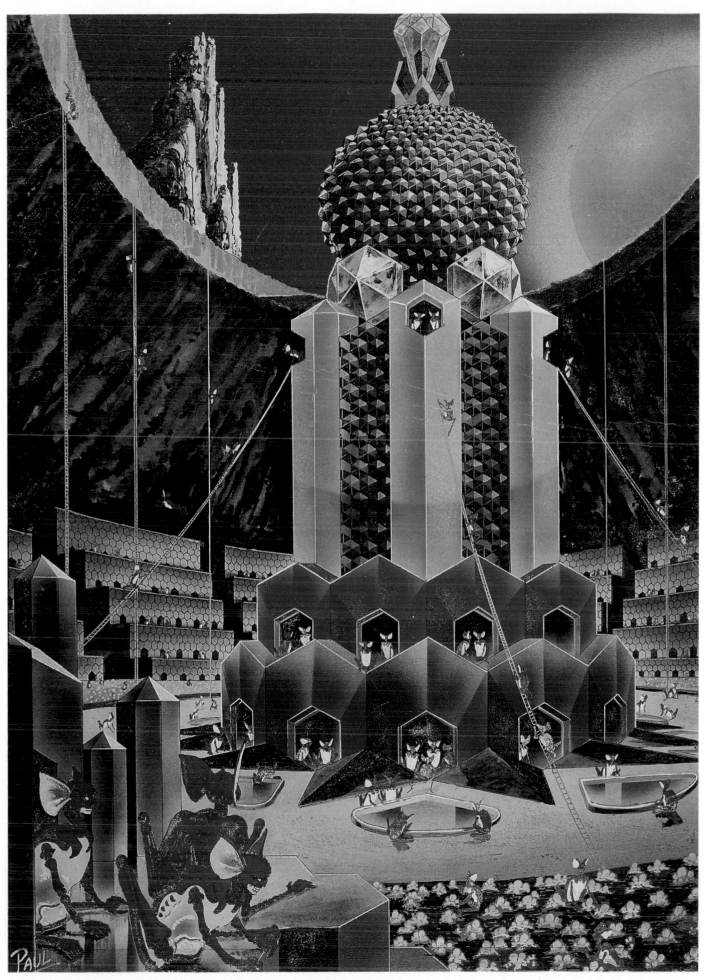

Frank R. Paul: "Quartz City on Mercury," *Amazing Stories*, 1941 (back cover)

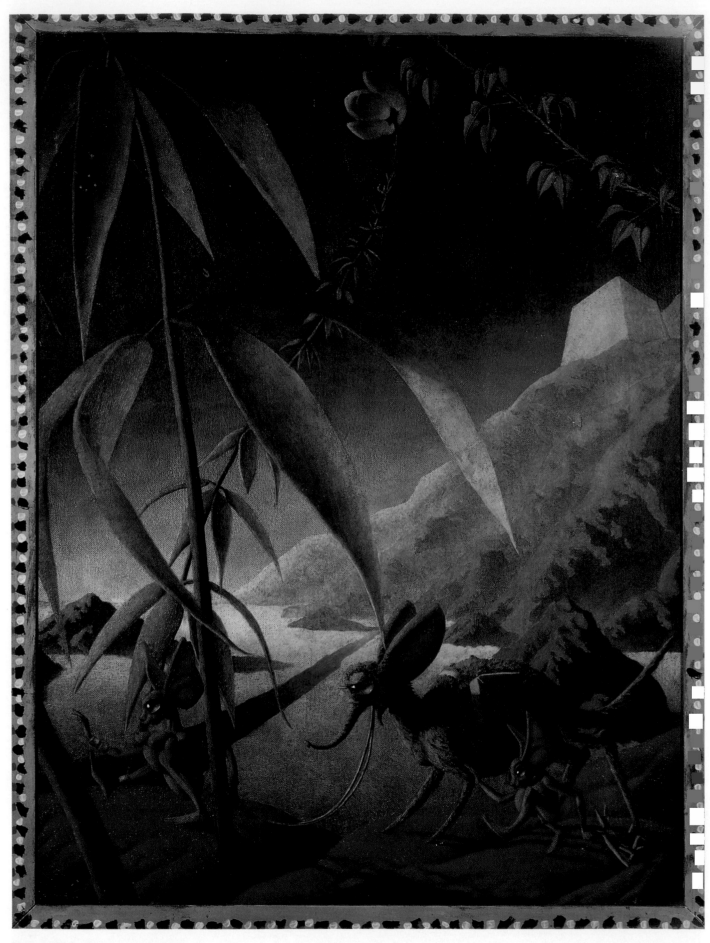

Hannes Bok: *Martian Picnic*, 1943

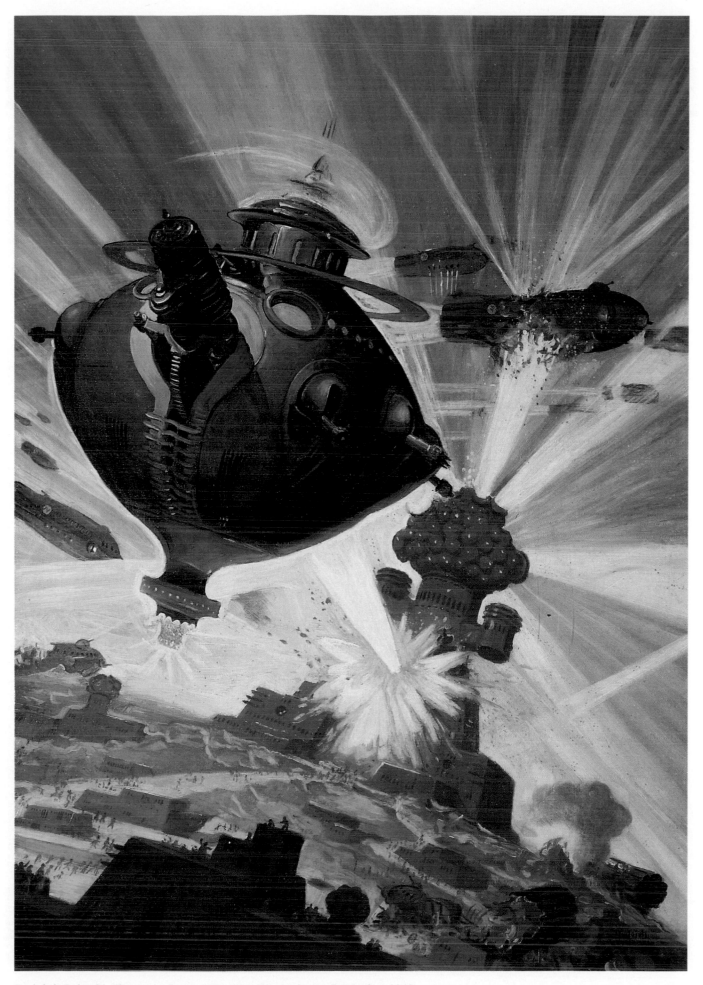

Rudolph Belarski: "Storm in Space," *Thrilling Wonder Stories,* December 1942

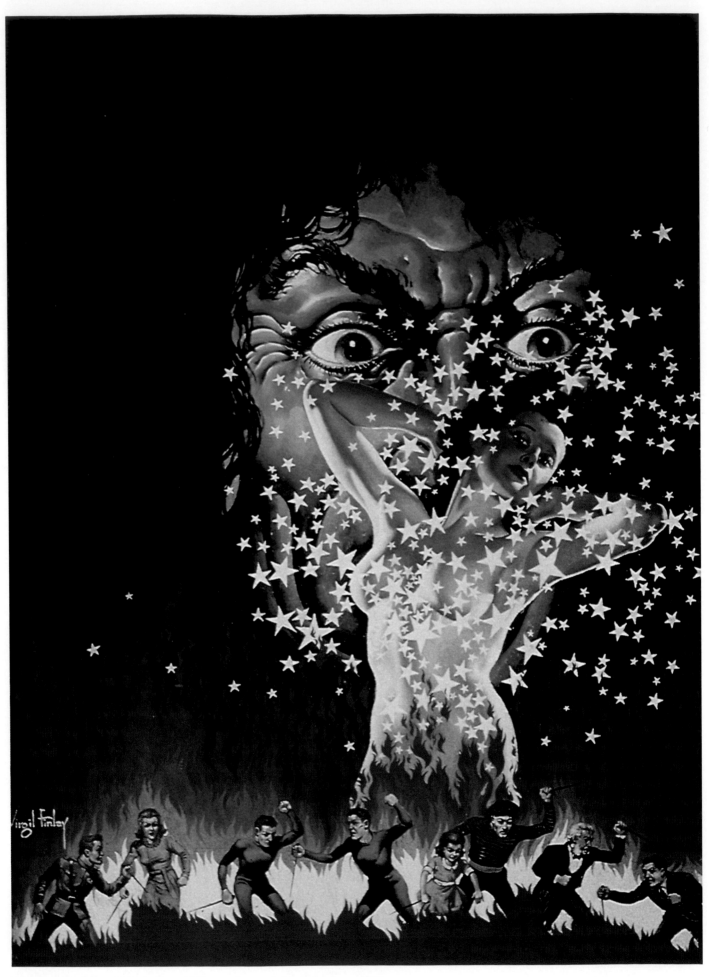

Virgil Finlay: "Burn, Witch, Burn!" *Famous Fantastic Mysteries,* June 1942

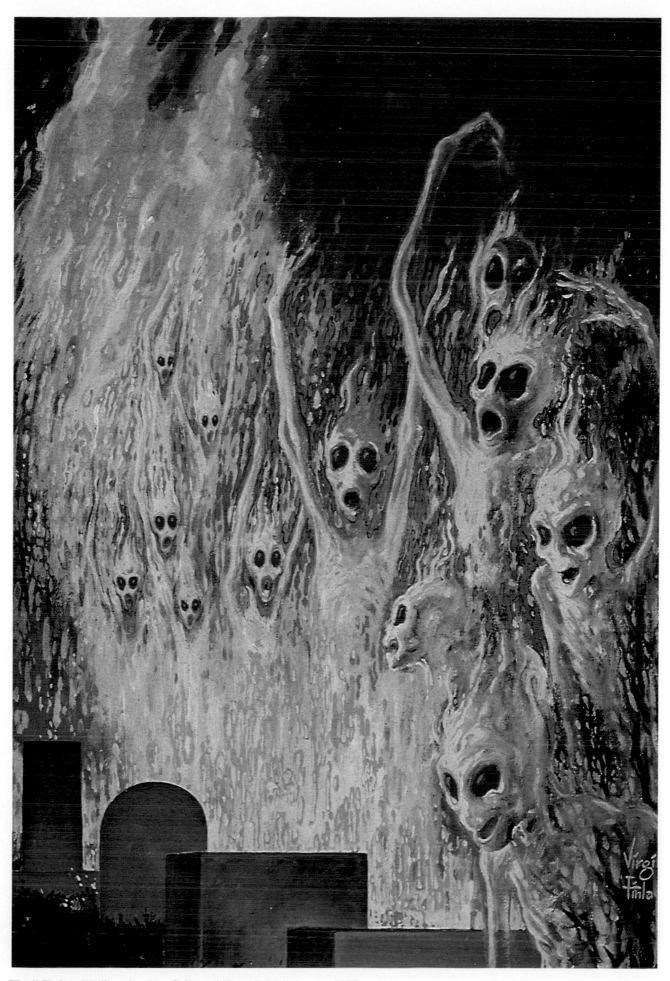

Virgil Finlay: "Hallowe'en in a Suburb," *Weird Tales,* February 1952

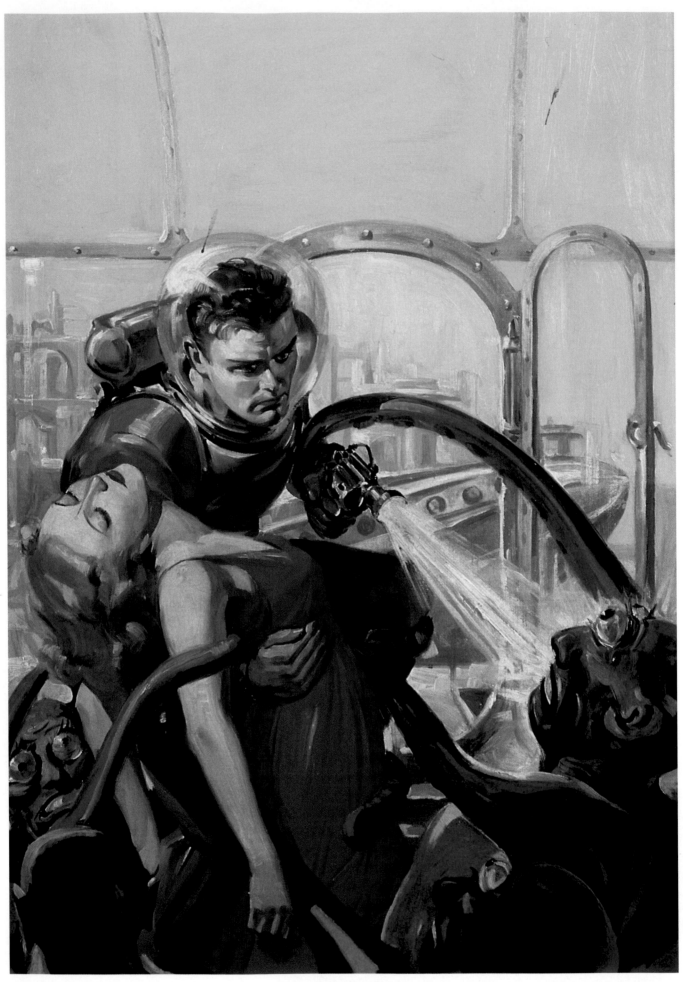

Howard V. Brown: "Interplanetary Graveyard," *Future Fiction*, March 1942

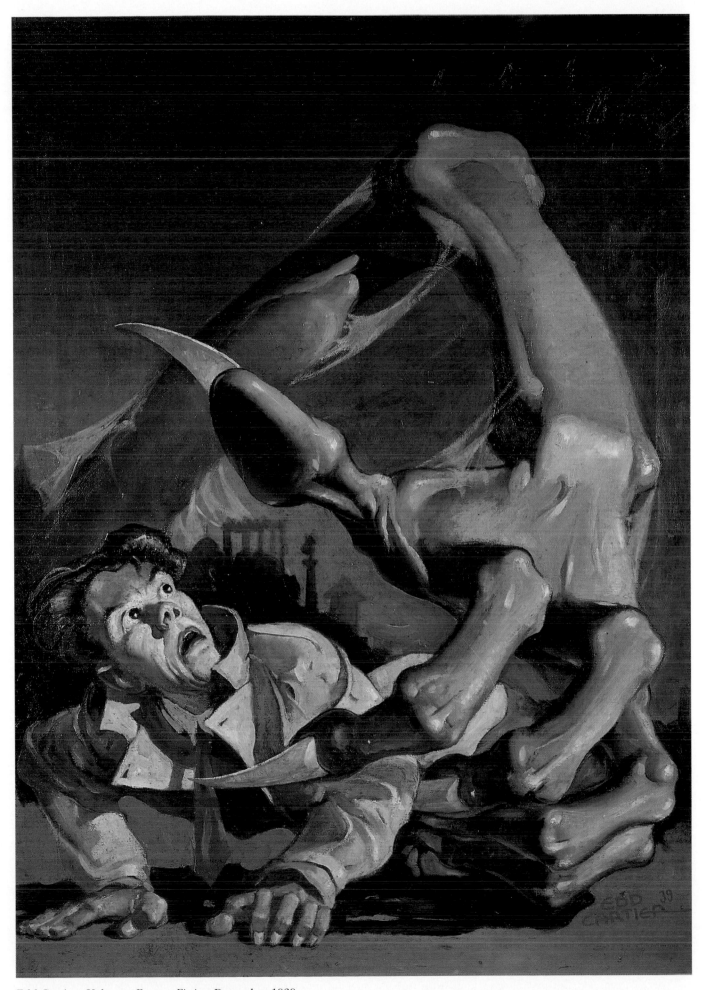

Edd Cartier: *Unknown Fantasy Fiction*, December 1939

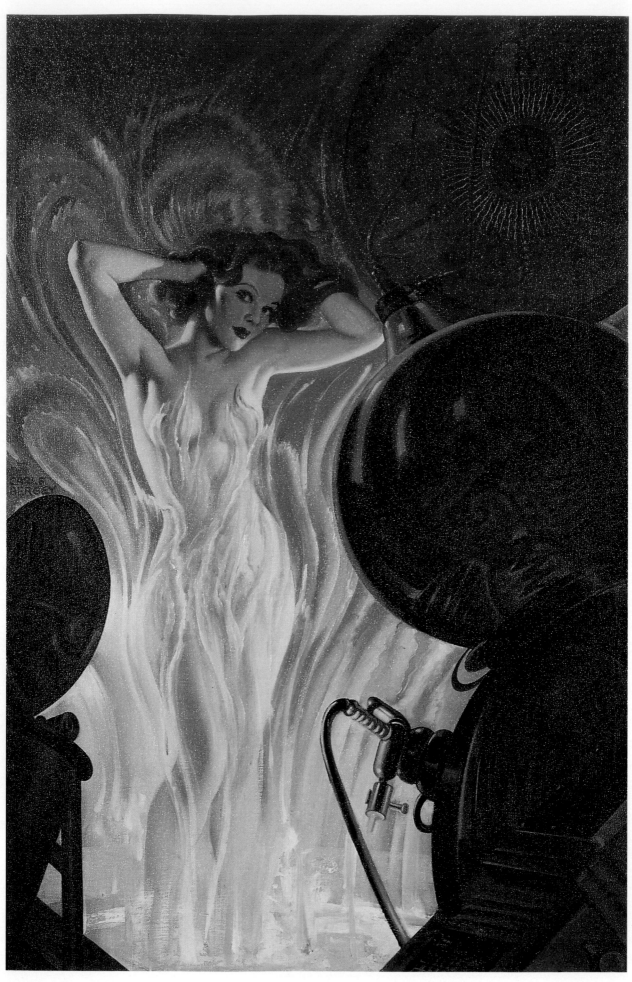

Earle Bergey: *Startling Stories*, September 1950 (Book Sail Collection/John McLaughlin)

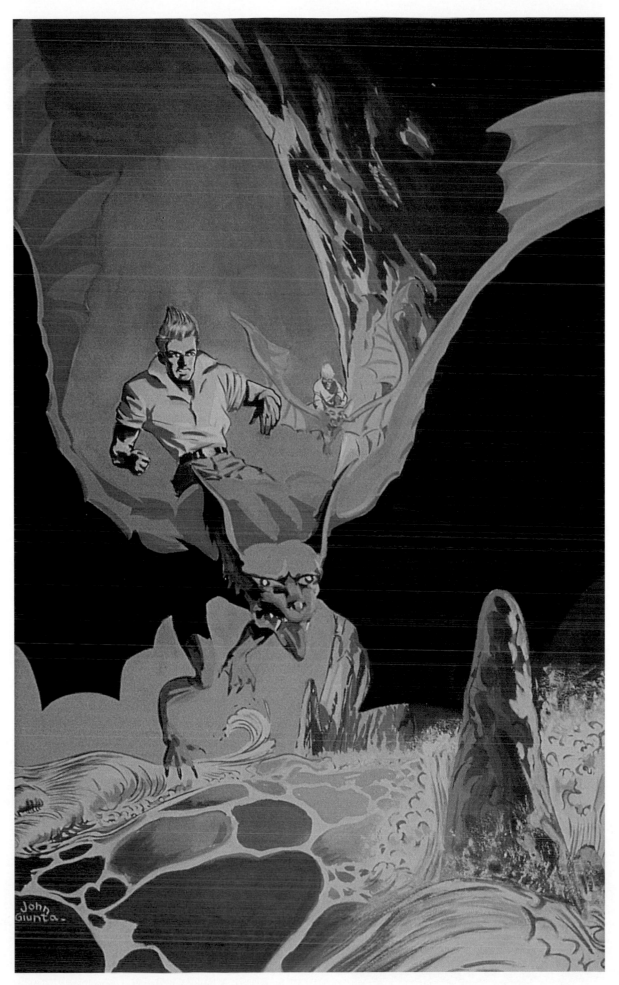

John Giunta: *Weird Tales,* March 1944

The New Knights

The Shadow, The Spider, Doc Savage, The Phantom, Tarzan, and Operator #5 were all heroes in the pulps of the thirties and forties. Stare at their strange faces—contorted in rage, tightly wrinkled for revenge—on the covers, then read the stories inside, and wonder: Who are they, really? Is there a common thread that binds them together, a distant point of origin? If we consider them closely, we can see that their single points are connected in a straight line, from the twelfth century into the twenty-first. From Sir Lancelot to Schwarzenegger, the spirit of the *knight errant* animates these heroes.

After the sack of Rome, bands of barbarians roamed and pillaged throughout Europe. Desperate nobles built fiefs, small towns encircled with fortlike barricades. Men who could fight back hard were needed. At the age of seven a boy would begin his military training to join the knighthood and become a professional warrior. A knight at age twenty-one, he was trained to kill with a double-edged sword, a sharp ten-foot lance, and a battleaxe that could slice through chainmail and metal armor; armored, and on an armored horse, he rode forth in courage seeking harm's way. The knight errant of those times is our century's top gun.

These men of courage lived loyal to the Code of Chivalry. They shunned wealth, fought crime, and brought law and order to town and country. They were defenders of the faith...and of good women. Their concept of chivalry and the Code of Courtly Love elevated the status of women and made each knight responsible for the protection of women, bound to act toward them with a demeanor of courtesy and respect.

A popular barbarian blood sport was burning down churches, often with priest and parishioners locked inside, so there was a real need for heroic knights.

The Shadow Magazine newsstand advertising card, 1933 (™/© The Condé Nast Publications, Inc.)

Tom Lovell: "The Romanoff Jewels," *The Shadow Magazine*, December 1932 (™ The Condé Nast Publications, Inc.; black-and-white interior illustration)

Fighting evil gave meaning to their lives. There were no police, law, or lawyers in between. Faced with the crime, the knight fought the criminal and became judge, jury, and if necessary, executioner. If one can believe the songs and poems of medieval Europe, the Arthurian legends, and writers from Chaucer to Scott, then the knight errant was man made perfect.

Thousands of miles away under a different setting sun was his mirror image in time and kind: the samurai warrior with his Bushido code of chivalry. Japan and Europe had the same problem at the same time— the need for law and order. Late in the twelfth century, Yoritomo battled against unbearable chaos, gained power, and sponsored the samurai, called Bu-shi, the fighting knights. They fought without fear; their superb training in the martial arts and their spirit of daring made them furious in battle. Bushido was their code: Fight to the death! Surrender is the shame of cowards! Strike with surprise when it is the time to strike! Die when it is right to die with your honor, facing the enemy! But also love the beautiful, show affection to the young, protect the weak, and pity the poor.

A new knight, from the mid-twentieth century, possessed a code of honor, and was brother to the samurai, cousin to the knight errant:

The Shadow Knows

Wherever crime is known; wherever justice seeks to rule—there the deeds of this master of the night, this creature of blackness are common knowledge. All the world knows of The Shadow and his astounding deeds against the menace of mobdom. With flaming automatics he rides herd over the underworld.

Before crime's plans have been put into being by some mastermind of the underworld, word has come to The Shadow from his agents in far-flung corners of the world—and The Shadow lays plans to thwart the hordes of evil.

"Crime does not pay!" is The Shadow's battle cry, and with these words on his lips he goes forth in his unceasing fight against evildoers. To vanquish his foe, no matter how diabolical

John Coughlin: "The Gray Major," *Detective Story Magazine,* August 1930

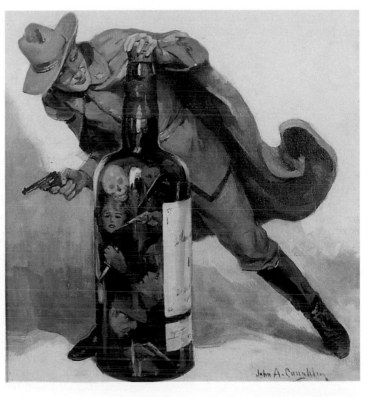

The Pulps and Their Illustrators: A Brief Survey

WALT REED

Today we look back at the old pulp magazines with nostalgia and some measure of condescension. They are campy and unsophisticated, oftentimes gross and tasteless. Yet they also fascinate us with their facade of hardboiled reality while usually offering terrific texts and artwork.

Even in their heyday the pulps were not taken too seriously. The most scandalous and dangerous adventures could always be confronted from the safety of the living room easy chair.

With an ancestry going back to the chapbooks and the penny dreadfuls, the pulps were carrying on a venerable tradition of exploiting the sensational adventures of pirates and notorious highwaymen or fights with Indians on the western frontier. The pulps simply updated the old subject matter and put it in a cheaply produced pulp paper package with a gaudy cover.

Everything the pulps were was summarized in their covers. Like the circus sideshow banners that drew in the gullible with lurid paintings of freaks and ferocious beasts, the pulp covers also promised more than they delivered.

Yet readers still got their money's worth. With a complete novel or novelette and several short stories in an issue, all for ten or fifteen cents, there were a lot of vicarious thrills at a bargain price. In time, the pulps became specialized—or organized around particular subjects. The Old West was probably the biggest favorite, including its subcategory, the ranch-romance titles. Next were detective stories and mysteries published in *Underworld, Black Mask, Popular Detective, The Shadow,* and other favorites. Some other categories included various sports titles, "spicy" magazines, aviation/war, and science fiction/fantasy. Each had their diehard fans.

Artists tended to stick to one genre as well. Western artists had to be convincing to knowledgeable readers even if they were like Nick Eggenhofer, who for many years had never been west of Pinecliff, New Jersey. They were supposed to know their Springfields and Colts, too, avoiding the unforgivable gaffe of one artist who faithfully painted the telltale casting marks of a dimestore revolver replica. Whatever else the color scheme, red was almost always used as the focal center of the picture. The cowboy hero wore a red shirt or a red bandanna neckerchief. The detective's gun was always in the act of firing, with a bright red flame. A threatening animal always bared the red of its open mouth or bloody fangs. The hapless heroines of spicy detective covers usually wore a red—if torn and abbreviated—dress.

Action was always depicted at its height, in midleap, midfall, or midpunch, or at the point of impact, collision, or crash.

The artists who painted these covers knew the requirements and they tried to outdo each other with ingenious variations on the themes of mayhem and murder. Although they were looked down on by their artistic counterparts in the slicks (higher class magazines were printed on coated or "slick" paper), it was a difficult market to paint for; there was a lot of skilled competition. Most cover artists had a standard art-school training. They could draw or paint figures expertly and make complex compositions that would tell a self-contained story within a very circumscribed space. And in the same space they had to allow room for the magazine's logo as well as a roster of featured authors.

Because the level of pay for the pulps was so low—covers paid from fifty to three hundred dollars during the Depression—it was a starting place for young artists on the way up and a haven for veteran illustrators on their way down. The best markets for cover artists, of course, were the national family weeklies or monthly magazines like *The Saturday Evening Post, Collier's, Liberty,* and *Ladies' Home Journal.* Many artists, however, got their start with the pulps. Tom Lovell, John Clymer, Lyman Anderson, Emery Clarke, Robert G. Harris, Walter Baumhofer, and others were all graduates. Even Harvey Dunn, N. C. Wyeth, Frank Schoonover, Gayle Hoskins, and other students of Howard Pyle periodically painted covers for the pulps.

There was a large middle group of pulp cover artists who were the mainstay of the profession. They had a mindset in perfect sync with their subject matter. For many years, Nick Eggenhofer was known as the King of the Pulps because of his dominance of the western pulps, for both covers and inside dry-brush illustrations (and he did eventually go West). The Rozens—Jerome and George—had done some marginal slick illustrations but found their ideal medium in the pulps. John Newton Howitt had a long successful career working for *The Saturday Evening Post* and other major magazines, but as his work went out of style there, he adapted successfully to the requirements of the pulps.

Rudy Belarski, Graves Gladney, John Scott, and Laurence Herndon were all good journeymen artists, who could do credible covers in any subject. H. Winfield Scott, who lived in upstate New York, was one of the fastest. His specialty was westerns, and he could turn them out with rapid-fire versatility, delivered while the paint was still wet.

Science fiction and fantasy artists were in a world—or galaxy—of their own. Their rockets were launched into space long before Cape Canaveral, even if they sometimes looked suspiciously like parts of household appliances. We have yet to corroborate the accuracy of Venusians or Martians as depicted.

Even by pulp standards, the fantasy artists were regarded as somewhat peculiar. Those titles had the most limited circulation with the lowest pay scale and some of the weakest art, but their fans were the most vociferous in their loyalty. For years the dominant artist was Frank R. Paul, whose people were stiff and stilted, but who was great with domed cities and monsters with octopus arms or insectlike bodies. J. Allen St. John brought many of Edgar Rice Burroughs's more fanciful stories of netherworlds to life.

The pulps had barely survived the Depression when they found a formidable competitor in the comic books. The new superheroes performed their death-defying exploits with awesome aplomb, and the stories had an easy-to-read continuity that found buyers in an even younger age group. Many publishers quietly shelved their roster of pulp titles and adapted to the new format.

After World War II the paperback revolution salvaged the careers of many pulp-cover veterans who readily switched to the new format. From our vantage point now, across a sea of paperback titles and comic book art, we can begin to judge the pulp phenomenon with new appreciation—even those of us who were once their ardent fans. There is a lot of pleasure to find in the process.

Walt Reed is the founder of Illustration House in New York City, one of the nation's premium venues for the sale of original magazine illustrations. He has authored several books on the subject of illustration art. An artist, he designed the fifty State Flag Commemorative stamps for the United States Postal Service in 1976. He has done book and magazine illustrations and has been a director of the Famous Artists School.

Walter Baumhofer: "Meteor Menace," *Doc Savage Magazine*, March 1934 (™ The Condé Nast Publications, Inc.)

the plan, and make justice triumph. Trailing his actions is his weird, chilling laugh—the omen that makes crooks cringe in fear: "The Shadow knows!"

Inspired by the success of The Shadow on radio and in print, Street & Smith published the adventures of a new knight, Doc Savage, Man of Bronze, in March 1933. Henry Ralston, their business manager, described the birth:

"We grabbed him right out of thin air. We made him a surgeon and a scientist, because we wanted him to know chemistry, philosophy, and all that stuff. We also made him immensely wealthy—he'd inherited a huge fortune from his father. He crusaded against crime of all kinds—plots against the United States, against industry, against society at large. He was very strong physically, a giant man of bronze, with eyes whose pupils resembled pools of flake gold, always in gentle motion."

Walter Baumhofer: "The Red Skull," *Doc Savage Magazine,* August 1933 (™ The Condé Nast Publications, Inc.)

The Doc Savage Code of Honor is the direct descendant of the Code of Chivalry and Bushido:

The Code of Doc Savage

1. Let me strive, every moment of my life, to make myself better and better, to the best of my ability, that all may profit from it.
2. Let me think of the right, and lend all my assistance to those who need it, with no regard for anything but justice.
3. Let me take what comes with a smile, without loss of courage.
4. Let me be considerate of my country, of my fellow citizens and my associates in everything I say or do.
5. Let me do right to all, and wrong to no man.

Could the similarity of the old and new knights in ethos, tales, and purpose produce a similarity in their art? Perhaps the magnificent portrait of The Shadow painted by George Rozen for the magazine's September 1933 cover

can provide the evidence. The Shadow is in danger. Criminals have captured him with an animal net and he is clawing to get out. His face, turned left, reveals the fear of a terror unseen. The large ear suggests that he is listening to a threat, and the narrowed eyes are concentrated on his enemy. The arched eyebrow adds more weight to the fear. Hat and cape are black, the painting's dominant color, accepted in all cultures as the color of death and mourning. The inside of the cape is blood red. The large theatrical nose and the varied facial cosmetics suggest an actor's paint and putty makeup. The yellowish skin tones and the narrowed eyes give him the appearance of an Asian.

Now compare it with its twin, hundreds of years and thousands of miles apart: a painting of a samurai from Japan's mid-ninth-century Fujiwara era. This knight also is in danger, and his face, turned left, shows the fear of a terror only he sees. The ears are listening to the taunts of his enemy and the narrowed eyes are focused on horror. The arched eyebrows of the samurai and The Shadow are painted in the same manner for the same purpose. Here too hat and cape are black—the painting's dominant color—and the larger-than-life nose and the facial hues suggest Kabuki cosmetics.

There are many more comparisons of the art of the new knights with that of their ancestors that would provide visual proof of the close relationship. One other should in particular be noticed. *The Spider* was published by Popular Publications from 1933 to 1943, and the stories were filled with sex and violence to the extreme. As with the samurai and European knights, an appearance was created to frighten the enemy. Richard Wentworth became

(Left) George Rozen: "The Grove of Doom," *The Shadow Magazine,* 1933 (™/© The Condé Nast Publications, Inc.)

(Right) Kabuki theater poster depicting a samurai from the Fujiwara era, mid-ninth century, Japan

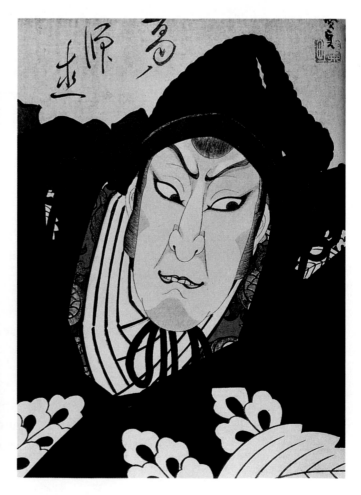

The Spider by using actor's putty to mold his nose into a hooked, hawklike beak; he wore a wig of long black hair, inserted sharp fangs into his mouth, and used thick padding to make his back and shoulders look deformed. He covered his body with a black cape and wore a wide-brimmed black hat and mask. He battled evil with two blasting .45s and left his mark—a crimson spider—on the forehead of his dead enemy. The early covers in the 1930s married chaos and cruelty and were painted by the master of gore, John Newton Howitt. Rafael de Soto painted the later covers with more sex: blonde women with red lipstick, torn dresses, and the look of terror.

In the realm of European art, The Spider's twin can be seen in the portraits of the Black Prince, Edward of Woodstock, eldest son of Edward III— a knight in black armor with a snarling face. Like The Spider, his acts of good and evil were combined and his face depicts the same fierce determination. His military successes made him a hero but his uncontrollable violence resulted in atrocities. Both share the same ugly face of rage.

Rafael de Soto: "Death and the Spider," *The Spider,* January 1940 (a later re-creation by the artist)

Did the best of the pulp artists—John Newton Howitt, Rafael de Soto, Walter Baumhofer, Norman Saunders, George and Jerome Rozen—study, look, learn, and borrow from the visual records of samurai and knight? If the answer is yes, then there is a depth of history and a pictorial evolution that should be considered in the evaluation of American pulp art; it had ancestors.

Related to the pulp hero, created and costumed from the imagination, was the private eye of the detective magazines, mirror-imaged from New York City streets and costumed in a 1930s wrinkled three-piece suit, white shirt and tie, wide-brimmed hat, and (sometimes) shined shoes.

Almost all of the covers were based on a single formula: there is a victim in immediate danger, usually a pretty girl; her dress has been torn by an attacking villain, who would be about to triumph except for a hero ready to spring into action. In the painting they are at crisis point, approaching a struggle to the death. The cover is a painted question: Who won? The answer: Buy the magazine and read the story.

The pictorial formula usually employed a black background so that the bright reds, yellows, flesh colors, and blasting guns would leap up and seize the eye. Although this was primarily a storytelling art, many of the artists worked into the canvas surrealist undertones in water and sky, luminescent shading,

The Lure of the Pulps: An Artist's Perspective

JIM STERANKO

Pulp fiction?

It's no secret that cultural analysts sometimes calculate the lowest common denominator of a literary form to define the society that produced it. Pulps were that common denominator in a period that roughly spanned the years between 1930 and 1950.

And pulp art, specifically cover imagery, defined their content.

At best, the pulp was a commercial amalgam that adopted the publishing frequency of turn-of-the-century dreadnauts and dime novels; was printed on woodpulp paper; used the talents of popular genre authors; and borrowed the concept of colorful dust jackets from their hardbound efforts. The result was an inexpensive seven-by-ten-inch magazine with a primary-hued cover that attempted to be impulsively irresistible.

Essentially aimed at male readers, cover art zeroed in on heroes and hellcats, frontiersmen and foreign legionnaires, loggers and leathernecks, spacemen and swashbucklers, pirates and pilots, gangsters and gun molls, Mounties, monsters, and of course, maidens in distress—not to mention undress!

With few exceptions, pulps were designed to be amusing and entertaining. Subtlety and seriousness were the province of the slicks. Pulps were fun, the quintessence of melodrama, and their art reflected that concept to perfection.

The pulp format was conceived more than ninety years ago and endured until the mid-1950s, replaced by comic books and paperbacks—both hybrid pulp forms produced by many of the same writers, artists, editors, publishers, and printers.

Approximately sixty thousand pulps were published, in twelve hundred titles. Most sported tailor-made covers rendered by commercial artists—including such vintage heavyweights as N. C. Wyeth, J. C. Leyendecker, Dean Cornwell, and Remington Schuyler.

Like much of American pop culture, many of those paintings were considered of throwaway value. Slightly more than 1 percent of the total number produced still exists, primarily in private collections, with a sprinkling of the more famous artists' renderings in museum and gallery repositories.

Although I was born at the twilight of the pulp era, I spent considerable childhood time digesting pulp products culled from the dusty shelves of used-magazine stores. During summer vacations, starting at about fourteen years old, I often hitchhiked from my Pennsylvania home to New York City—a 325-mile round trip—where several shops around Broadway and Forty-fourth Street had stacks of pulps leaning against their walls. I'd usually return from adventureland carrying two shopping bags loaded with old paper—a panorama of the fantastic.

The Shadow was my entry point into the pulp world, but that interest was initiated before I was five years old by his radio exploits and the comics. I discovered pulps a few years later and developed an obsession for the form that is no less as magical today as it was yesterday.

Weaned on pencil and paint, I developed an acute appreciation for pulp cover art, which I equated with the kind of images created for movie posters. Both forms, more often than not, capitalized on a visualization that focused on a central character, summed up the essence of the subject matter by combining a colorful title with photo-realistic art, and exploited a larger-than-life approach.

The technique is more complex than it appears. Years later, when I painted an armful of covers for paperback reprints of such pulp-spawned heroes as Conan, The Shadow, G-8 and his Battle Aces, and others, I repeated the formula—and realized that my youthful attraction to the magazines was appropriately a fateful preparation for the task.

And because of my artistic pursuits, collecting pulp cover paintings was simply an extension of collecting the magazines. I began in the early 1960s, when there was little interest in the form and material was somewhat more available.

My friendship with Bruce Elliott (who penned many of the digest Shadow novels) and Walter Gibson (who created the character) provided additional connections to locating cover paintings produced two or three decades earlier. Walter was particularly helpful in recalling to whom he had sent cover art over the years. He'd provide a name and location; I'd follow through with detective work and would often track down another original, sometimes three and four at a time.

Many pieces were obtained from the artists who painted them. As a commercial illustrator of book covers, record albums, and film posters, I developed a professional and personal rapport with Rafael de Soto, Walter Baumhofer, Jerome Rozen, Norm Saunders, and others, who graciously took the time to look back and share their insights and recollections of the pulp era.

Those associations had a profound, enriching effect on my overview of the area in which the artists specialized, one that enabled me to envision their achievements from a unique perspective—through their eyes, their words, their memories. Most of them are gone now, but their accomplishments will continue to endure as long as there are collectors and admirers like us who view their art as nostalgic guideposts on life's remarkable road to adventure.

Jim Steranko is an author/designer/historian of contemporary pop culture. As a comics writer and artist, he is most noted for his work on Captain America, X-Men, *and* Agent of S.H.I.E.L.D., *as well as for the graphic novels* Chandler *and* Outland. *He has lectured and showcased his work at more than 180 exhibitions worldwide, including at the Louvre. In the fantasy and adventure genres, he has painted a profusion of covers for movie posters, record albums, and book covers (including thirty Shadow paperbacks), in addition to working with such noted filmmakers as Steven Spielberg on* Raiders of the Lost Ark *and Francis Ford Coppola on* Dracula. *Currently editor and publisher of* Prevue *magazine, his two-volume* History of Comics *has sold more than a hundred thousand copies. He has an extensive collection of pulp magazines and cover paintings.*

Norman Saunders: "Give Hijackers Hell!" *Detective Short Stories,* July 1938

and shapes that did not pertain. It became a display of artistic virtuosity.

The first publication of an all-crime pulp was *Detective Story Magazine,* launched by Street & Smith as a semimonthly October 5, 1915. But it was not until the 1930s, with prohibition, Al Capone, gangsters, gang wars, J. Edgar Hoover, and Jimmy Cagney and Edward G. Robinson movies, that the detective magazine exploded into dozens of new titles—a boom in production and national popularity.

What were the mechanics of creating a cover painting? Harold Hersey in 1937's *Pulpwood Editor* describes the process.

First we concentrate on the magazine shop window: its cover. We have the artist paint a scene from the lead story, or use a general idea that typifies the story. We may have the artist picture the situation in the seventh chapter. That'll make the cash customers buy the mag if anything will.

The artist listens patiently to the description of what is wanted for the cover painting. In due course he appears with his painting [and] hands it over to the engraver, who reproduces it as a three-color-process job: red, blue, and yellow. There is an old saying in the pulpwoods that any color will do for a cover just so it's red. We examine the proofs, criticize and mark them with a few flourishes to prove that we forget more in one night about engraving than the engraver learns in a lifetime. He makes a great show of obeying our technical instructions and then delivers the plates to the printer who makes ready for the cover run.

The covers have been scheduled for the press, two colors up and the third following as soon as the first impressions have dried on the coated stock used for this purpose; we have selected meanwhile the story material that has been set in type and dummy the issue....

Cover paintings bring anywhere from fifty to a hundred dollars as a general rule. Interior illustrations average from five to ten dollars apiece. A skilled artist, capable of doing rapid work, can make a steady income.

Gradually I learned myriad little ways to improve a cover painting. Such things as never neglecting to show a character's eyes; that full faces are better than profiles; how to concentrate on important details yet never let any part overshadow the whole; how to arrange the display so that even if only a corner showed it would attract and hold a wavering eye. The seven-by-ten-inch space may be small but it would be used with a telling effect by a professional artist. Action must be concentrated into simple form. Use highlights on the characters' faces whether indoors or out. Where two characters could tell a story, eschew a third. Keep background down to essentials; suggest rather than portray a vista or the wall of a room. Doorways are forceful, dramatic, especially where a figure looms over the threshold, silhouetted

(Left) John A. Coughlin: *Detective Story Magazine,* August 1930

(Right) Richard Lillis: "A Straw for the Thirsty," *Private Detective Stories,* January 1945

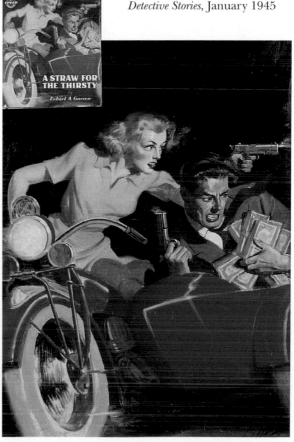

Remembering Rafael de Soto

JOHN DE SOTO, AIA

This brief memoir is dedicated to my beloved father, Rafael M. de Soto, pulp artist, teacher, illustrator, and the most spirited man I have ever known.

Rafael de Soto's works spanned the late 1920s through the 1980s. His education was mainly behind the easel; his work was fine art in a mode that was perhaps not fully appreciated by the editorial directors and publishers. I see the mastery in his work; and sometimes I wish we could go back to those smoke-filled rooms and get the first glimpse of the concepts being rendered and smell the fresh paint.

I remember that as a boy I felt that going into my dad's studio was like getting to play in a big toybox. The odor of paint and turpentine was as natural as the redwood half-timber bungalow itself. I would climb into the studio loft where a menagerie of props became toys.

I never thought that anyone would mind how much time I spent there. The props included World War II battle helmets, illustrations and paintings by the score, Marx toy guns (which somehow were mysteriously missing from my bedroom), a ukulele—I could write an inventory a mile long. I remember strapping on a western six-shooter and holster, putting on a World War I helmet, grabbing a model submarine, and then playing a tune on the uke— and maybe even pounding on an old Indian drum. Dad, being half deaf, hardly heard me up there.

Browsing through Dad's illustrations was a little shocking for an eight-year-old. They became more and more exciting each time I flipped through them. Every one had a story (Dad told me that sometimes the art director would come to him and ask him to do a painting *first*, from which the pulp writers would then create a story). There were action and intrigue everywhere I looked—we had Indiana Jones and the Terminator years before they ever hit Hollywood.

A lot of nightmares: I still remember those ghouls torturing shapely women. As I got older, I became numb to the horror stuff, passing those over. It was time for the anatomy lessons: all the sexy poses, one after another, for Pocket Books. Mom used to say, "Get these away from the boys!" Of course, I easily found them in the loft. Who needed Saturday-morning cartoons? This was great stuff!

There was a darkroom in the studio that Dad built to develop the photos he took of his models. I remember he used to let me in to count for him, like a timer. It was great to see these develop before my eyes. And the smell of hypo was soon as evocative as the turpentine's.

As the years went on I became more interested in the building of model customized AMT cars, and later, in high school, in building models

of houses. The studio became my place to draw, also. I had the greatest education anyone could ask for in the visual arts. By looking over Dad's shoulder, I learned from a master. Every time I pick up a brush to do a rendering or painting, I think of my time in the studio with him, and offer thanks that Rafael de Soto was my father.

John de Soto is the son of the famous pulp artist Rafael de Soto and is an architect whose work includes designs for the National Broadcasting Company. He recently proposed a design for the Center for Popular Culture at Bowling Green State University in Ohio.

Rafael de Soto: "Eyes Behind the Door," *Detective Tales,* December 1947

George Rozen: "Maid for Murder," *Detective Fiction Weekly*, March 1938

against a deep, mysterious darkness. A face at the window. If a gun was being pointed, focus the attention upon the weapon, the hand that grips the butt and the expression upon the face of the man who is aiming it.

By 1937 Harold Brainerd Hersey had spent twenty-five years editing, publishing, and originating pulp magazines. His knowledge and viewpoints are valuable on-the-spot reporting, and they illustrate the severe limits that restricted the artists' creativity.

In his book *The Fiction Factory*, Quentin Reynolds describes the potential damage to talent and ego at Street & Smith's pulp-art department; Pop Hines was the boss.

It certainly was a humbling experience. Pop Hines always had a wet palette in his office. We'd bring in our paintings and if he didn't like them he'd scream and tell us to get busy then and there. He ran an artistic assembly line and he looked upon paintings and drawings submitted to him much as a shop foreman looks upon the products of his machine shop. They had to conform exactly to his specifications. Hines would get illustrations to be used

for the cover of any given issue and paste them onto a board. If one was too large he'd merely take a sharp knife and cut it down to size. They used to say that Pop would crop the head off Whistler's "Mother" if he thought it would fit the page better.

The history of creating this art that Hersey, Reynolds, and others recorded makes one sharp point. Before the artist could put paint on blank canvas he had to find solutions to problems that were not his: cheap and limited printing technology, a little money for a lot of work; the Hersey list demanding conformity of colors, composition, and content; shrewd tricks to reduce and delay his payment; then at the finish, facing someone like Pop Hines. In utter despair Hannes Bok wrote to a friend:

I recently made the decision to quit the pulp field for good. Whether or not I continue to paint at all, I can't say. I have devoted twelve years painting in the pulp-fantasy field and have no more now than when I first began. Also, I have a large number of legitimate gripes against publishers, and I am convinced that the only way to avoid a repetition of such unpleasant experiences is simply to desert this field entirely, which is what I am doing.... This break is final, and from now on I shall have nothing to do either with the pulps or

Rafael de Soto: "She's Too Dead for Me!" *New Detective Magazine,* July 1946

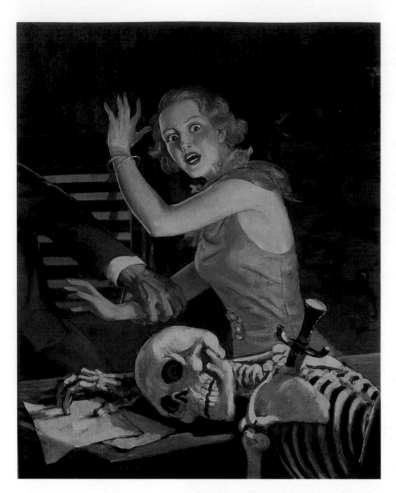

W. F. Soare: "The Fear Merchants," *Secret Agent X Detective Mysteries*, March 1936

their fans. I don't want to be (and cannot be) induced to remain in the pulp-fantasy racket, which is what I have recognized it to be—*a racket.*

We must ask, then, given these counterproductive working conditions: How did Norman Saunders, Walter Baumhofer, Tom Lovell, Rafael de Soto, George Rozen, and other pulp artists climb over these mountainous obstacles month after month and still create masterpiece after masterpiece? Hundreds of their paintings for the covers of the detective, hero, and weird-menace pulps were some of the highest quality professional American art put on canvas during the 1930s.

Somehow these artists were able to put into these covers, with amazing imagination, every variety of human emotion related to images of horror and terror embedded in our worst dreams. At the same time they used visual techniques that created the illusion of depth and that forced the viewer's attention to the main action in the foreground, and they exaggerated details to emphasize an emotional or psychological aspect of a character. The best of pulp art are paintings that *move*—motion pictures on the cover of a magazine.

Knight errant, samurai, pulp hero, or pulp artist: all were men of honor who shared the same code of honesty in a task, bravery in combat, and the fierce determination to give freely of their very best. In the 1930s and 1940s, the new knights of art rode forth, ready to do battle not with sword and spear but with brush and palette. They were heroes of populist culture.

George Rozen: "The Book of Death," *The Shadow*, January 1942 (™ The Condé Nast Publications, Inc.; Steranko Collection)

George Rozen: "Vengeance Bay," *The Shadow*, March 1942 (™ The Condé Nast Publications, Inc.)

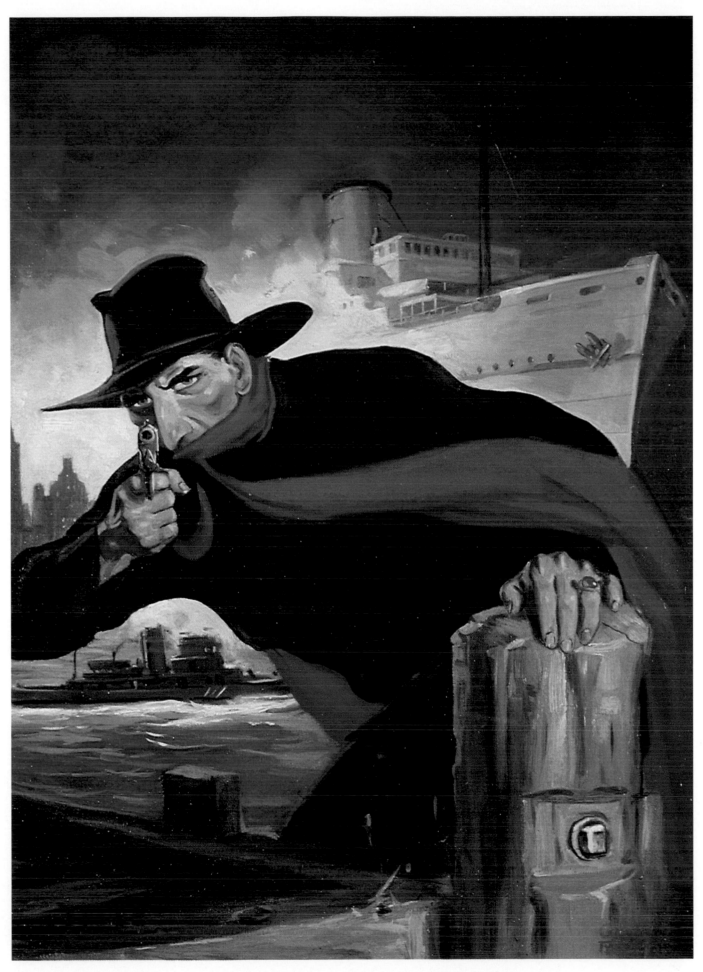

George Rozen: "Dead Man's Chest," *The Shadow,* Fall 1948 (™ The Condé Nast Publications, Inc.)

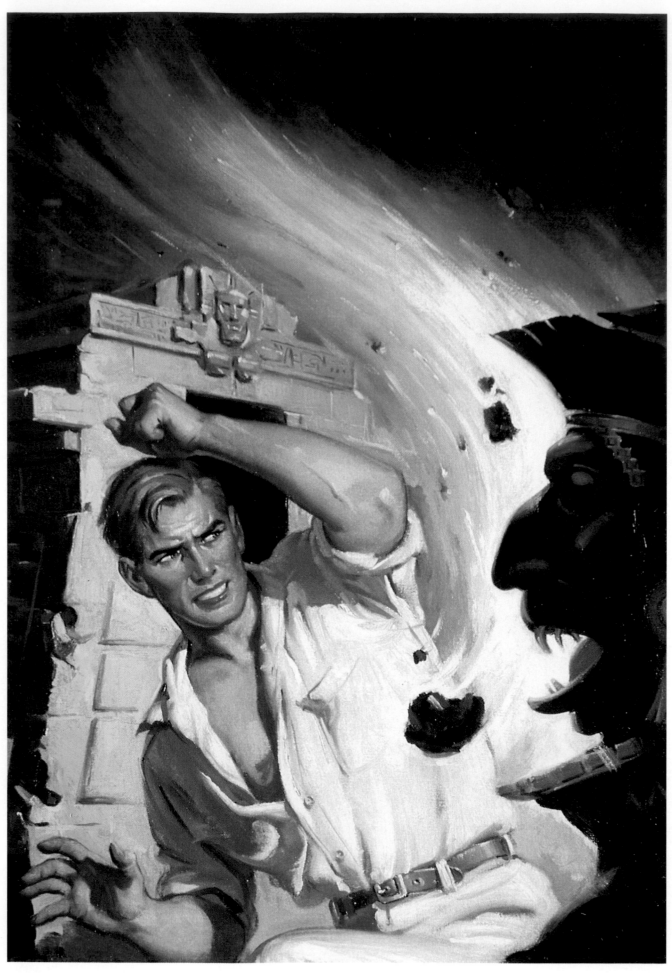

George Rozen: "The Green Master," *Doc Savage Magazine,* Winter 1949 (™ The Condé Nast Publications, Inc.)

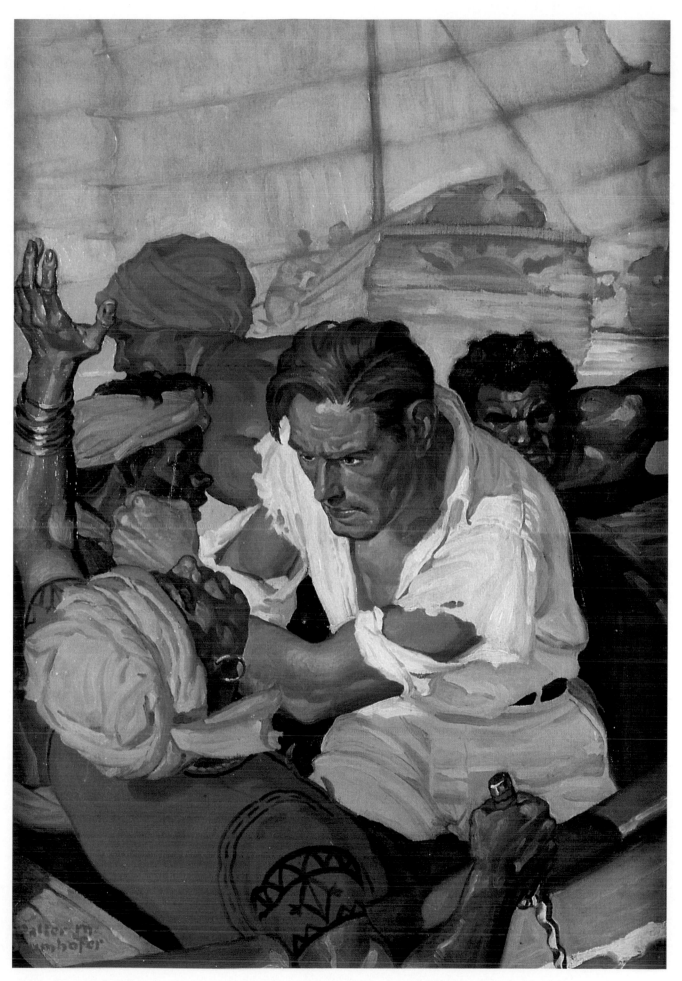

Walter Baumhofer: "Pirate of the Pacific," *Doc Savage Magazine,* July 1933 (™ The Condé Nast Publications, Inc.)

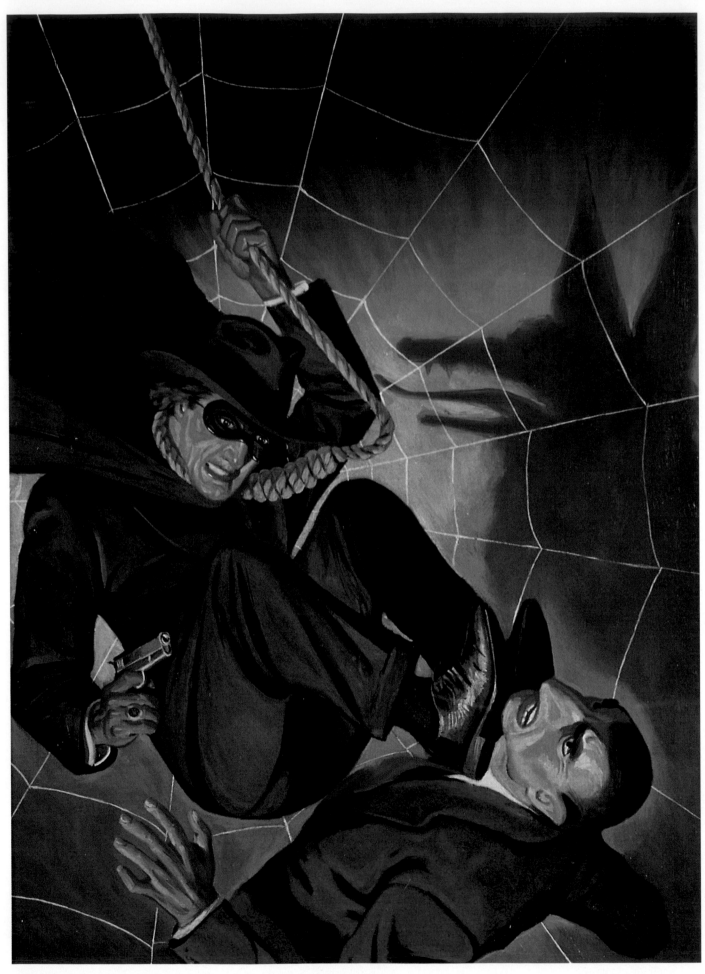

Rafael de Soto: "Revolt of the Underworld," *The Spider,* June 1942

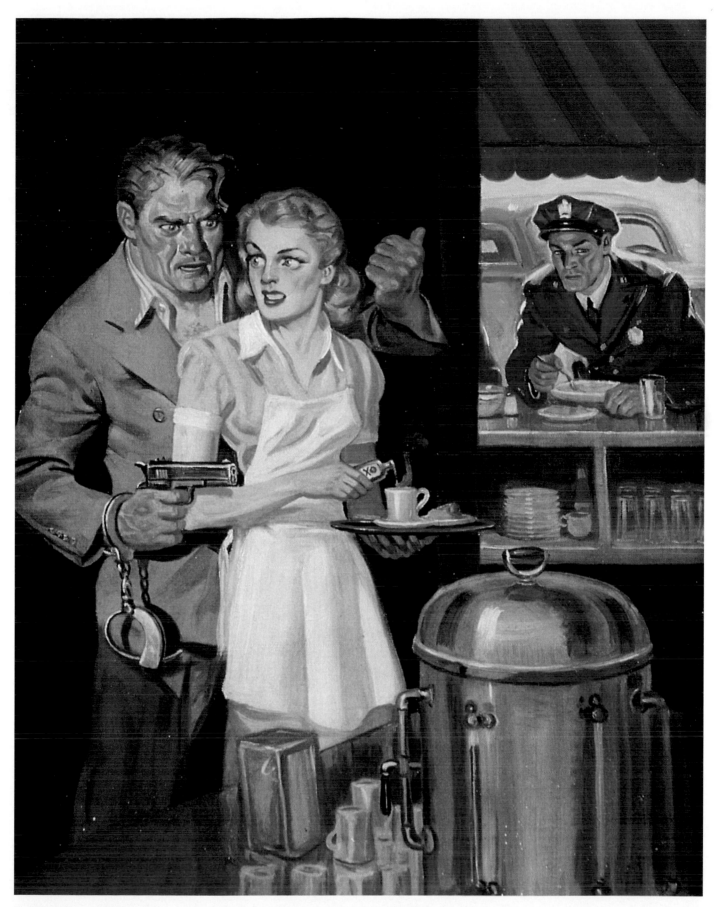

Rafael de Soto: "The Bookie and the Blonde," *Dime Detective Magazine,* July 1940

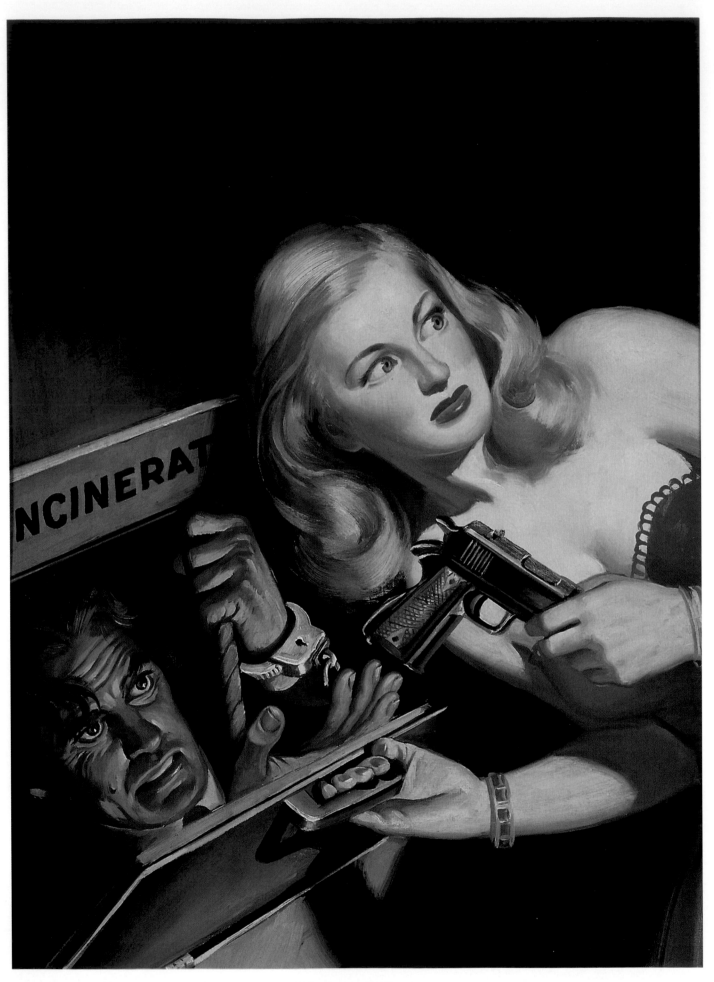

Rafael de Soto: "Softly Creep and Softly Kill," *Detective Tales*, August 1947

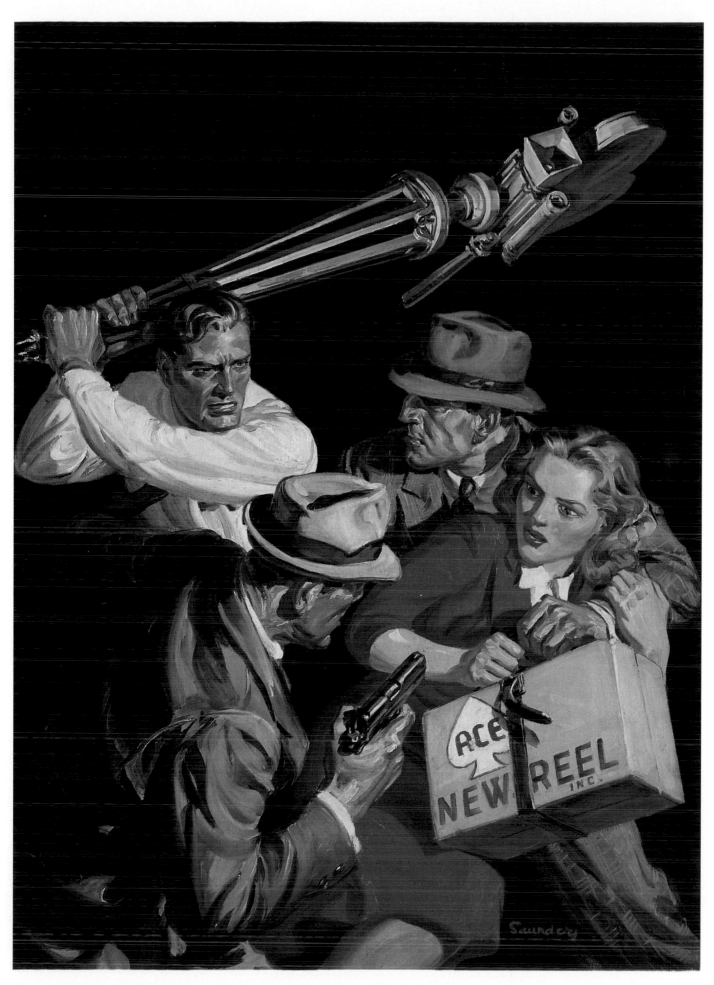

Norman Saunders: *Ten Story Detective*, 1938 (Syracuse University Art Collection)

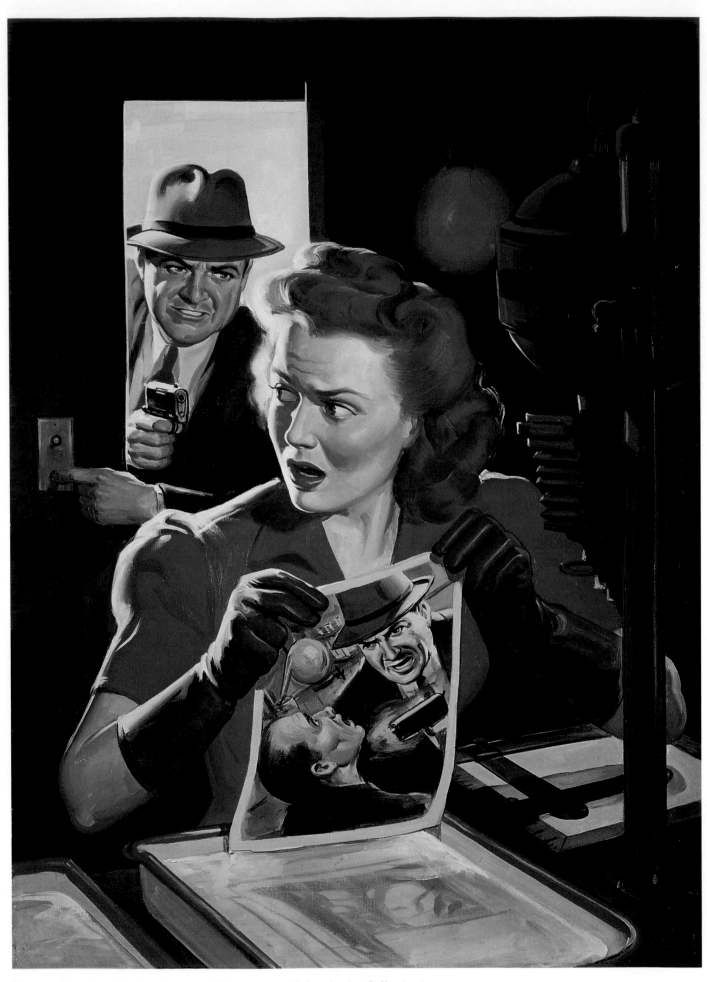

Norman Saunders: *Ten Story Detective*, 1938 (Syracuse University Art Collection)

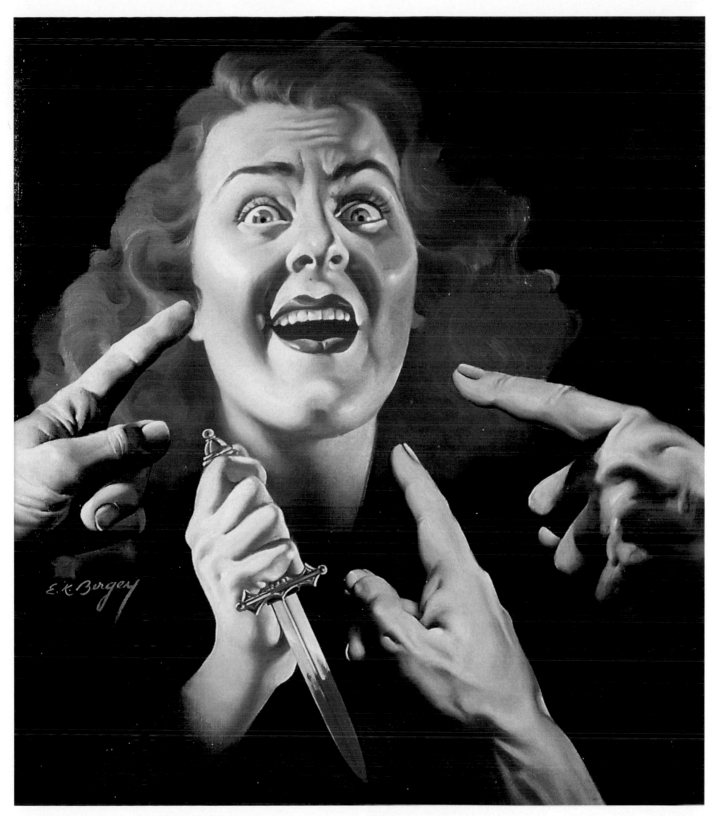

Earle Bergey: "Doubling in Murder," *Feature Detective Cases,* July 1947

THE NOBLEST SAVAGE

The greatest explosion of popularity for the pulps began with the invention of Tarzan by Edgar Rice Burroughs. It was an explosion whose shock waves have endured to this day. From magazines to movies, from books to radio and television, the idea of Tarzan is so appealing that it has spread worldwide and has penetrated deep into our psyches—it is a staple of world folklore. No other fictional character in history has remained so popular and alive for each new generation. Tarzan was born in the pulps, and his first appearance in *All-Story* magazine for October 1912 was an immediate success.

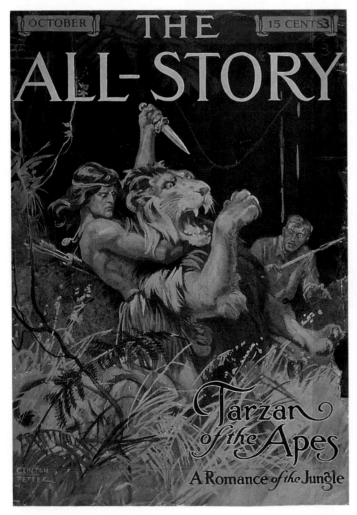

The story of Tarzan is simple. Lord and Lady Greystoke were victims of a mutiny, marooned in an African jungle. Fighting to survive, Lord Greystoke built a log cabin. But when their son was born his wife went mad and died. The boy was just one year old when a brutal pack of huge apes attacked and killed his father. One of the fiercest apes, a female named Kala who had just lost her own baby, scooped up the boy and took him back with her into the dense jungle, where he grew up with the pack. They named him Tarzan, or "White Skin Boy." He survived and grew into manhood with superior strength and intelligence. He eventually returned to his parents' abandoned cabin and found his father's knife. Burroughs describes how in a fight to the death he engages his hated enemy:

Tarzan of the Apes placed his foot upon the neck of his lifelong enemy and raising his eyes to the full moon, threw back his fierce young head, and voiced the wild and terrible cry of his people.

One by one the tribe swung down from their arboreal retreats and formed a circle about

Tarzan and his vanquished foe. When they had all come Tarzan turned toward them: "I am Tarzan," he cried. "I am a great killer. Let all respect Tarzan of the Apes and Kala his mother. There be none among you as mighty as Tarzan. Let his enemies beware."

"The Return of Tarzan" was Burroughs's second saga, published in *New Story Magazine*. After that, it became a sharklike feeding frenzy: Burroughs could auction Tarzan sequels to the highest bidder—*The Blue Book Magazine, Argosy, Thrilling Adventures*.

But the idea of Tarzan is not simple. Why does the mere mention of his name conjure up a favorable image in our minds and excite a passion of romantic approval in anyone who loves a good story, all over the world?

Perhaps the earliest ancestral appearance of the Tarzan Idea was in the Bible: Adam before the Fall, before Eve, her apple, and the serpent. The first man's body was perfection, his soul was without stain, his mind pure with no hint of evil, and his spirit fearless—since there was nothing to fear in his jungle, the Garden of Eden. Adam was the original Noble Savage and Tarzan of the Apes is his direct descendant.

Tom Lovell: "Edgar Rice Burroughs," 1969

Burroughs believed that the spark that ignited his imagination was the classical story of Romulus and Remus. They were twins fathered by Mars, god of war, and the vestal virgin Rhea Silvia. The children were ordered to be drowned in the Tiber but were miraculously saved to be suckled by a she-wolf. Romulus founded the city that was to bear his name and made it a refuge for the poor, for runaway slaves and the persecuted. At this point the myths converge and convey another part of the Tarzan idea. Suckle the mother's milk of wolf or ape to take the animal's strength inside, and you will inherit its fierce will to face death in battle and emerge victorious over an enemy. The strength of the Tarzan idea is that it has a believable myth embedded into the center of its fiction, like a hard diamond in soft rock. The power of the idea is that we want to believe it.

Of course, there were others before Burroughs. Rudyard Kipling claimed that Tarzan was patterned after Mowgli in *The Jungle Book*. The wolves are surprised:

"Man!" he snapped. "A man's cub. Look!" Directly in front of him, holding on by a low branch stood a naked brown baby who could just walk—as soft and as dimpled a little atom as ever came to a wolf's cave at night. He looked up into Father Wolf's face and laughed.

"Is that a man's cub?" said Mother Wolf. "I have never seen one. Bring it here."

Father Wolf's jaws closed right on the child's back; not a tooth even scratched the skin, as he laid it down among his cubs.

"How little! How naked—and how bold!" said Mother Wolf, softly. The baby was pushing his way between the cubs to get close to the warm hide. "Ahai! He is taking his meal with the others. And so this is man's cub. Now was there ever a wolf that could boast of a man's cub among her children?"

Important Pulp Paintings in the Burroughs Collection

DANTON BURROUGHS

To most people pulp art is something they either bought from the newsstands when they were kids or else discovered when they were older and began to collect the exciting old magazines themselves. For me it was different. Because my grandfather was Edgar Rice Burroughs, and my father illustrated many books, that was the kind of artwork I commonly saw around the house. It just seemed natural to me. Whereas other homes might have paintings of sunsets or scenes of bucolic rural life, I saw framed paintings of Tarzan of the Apes.

One of the most striking of these is the cover to *Tarzan and the Jewels of Opar.* This colorful painting from 1918 by J. Allen St. John shows a knife-wielding Tarzan in a life-and-death battle with a huge black-maned lion. In the distance La of Opar watches from the altar where someone is about to be sacrificed. The subdued yellow of the background sets off the powerful majestic golden color of the lion. Is it any wonder that St. John was my grandfather's favorite cover artist? It was a long time before I came to realize that having a St. John original hanging in your home, much less any painting of a man wrestling a lion, wasn't commonplace. But I grew to appreciate this painting's finer qualities over the years until I could see the artistry beyond the powerful (and long familiar) image. And it was familiar: though my grandfather died when I was about six, I still remember going to his house and watching 16mm Tarzan movies. Then as I grew older I realized just what treasures our family possessed because what others bought, read, and enjoyed was part of my family legacy. It was my grandfather's imagination that produced the stories that enabled St. John to create these unforgettable images that have excited people for decades. St. John moved easily between the covers of pulp magazines and the covers of my grandfather's books, and he put just as much imagination and artistry into one as the other.

Another Tarzan painting I grew up with isn't as dramatic as the St. John, but is by an artist even more famous—N. C. Wyeth, who would go on to become acknowledged as one of the great American illustrators of the twentieth century. His only Tarzan paintings were based on a single book, *The Return of Tarzan,* but that's certainly a significant title. The painting we have is the one that served as the cover illustration on the original *New Story* pulp-magazine serialization of the tale, as well as on the first-edition hardcover book. Wyeth was a different sort of painter than St. John, although both made an interesting use of light in their color paintings. In this one, which is an outdoor scene, it's clear that the sun is at Tarzan's back, as the front of him is in shadow. You can look closely at the painting and see the brushstrokes and how the leaves were delicately formed, and the way the foliage in the back isn't as precisely rendered in order to create the feeling of dis-

tance. So the first thing your eye is drawn to is the image of Tarzan in a lion-skin loincloth high in the branches of a tree. The sky at the top is rather blank because that was where the pulp magazine's name was (and later where the book title went). The more you look at this deceptively simple canvas the more you see the interesting little things it has. The tree, for instance: the branch that stretches from left to right across the image has a skeletal quality; the branches are denuded of all semblance of life, and it gives them the look of bony fingers.

This Wyeth painting has an interesting, and partly apocryphal, history. In 1913 my grandfather attempted to buy one of the two Wyeth paintings done for *New Story*. The one he wanted would only be sold by Wyeth for a hundred dollars, a princely sum for anything in 1913. Edgar Rice Burroughs wrote back to A. L. Sessions, the editor of *New Story*, and in a letter dated June 14, 1913, Burroughs stated, "I want to thank you for the trouble you have taken relative to the cover design by Mr. Wyeth. I am afraid, however, that Mr. Wyeth wants it worse than I do, so I shall be generous and let him keep it." Many years later, in 1965, Hulbert Burroughs learned of a Wyeth Tarzan painting that still existed; he purchased it for fifteen hundred dollars, believing that it was the same one his father had been unable to afford in 1913. In fact, the one my grandfather sought in 1913 has apparently been lost to the ages. Oddly enough it wasn't even as interesting a painting as the one we have; the picture Edgar Rice Burroughs sought to purchase shows two men in ordinary desert garb riding horses (presumably one of those men is Tarzan). The painting Hulbert bought is actually more significant, because it shows Tarzan in his traditional setting.

But we had more than Tarzan on view. Another St. John painting I grew up with was the strange and disturbing painting that appeared on the dust jacket of *The Moon Maid* in 1926. This is the painting of the title character in a red dress, riding on the back of the ugliest centaur you've ever seen. They're called Va-Gas. Other people had paintings of horses in their home. We had a Va-Gas whose head looked like a demon. What's also strange about this painting is that St. John rendered the Va-Gas in midleap so that none of its feet are touching the ground.

Some parents try to shield their kids from weird or disturbing images, but if those are the kinds of things you grow up with, then you don't think of them as weird or disturbing. To me the weird was commonplace, and it was also fun. There was certainly nothing threatening about it, and I was able to grow up with an appreciation of what my grandfather and my father did. My grandfather was a writer and my father was an artist. I was constantly surrounded with examples of popular fiction and imaginative commercial art. It certainly gave me a broader view of what life offered a person, both in the arts and in entertainment.

Danton Burroughs is the grandson of Edgar Rice Burroughs. He is director of Edgar Rice Burroughs, Inc., and governs the worldwide commercial activities that utilize Tarzan and other ERB franchises. He is perhaps the most knowledgeable scholar, conservator, and collector in this field of popular culture.

Said Father Wolf: "He is altogether without hair and I could kill him with a touch of my foot. But see, he looks up and is not afraid."

Shere Khan the tiger thrust into the entrance. "My quarry. A man's cub went this way. Its parents have run off. Give it to me."

"The wolves are a free people," said Father Wolf. "They take orders from the head of the pack, and not from any striped cattle killer. The man's cub is ours to kill if we choose."

The tiger's roar filled the cave with thunder. Mother Wolf shook herself clear of the cubs and sprang forward.... "The man's cub is mine—mine to me! He shall not be killed. He shall live to run with the pack and to hunt with the pack; and in the end, look you, hunter of little naked cubs—he shall hunt thee!"

Who is Tarzan? In essence, he is the very definition of Jean-Jacques Rousseau's Noble Savage. Perhaps he is the Noblest Savage of them all. He is an idealization of man pure in nature; free from corruption, vanity, pride, egoism, envy, and greed; honest without fault or selfish purpose; fearless, compassionate, and loyal, with hard ideals. He is an aristocrat of the natural world entitled only from merit and character. He can exist because as in Adam's Garden of Eden, in Tarzan's jungle there is freedom from all human evil. In his magnificent *Social Contract,* Rousseau begins with the famous statement: "Man was born free, but he is everywhere in chains." Not Tarzan.

What connection does all of this have to the art? In many of the heroic pulp paintings, on top of the coat of white paint that primes the canvas and underneath the brushstrokes of the picture, Tarzan is sandwiched in between. In print and paint his influence is everywhere. Look at the muscled perfection of Doc Savage on Baumhofer's covers: that body belonged to Tarzan first. Look at the will-to-win-against-death set in wrinkled rage on the face of George Rozen's The Shadow: it was the same with the Lord of the Jungle fighting the horrendous snake wrapped around his body. Tarzan, idea and image, permeates all of the hero pulps and is its most important and popular invention.

Edgar Rice Burroughs selected J. Allen St. John to illustrate his stories. It was the right decision. It produced masterpieces. He once told St. John that he believed that his illustrations were responsible for half the sale of his books and said: "I consider J. Allen St. John one of the greatest illustrators in the United States." Today his paintings command the highest prices, his name is known, and the appreciation of his art is growing rapidly.

J. Allen St. John's illustrations for the Tarzan and Martian stories of Burroughs were inspired, enthusiastic visual displays. But it wasn't just talent; it was also training. St. John was professionally trained; he studied at the Art Students League under William Chase, F. V. Du Mond, H. Siddons Mowbray, and Carol Beckwith; in Paris he studied with Jean Paul Laurens, then in Belgium with Henri Vierin. His work was in great demand, and he became a much sought-after illustrator by such periodicals as the *New York Herald, Harper's Bazaar, Delineator, Redbook,* and *Boy's World.* He was appreciated during his lifetime; his work was exhibited at the National Academy, the Pennsylvania Academy, and the Art Institute of Chicago and is included in many private and public collections.

J. Allen St. John: "Tarzan and the Jewels of Opar," book jacket illustration, 1918 (Edgar Rice Burroughs Collection/Danton Burroughs)

St. John's best depiction of Tarzan is his jacket painting for the 1928 hardcover book *Tarzan, Lord of the Jungle*. It is a death struggle, man against beast. An ugly python has circled his waist and trapped the ape at his feet. The jaws of the snake are wide open and ready to attack. But Tarzan's hand is on its throat, arm muscles tight, and in the other hand is a long knife ready for the death stab. Recalling the technique of Croce, we note that it is really a triptych: the unseen painting on the left would be Tarzan and the ape, surprised and suddenly caught by the snake; on the right would be the imagined picture of Tarzan cutting the beast to death and escaping. But there are also two daring details. The Ape Man's expression is not one of

A Conversation with
J. Allen St. John,
Dean of Fantasy Illustrators
(1950)

DARRELL C. RICHARDSON

For a number of years I have had a great admiration for the art of J. Allen St. John. I was introduced to his work through his magnificent illustrations in the Tarzan and Martian books of Edgar Rice Burroughs. Later I began to collect books and magazines that contained his illustrations. More recently, I have been collecting original paintings and illustrations of his.

Last summer I had the privilege of meeting Mr. St. John and having a long visit with him in his own studio in Chicago. Arrangements were made to meet Mr. St. John at the Art Academy. Entering the main office of the school, the first object of my attention was a huge painting of Tarzan and Jad-Bal-Ja hanging above the door. It was immediately recognized as St. John's original for the book jacket of *Tarzan and the Golden Lion*.

Frank H. Young, president and founder of the American Academy of Art, introduced me to Mr. St. John, a very tall and elderly gentleman. He immediately suggested that we walk into the next room for a chat. I noticed a familiar drawing on the wall of his classroom. It was one of the original illustrations for the book *Tarzan the Terrible,* showing the tailed man of Pal-ul-don carrying Jane away as she struggled and fought fiercely. Mr. St. John explained that he kept it framed and in his classroom because it was one of the finest examples of a "wash drawing" that he had ever done.

I mentioned many specific St. John illustrations that appealed to me from *The Blue Book Magazine, Weird Tales,* and *Amazing Stories.* Mr. St. John seemed amazed at our knowledge of his work but was sincerely astounded that anyone had such an interest in his art. I assured him that he has hundreds of fans who admired his work immensely. This is especially true of Burroughs fans who consider that Burroughs tales and St. John's pictures go together like ham and eggs....

The following afternoon we arrived at Mr. St. John's address on Ontario Street and were shown into his studio. The atmosphere of the studio, the massive easel, railed balcony, mixture of drawings, paintings, and objects of art seemed in every way to be appropriate to our expectations.

Knowing of our interest in Burroughs, Mr. St. John had set out a stack of his own personal collection of Burroughs illustrations to show us.... One by one St. John would take a picture from the stack and place it on the easel where we could view it. Many of St. John's Tarzan and Martian illustrations were painted in heavy oils on board, without the use of colors other than whites, blacks and shades of gray.

In reply to the question "What is in your opinion the best illustration for a Burroughs tale?" St. John pointed out the one in *Tarzan the Untamed* where Tarzan, after nearly dying of hunger and thirst in the desert, feigns death; and when the vulture swoops down, he quickly comes to life and stretches forth his mighty arm to strangle the great bird. I asked Mr. St. John how he went about illustrating a story. He replied, "Well, I first read the story for enjoyment just as you would. Then I read it a second time and jot down ideas about various scenes that appeal to me for illustrating purposes. I then try to illustrate the story accurately according to the author's description...."

Just before we left he showed us a portfolio of his work, which included illustrations from many books and magazines,...quite a pile of cover paintings for western books by George Ogden, W. R. Raine, Charles A. Seltzer, and others.... He showed us a painting he had just completed: a shaggy satyr kneeling before an ancient stone statue of Pan with a beautiful nude maiden astride his shoulders. The delicate coloring, the almost eerie beauty of the sylvan glade, [and] the mythological subject itself make the painting one of the finest pieces of fantasy art I have ever seen. He titled it *Ave Pan* and had done it in casein (rather than oils), a medium that had intrigued him in recent years.

I shall always look back upon my visit with this great fantasy artist with genuine pleasure. Cultured and reserved, with a thoughtful and modest manner, Mr. St. John impressed me as a friendly and courteous gentleman of the old school.

> *Darrell C. Richardson read his first Tarzan book at the age of eight, and then and there decided to model his life on the Lord of the Jungle. He has lived his life with courage and devotion to his principles. Dr. Richardson is an author, archaeologist, and Southern Baptist minister. "I do have the largest collection of Burroughs in the entire world," he says. He has had forty-one books published under the pen name of D. Coleman Rich and has recently published the first complete illustrated bibliography of J. Allen St. John.*

fear or pain from the snake's tightening embrace—it is one of indifference. It is the same expression found on the face of the earliest church paintings of Saint Sebastian: his body pierced by painful arrows, the saint's face displays neither pain nor fear because God's mercy has saved him from both. Over and over again in the paintings of martyrs and saints that same face of indifference speaks through paint. The face of Tarzan is the face of Saint Sebastian.

The second unusual aspect of this large painting is that it is on masonite board. The front side of masonite is smooth, takes paint easily, and is always preferred. But the back is not meant to be used because it is unfinished, serrated, and rough surfaced, and the flow of paint from brush to board is difficult to control. But St. John used the back. Why?

J. Allen St. John: "Tarzan, Lord of the Jungle," book jacket illustration, 1928

Because the background is a jungle scene and the rough surface aids in the creation of that visual reality. It is a brilliant choice that enhances the entire painting. There are two different paintings. The foreground of Tarzan, ape, and snake are realistic images that tell the story and are detailed, in focus. But the background is entirely different, painted in an impressionistic style. It is illuminated in the center by bright sunlight so intense it is as if a lightbulb was built into the back; it blinds the eye, and the trees and foliage become vague outlines devoid of natural colors. Why did he do this? Because he wanted to control the eye and force it to focus on the foreground figures telling the story.

According to the artist, his inspiration for this painting was Laocoön, the ancient Greek story and sculpture. Laocoön was a priest of Apollo who made the gods angry when he broke his vow never to take a wife.

During the siege of Troy he tried in vain to dissuade his countrymen from bringing into the city the huge wooden horse of the Greeks. The Trojan Horse was a camouflaged fortress: suddenly two enormous serpents emerged from the sea and strangled him and his sons. The Trojans opened the city gates and brought the horse inside in an attempt to appease the gods.

The Laocoön group resides in the Vatican Museum and dates from the second half of the second century B.C. Virgil described it in the second book of his *Aeneid,* and Michelangelo, seeing it for the first time, burst into tears. Pliny said: "Of all paintings and sculpture this was the most admirable." Laocoön and Tarzan, Lord of the Jungle, share the same struggle of human courage against the beast of death. Both of their bodies swell with suffering, their muscles taut in agony. The two images, separated by thousands of years, are connected in theme and visual details.

In addition to his Tarzan work, J. Allen St. John created one of the most universally applauded masterpieces of pulp painting, a memorable cover for *Weird Tales.*

The story is that one morning in early 1933, Farnsworth Wright, the magazine's editor, unwrapped a painting sent to his office by St. John. He was stunned and stared at it in silence, as if hypnotized. It was the cover painting for "Golden Blood." Breaking the spell, he wrote to the story's author, Jack Williamson, praising "that colossal golden tiger looming gigantic against the sky...and in the foreground Price and Fouad sitting astride their white camels and looking quite Lilliputian by comparison.... What a gorgeous splash of color—the golden yellow tiger, the vivid green of Vekyra's robe, and the intense crimson of Malikar's garment."

The *Laocoön* group, second half of the second century B.C. (Vatican Museum)

There are paintings that strike with a single blow; great paintings that in the split second of first glance overpower reason, that travel directly from the eye to the astonished soul via sensual apprehension. "Golden Blood" is one. Here words won't work; it must be seen.

The popularity of the Tarzan Idea inspired a new army of artists, writers, and imitators. One superb painting stands out, adding to the hero's myth: a tense and fearful Tarzan emerging from a jungle, a trap of green leaves and vines suggesting danger, death, and anarchy: this is the great N. C. Wyeth's "Return of Tarzan" for a 1913 *New Story Magazine.* It must have been a joy for him to paint; he signed his name in the lower left-hand corner of the painting in large letters. *The Blue Book Magazine* was known for using the best artists and writers and paying the highest rates to get them. Laurence Herndon created the cover for their

The Paper They're Printed On

ALISON M. SCOTT

I saw my first pulp magazine in the autumn of 1964. I was in the third grade at Vista Elementary School in Kennewick, Washington. Every year, the PTA sponsored a rummage sale to raise money for equipment and extracurricular activities, and that year I had one dime to spend. Being a frugal child and careful with my money (traits I have since lost), I roamed the classrooms in which the sale was held for at least an hour, trying to decide what I wanted most—a game, a toy, or a risky but tantalizing "mystery grab bag."

I was turning the alternatives over in my mind when I came upon a pile of books and magazines tucked away in a corner of the kindergarten room. The first thing I saw in the nondescript heap that I coveted was a copy of the Penguin Classics edition of *The Odyssey,* in the old-fashioned brown, cream, and black cover. I didn't know Homer from Adam, but I was proud of my reading skills and it looked like a very grown-up book. I could get it for a nickel and still have something left for a brownie or a piece of cake at the bakery table.

Thoughts of the prestige value of the classics and the practical value of dessert fled, however, when I encountered an altogether glorious and thoroughly desirable object just a little lower down in the stack. It was a copy of the September 1949 issue of *Startling Stories,* and I knew it was love at first sight.

I had read some science fiction for "young readers"—*Danny Dunn and the Anti-Gravity Paint* by Jay Williams and Raymond Abrashkin sticks in my mind—but this was the real stuff. The featured stories were "The Hothouse Planet" by Arthur K. Burns and "The Portal in the Picture" by Henry M. Kuttner (a story that inspired my ongoing interest in alternative histories), but what I really wanted was the cover of this magazine—which depicted a woman holding a rifle and kneeling in the foreground of a grassy, open space, while in the background a dinosaur was busily engaged in eating her male companion. Here was glamour, strange new places, action, and excitement, all dramatically captured in Earle K. Bergey's entrancing illustration and transformed into something I could possess for the terrific sum of ten cents.

I spent my entire fortune and carried my treasure away in triumph; I kept it with me, through grade school, high school, college, graduate school, and several different jobs, until I gave it to the Bowling Green State University Popular Culture Library in 1994, near the thirtieth anniversary of its purchase.

In the course of my education as a literary scholar and as a librarian, I learned a great deal about the history of pulp fiction, its production, distrib-

ution, and reception, ranging from the chemistry of wood-pulp paper manufacture to myth analysis of the western-adventure story. I was particularly pleased when I felt I understood printing processes thoroughly enough to explain to myself and colleagues the differences between the paper used for those covers: interior pages were printed on extremely cheap, rough-surfaced paper manufactured from wood ground into a pulp, chemically treated, and formed into sheets. The lignin inherent in the wood, combined with chemical treatments, left wood-pulp paper with very high acid content; over time, this leads to the characteristic yellowing and brittleness found in pulp magazines, newspapers, and paperback books. By contrast, pulp-magazine covers were printed on lightweight but good-quality paper stock, coated with china clay to create a smooth printing surface that resists abrasion and takes ink well. The clay used to produce the "slick" surface on the paper has the incidental benefit of increasing the alkaline content of the paper and thus slightly resisting the deterioration caused by the acidic decay of wood-pulp paper.

The satisfaction that I take in my academic understanding of pulp magazines, substantial though it is, nonetheless pales in comparison to the pleasure that the magazines themselves excite: pieces of portable literary and visual art, pulps inspire admiration and delight.

Alison M. Scott is the head librarian at the Popular Culture Library of Bowling Green State University in Ohio. She is an expert in the science of paper conservation and remains a student of the newest techniques in this field. Due to her knowledge and interest, Bowling Green can boast of a superior collection in the area of pulp magazines.

"Tarzan, Guard of the Jungle" in a neoimpressionist style that results in a visual fluidity that propels the action of the scene.

If the images of the Lord of the Jungle are art, then the art of Burne Hogarth cannot be ignored. He drew the *Tarzan* Sunday-newspaper comics from 1937 to 1950. The originals were black-and-white inked drawings done on bristol board twice the size of the printed panels. He replaced another comics giant, Hal Foster of Prince Valiant fame, and transformed the *Tarzan* panels with a unique approach to comic art based upon his studies of human anatomy and his appreciation of the fine draftsmanship of Michelangelo and the artists of the baroque period. His style was like nothing that came before or since. The accent was on anatomy in motion, long muscles distorted, apes and men and tigers twisting beautifully through the sky, as if suspended in the air by their own sheer strength. The action was set against a background of razor-sharp trees and mountains, of birds and beasts with cutting beaks, claws, and teeth, all merging into a continuous illusion of motion.

In 1966 Hogarth's works were shown in Paris, and the brilliant French critic Francis Lacassin said in his article "Hogarth Between Wonder and Madness" (*Giff-Wiff* no. 13, 1965, Paris):

The twists of the plot are arranged to serve a set purpose: the dynamic depiction of Tarzan's anatomy. Pitted against him are opponents—men or beasts—well suited to free his kinetic energy. It is clear that Hogarth does not strive so much to develop the point of the narrative as to express the inner drama of the action.

In turn the atmosphere yields to the frenzy which consumes the living. Nature seems in a feverish trance: the grass and the trees bow under the threat of an ever raging storm and the fire stirs up the bowels of the earth, and in some apocalyptic explosion it illuminates the peaks of volcanoes....

A high wall is destined to bring into display the hero's muscles while he climbs over it, a branch stands out so he might crouch down in a simian position in order to jump on his enemies.... Tarzan in his most familiar gestures

J. Allen St. John: "The Moon Maid," book jacket illustration, 1926 (© 1926 Edgar Rice Burroughs, Inc.; Edgar Rice Burroughs Collection/Danton Burroughs)

Laurence Herndon: "Tarzan, Guard of the Jungle," *The Blue Book Magazine,* November 1930

strikes up stage postures charged and speeded up by the artist's obsession with dynamic action.

But Hogarth didn't paint for the pulps. Nevertheless, it is important to include him in this discussion because it brings us to an enlarged definition of the art form: pulp art is not just what was painted to decorate a seven-by-ten-inch dime magazine during the 1930s and 1940s, a painting half lost because the splashy type blocked out much of the image. Hogarth belongs because of the spirit and craftsmanship of his work, because of his storytelling powers, because of the heroic, action-packed nature of his illustrations, because of his stewardship of the greatest of pulp creations—and because pulp art does not have any size-and-price limits. It is a complete aesthetic unto itself and can be found in wider venues. Include among pulp images, for example, Winslow Homer's *Gulf Stream* and John Singleton Copley's *Watson and the Shark.* Perhaps a hundred years hence artists will discover this way to paint a painting again, and use it in invented forms beyond our dreams that will, as in the past, shock, delight, and amuse.

J. Allen St. John: "Golden Blood," *Weird Tales,* April 1933

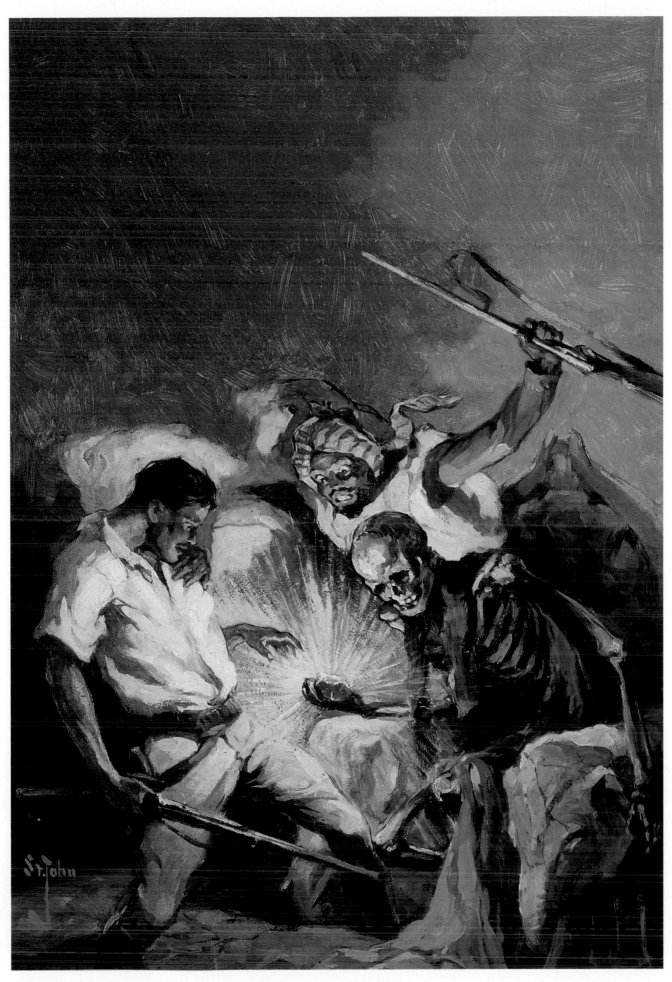

J. Allen St. John: "The Fire of Asshurbanipal," *Weird Tales,* December 1936

N. C. Wyeth: "The Return of Tarzan," *New Story Magazine* and book jacket, 1913 (Edgar Rice Burroughs Collection/Danton Burroughs)

Laurence Herndon: "Tarzan, Child of the Jungle," *The Blue Book Magazine,* December 1930

Laurence Herndon: "The Land of Hidden Men," *The Blue Book Magazine*, May 1931

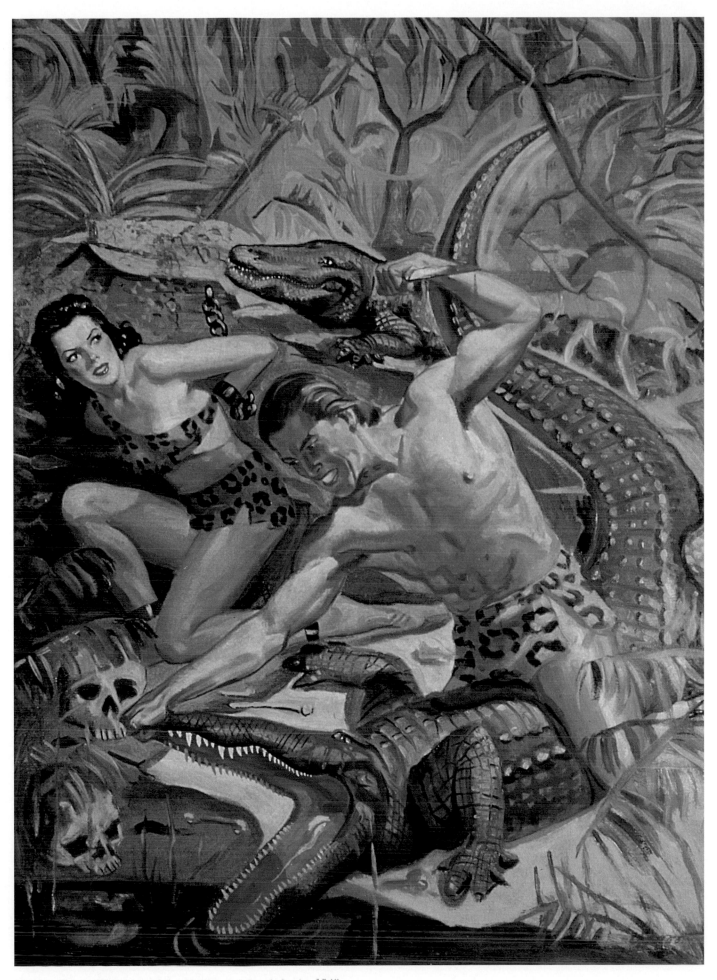

George Gross: "Huntress of the Hell-Pack," *Jungle Stories,* 1949

Edgar Franklin Wittmack: *All-Story*, c. 1926

LADIES IN TERROR

Sex and money: both were scarce during the 1930s. Sure, pulp publishers, editors, and artists knew that "sex sells," but it was against the law. And the law was enforced by the police, by the U.S. Post Office, by self-appointed censors harassing newsstand dealers, and by militant moralists like Mayor Fiorello La Guardia of New York, who tossed pinball games into the East River, closed burlesque, and cruised the newsstands with head shaking no at the sight of Spicys and Saucys, *Horror Stories* and *Terror Tales*.

Two men had the courage in 1934 to dare the devil. Harry Donenfeld and Frank Armer started Culture Productions and sent to press the first *Spicy Adventure Stories, Spicy Western Stories, Spicy Detective Stories,* and *Spicy Mystery Stories.* They adopted the action formats of other pulps and combined them with heated sex. They paid the highest rates and attracted artists willing to paint sex and violence: H. J. Ward and H. L. Parkhurst. They paid writers three to five cents a word, while the other pulps paid only one cent or less. They bought the best and paid them promptly. The wholesale cost of the magazine would remain at two cents, but the retail newsstand price could be raised from ten to twenty-five cents—with no returns: they knew that the entire press run would sell out. Customers seemed to know just when to line up, and as soon as the magazines hit the stands they were gone. Some people would buy the entire batch at news-stand retail, then become dealers and sell them at several times retail.

Culture Productions had enemies who wanted this to stop. Although their editorial office was in

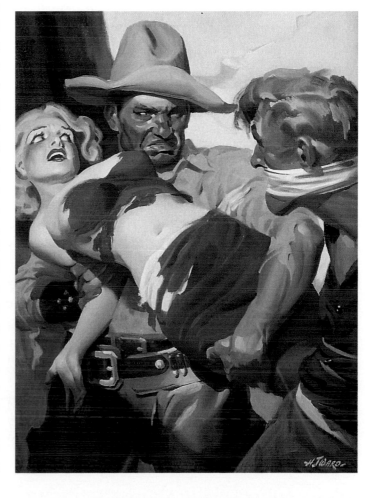

H. J. Ward: "Gunsmoke Gulch," *Spicy Western Stories,* April 1938

Painting the Story

JOHN LOCKE

The cover of the first pulp—the October 1896 issue of *Argosy*—gave no clue as to its revolutionary content. No story titles were listed, no authors, no illustrators. Instead, it marked its presence with sparse red print and a floral border on a plain background—a thoroughly stodgy ancestor to the glory of a 1930s newsstand displaying hundreds of pulps in a constellation of dazzling covers. But give publisher Frank Munsey his due. Beneath his minimalist cover lay the winning formula: a dime's worth of fiction on cheap paper.

By 1915 or so, the pulp market was firmly established. Pulp had yet to earn its enduring bad name, so there were still cultural heights to ascend. Virtually every magazine bore a painted cover; not mere illustration, but a work, however futile the ambition, in the medium of the masters. The early covers were sadly polite for the most part—art with manners, the antithesis of what the pulps came to represent. These covers offered fine art to the common man when common art would have been his pleasure.

As the 1920s approached, the branching of the pulps into genre fiction—*Detective Story Magazine, Western Story Magazine*—began to fragment the readership. The pulps withdrew their appeal to the highest common denominator. Gone, and none too soon, were covers suitable for all, dull depictions of a lady in a hat. Still, most covers owed as much to portraiture as to action. It's the difference between a cowboy posing on a horse and riding a horse. Once he gallops away, once he pulls his pistol, once the passage of time and events are introduced, the painting tells a story, bringing the cover into closer accord with the magazine's content.

A second wave of experimentation in the late twenties sought to divide the market into increasingly smaller niches. It was the invasion of the fly-by-nighters, a scramble for easy money, and the start of the craziest decade of the pulp era. Obscure titles like *Submarine Stories, Fire Fighters,* and *Gangster Stories* came and went as quickly as sales justified. That was the business: bombard the market with new titles and ride with the winners. To entice the reader to gamble on a new commodity, the covers had to get more exciting.

A novel attempt at specialization from this period, *Triple-X,* offered aviation, western, and war stories. Fair enough. But to avoid alienating the fans of any of the genres, the covers frequently illustrated stories blending all three, which the student of history will recognize could only pertain to cowboys in the aviation divisions of the Great War, a legend that surely never was.

Through the thirties, the pulps matured as a product crafted for consumer taste. Publishers learned how best to use the cover itself to advertise the content. Certain bright colors attracted browsers like bees seduced by

wildflowers. Certain logos—for *Astounding Stories, Dare-Devil Aces, Rapid-Fire Action Stories*—screamed excitement for the hard of seeing. Above all, since the story was the thing, cover illustration evolved to provide an instantaneous and often involved description of the tales inside. Painters strived to incorporate the storyteller's craft within their own work.

These stories, which some strain to call literature by naming a rare few that come close, seldom taxed the reader's patience with subtleties. Character was important only insofar as it hinted at the hero's propensity for getting into trouble. Society rarely surfaced in the pulps as a subject of social criticism but instead as a ready source of victims, obstructions, and danger. Plots moved rapidly from event to event, stringing peak moments together like the baubles of a costume necklace. It was these critical moments that the reader waited for and the cover artist often sought to depict.

Tom Lovell's cover for the November 1936 *Ace-High Western* is a fine example. What a tale its moment tells! Our gunslinger is the man pictured in the wanted poster. The law has authorized his murder, putting his life in continuing jeopardy. Has he done something to deserve this? His confederate, a beautiful young woman, tears down the poster. Wife, lover, idealistic school marm? They're caught in the act. He will defend himself with deadly force. But is he concerned? Naw, there's still time for one last drag on the cigarette.

In photojournalism, critical moments captured on film vie for the Pulitzer. But the pulp painter, limited only by his imagination, conjured such images at will, churning out one cover after another of action that in reality would be missed in the blink of an eye. Rudolph Belarski's *Thrilling Adventures* cover of January 1937, with its emphasis on a single character, is rooted in portraiture. But it captures a denouement; it freezes time on that critical moment like a lucky photographer's shot. Something has happened to the navy man in the picture. We see what it led to at the precise moment of reprisal: two-fisted, blazing gunplay. And the story? On close observation, the officer is a physician, indicated by caducei on the collar. But why would an officer, a gentleman, and especially, a doctor shoot at anyone? It must have to do with the fresh wound on his forehead. Pay the dime and find out.

Lest one get the impression the pulps were exclusively a male club, note that women's titles were among the mainstays of the business. The stories were every bit as adventurous as the men's, although for female readers of the time, the flush of romantic attraction constituted action, and unrequited love, danger. Though generally mired in the "lady in a hat" school, love covers did on occasion exhibit a depth of narrative equal to the best men's covers. A case in point is the Winter 1943 *Popular Love*, by the prolific Earle Bergey. Bergey's innocent heroine is situated between two sailors. In ordinary time, the conflict among such a threesome would be the woman's—whom to love. But in the midst of World War II, it's the sailor's dilemma, between serving his heart, or his country by, say, not violating curfew. The deftly rendered expression of Bergey's shore patrolman puts all into perspective: it may be against the rules, but it ain't completely wrong either.

As cover subjects became more elaborate through the thirties, detective

and horror pulps became grimmer and bloodier to behold, depicting ever more gruesome forms of torture and murder for the reader's delectation. We of the present generation fear that we invented bad taste; so it's somewhat reassuring to discover that the mythic innocence of America's past was also beset by vulgarity. In fact, it's hard to imagine a modern analogue to the cover of the November 1940 *Strange Detective Mysteries* ("mystery" having become a euphemism for grotesquerie). The poor woman in yellow is about to have her panhandling prospects enhanced by intentional maiming as prior victims look on in horror.

A nasty little picture, this last, and it helps explain why, with few exceptions, the creative vitality was sputtering out of the pulps. When the business requires constantly raising the customer's eyebrow with new thrills, it stands to reason that extremes of expression will be tested. Though no one can objectively say how far is too far, the pulps raced for the other side until, it seems, the frontiers of pulpness had been reached and eclipsed. Then the pulp era collapsed, exhausted. One looks at representative covers of the 1940s and marvels at how deflated of life the art had become. The pulps had turned into a bland and forgettable product compared to the wonders that were commonplace only several years before.

John Locke is a computer programmer for the U.S. Navy. He is a student of popular culture and has been a fan of pulp magazines and cover art for more than twenty-five years. His general collection of pulp magazines is particularly strong in the area of 1930s pulps.

H. J. Ward: "The Whisperers," *Spicy Mystery,* April 1942

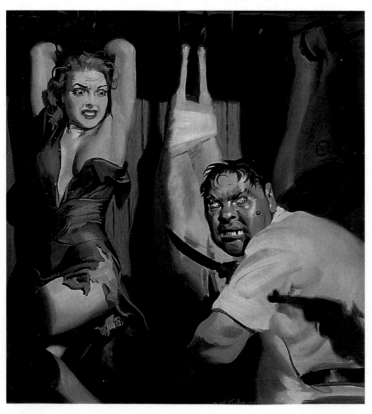

New York, their masthead listed a Delaware address, to cause confusion and prevent harassment. Harry and Frank became invisible men. During the worst years of the Great Depression they made a lot of money.

Why the astonishing popularity of these pulps? The answer is simple. From Hollywood to Manhattan and all points in between, the censor's scissors were cutting. Myrna Loy and William Powell—Nora and Nick Charles of the Thin Man movies—were a married couple, but in their bedroom the twin beds had to be exactly three feet apart and their bodies fully clothed in pajamas; if they kissed, it had to be with closed mouth, and it could not last for more than thirty seconds. It was not until 1939 that Clark Gable could speak that naughty word: "Frankly, Scarlett, I don't give a damn." No four-letter words were spoken in the movies, or on the radio, or put into print. The

Norman Saunders: *Ace Detective*, 1938 (Syracuse University Art Collection)

only "legitimate" pictures of nude female bodies were found in "health"-oriented nudist magazines.

Sexual censorship for the pulp covers could be defined in two words: no nipples. The cover could show a woman being tortured or mutilated, but revealing a breast *in toto* was crossing the line. But while this was the case outside, the interior illustrations of the Spicys in black and white actually showed nipples. Sure it was worth twenty-five cents!

The Culture stories included special paragraphs called "hot parts" to turn up male heat, but they always stopped at the edge of the cliff ("He helped the lady out of the water and was somewhat surprised to notice that she had lost her skirt; now only a tantalizing wisp of silk covered those well-curved hips and the silk blouse was plastered by the water to firm mounds of flesh").

But all of this was about to end quickly. One day in April 1942 Mayor La Guardia spied an unusual *Spicy Mystery* on the newsstand and exploded in instant rage. He ruled on the spot: "No more damn Spicy pulps in this city!" H. J. Ward was the cover artist and it was one of his most daring: sexual tension, violence in action, a beautiful woman, all painted with aggressive brushstrokes to create a cover that couldn't fail to catch the eye. This scene in a refrigerated meat locker, of a nearly naked woman hanging from a meat hook and screaming in terror as a crazed butcher menaces her with a huge knife,

Rafael de Soto: "Blood on My Doorstep," *New Detective Magazine,* July 1949

was too much for La Guardia and others who shared his moral stance. It was a bitter fight to the very end. As the cover art became more and more explicit, these pulps' foes turned up the volume of their screeching protests. They won and the Spicys stopped. The publisher, Harry Donenfeld, switched to money-making comic books, became the head man at DC Comics, and was eventually responsible for much of the success of Superman and Batman.

Nothing before or after ever approached the Spicy covers. This was a unique and very different genre of American painting: romantic fantasies extracted from deep inside men's minds. They are in violent motion because they had to depict stories in violent motion. The entire corpus of this work was a few hundred paintings created by just two men. H. J. Ward's style was pure speed. His brushstrokes were wide, paint pushed to the end in an aggressive use of the brush. His technique of fast painting was perfect for illustrating the stories of fast-action violence.

H. L. Parkhurst's style was more at ease. His people looked posed, as if they knew they had an audience, and this slowed the action. Thin strokes outlined his figures and the backgrounds were more detailed than Ward's. It was a finished photograph. Sex was more suggested than explicit, and the scenes were often set in the country rather than in the city. They were magnificent and complete. While little is known of H. J. Ward's background, Parkhurst studied

at the Art Institute of Chicago, specializing in the depiction of anatomy. His first job was as a newspaper illustrator, then a magazine illustrator. But the Depression came and his refuge was the pulps. Many of his Spicys were done for the Trojan Magazine Company. But he was versatile and painted science fiction, detective, and other categories.

Only a few of these two artists' paintings remain, but one must see the originals to appreciate the true quality of their work. Here the inventive use of color; of dark and light for background and foreground placement; of highlights painted on guns and knives to accentuate danger; of women in peril and fear—are clear, visible, and large enough to be seen. All of this quality and value was lost in their reduction in size to magazine dimensions, and the cheap printing process not only faded the artist's original colors but completely eliminated some to cut the cost of the printing. Worse, whole sections important to the picture's appeal and understanding were covered over by the magazine's extensive cover lettering and type.

Another telling example of this genre is Ward's cover for *Spicy Detective* for August 1936: it is a gunfight to a sexual finish. The struggling detective is trying to disarm a gorgeous redhead; one hand pulls her hair and the other is reaching for her .38. Fighting back, she's trying to shoot him with one hand, while tearing at his lower lip with the other. Her clothes are torn enough to show an almost bare breast and all the leg that 1936 would allow. It is a motion picture of the middle of the story: the visible painting in the center of a Crocian triptych. The invisible painting on the left must be her being surprised by her attacker. These two dictate the third: the invisible painting on

H. J. Ward: "Two Hands to Choke," *Spicy Detective Stories*, August 1936

the right is the one the twenty-five-cent customer then may have really wanted to see; but the sexual victory of the male attacker could never have been printed or even painted. Each stroke in the painting works toward the center as if it were a map drawn by the artist to lead your mind and eye. Suddenly, it is obvious that one word defines this painting, the same word that links all of Spicy art: *no*. Each cover is a picture of female resistance; man, the hunter, is aroused by the chase.

Ladies in terror had other enemies. During the 1930s the "yellow peril" concept had rented space inside the American mind. Asian immigration was close to zero, and the group's population and power were small—except in the imaginations of the pulp artists and writers. They had, as did apparently their paying customers, a need for bad guys who looked different, for devious and deceitful white slavers who wanted American women, particularly blonde-haired, blue-eyed pretty young things.

Into this prepaid and ready-to-buy racist market slinked in one Wu Fang. He was your ordinary 1935 Asian villain who only wanted to conquer the world and torture white women. He was a pioneer in

The Art That Dared to Be Wild

JAMES VAN HISE

What is it about pulp art that makes it stand out as unique, different from the kind of cover art featured on the books and magazines of today? Only its outrageousness. It dared to be wild, and too much was never enough.

A look at the covers of any number of different pulp titles will show that there is often a common link: an emphasis on the wild and the weird. Different artists brought their own temperaments to the art, but what they had in common was a desire to dazzle and catch the eye of a potential customer as he perused the newsstand.

All of these artists are gone now, but their art lives on as the legacy of an era. Almost no one tries to use the hard-sell covers that pulp magazines did because it would be considered too outrageous for what has become a more circumspect clientele. Covers today tend to be more subtle, even on the science fiction books. The tides of cultural trends have moved away from the damsel in distress to such a degree that to do anything in that realm would evoke harsh criticism. While this thematic approach was not as prevalent in the more sedate Street & Smith titles such as *The Shadow* and *Doc Savage,* it was more than made up for by Popular Publications on *The Spider* and *The Mysterious Wu Fang.* Those titles featured women not only in peril but as objects of impending torture and threatened violence as well. But then, that was only because the covers were a true representation of what the magazines contained.

Today the pulps are judged more by their lingering cover art than by their content, since so much of what was published there remains out of print. While all of the Doc Savage stories have been reprinted, only a small fraction of the 325 adventures of The Shadow have been reprinted and only about 25 of the *Spider* magazine stories have been reprised—haphazardly— over the past quarter-century. What clings in our memories the most are the covers.

Margaret Brundage, the queen of *Weird Tales* magazine, was less appreciated by the fans of the magazine in the 1930s than she is today. Only a few of her original covers have survived, but they reveal a startling vividness of color and technique that the published versions could only hint at. Her covers of damsels in distress put her exotic females in situations as evocative as they were weird, and as delightful as they were strange. Very few directly represented a story in the magazine so much as they represented the oeuvre that the unique magazine was creating month to month and year by year. Today her work is as much a part of the history of *Weird Tales* as are the authors—Robert E. Howard, H. P. Lovecraft, Clark Ashton Smith, and others—whose names are forever linked to that venerable title. She remains an

unusual figure in the history of pulp-magazine art, and not just because she was the only woman to contribute a spate of covers to the form.

Two of the pulps' most popular cover artists were often confused with one another. Twin brothers George and Jerome Rozen had similar art styles and contributed dynamic covers to competing publishers. George Rozen painted the colorful and weirdly atmospheric covers for many issues of *The Shadow*; a book could be produced just reprinting his magnificent covers alone.

But while George Rozen's covers were dynamic, they were restrained when it came to employing the more outrageous touches that other publishers preferred. This is where Jerome came in. Just as beautiful, but infinitely more threatening, are his covers for Popular Publications' *The Mysterious Wu Fang*. The cover for the first issue of *Wu Fang* shows the "yellow peril" villain of the title lurking in the background while in the foreground poisonous reptiles leap from a coffin, including a snake that attaches itself to a man's neck. Other covers of *Wu Fang*, and its mate *Dr. Yen Sin*, featured beautifully rendered depictions of torture and violence, delivering the kind of images that other forms of entertainment of the time (such as movies) were decades away from embracing.

Rafael de Soto gave violent life to The Spider on many covers that truly reflected exactly the kind of mayhem the magazine delivered each and every issue. The Spider, guns blazing, clashed with a parade of weird and wonderful villains whose methods of extortion and death were endlessly inventive and seldom repeated themselves. The very violent Spider stories of the 1930s and 1940s hold up in terms of readability far better than those of virtually any of the character's pulp contemporaries.

Norman Saunders's pulp covers delivered a chorus line of scantily-clad ladies who appealed to the fans of that era but would offend the tender sensibilities of many of today's more watchful readers. One of his weirdest and most inventive images was on the cover of the January 1935 issue of *All Detective Magazine*. It features an orange and gold hawklike man poised to stab a shackled woman who is being offered up for sacrifice—very over the top and very much of the 1930s. When the pulps died Saunders went on to do book and magazine covers, as well as paint what has become the single most popular series of bubblegum cards in history—the 1962 Mars Attacks cards. They featured, in all their violent glory, the impact and no-holds-barred take on their subject that the pulps employed years before.

But not all pulp artists exploited their subjects in the same way. Walter Baumhofer was the main cover artist for *Doc Savage*, and like *The Shadow*, the covers were more restrained. Baumhofer's work captured the sense of adventure of the *Doc Savage* series and his covers were more akin to the high-adventure school of *Argosy* and *Blue Book* rather than the violent richness of the Popular Publications crowd. Interestingly, Baumhofer painted the cover of the very first issue of *The Spider*, and while it is eerie and evocative, the subsequent cover artists usually preferred images that were even more wild and weird.

Speaking of weird, the science fiction pulps certainly didn't take a back

seat in this era, and the most admired of the sci-fi cover artists was Frank R. Paul. Paul's work exhibited a true sense of wonder, and even today his *Amazing Stories* covers from the 1920s still evoke the fantastic and provide a window on the way the future was. While other artists would render aircraft on other worlds as looking suspiciously like terrestrial airplanes (see the *Blue Book* covers for Edgar Rice Burroughs's "A Fighting Man of Mars"), Frank R. Paul pulled out all the stops and created never-before-seen aircraft designs that were as strange as real alien designs could actually be. Paul's gifted imagination seemed to spill out over the edges of the covers, as his paintings were crowded with details in the intense drive to cram as many ideas into one scene as possible. Paul's imagery remains unique to this day.

The pulps may be long gone as a viable form of expression, but they live on in their artistry, which intensely reflected the era in which they thrived, and whose richness and genuine artistic diversity deserves to be celebrated and preserved.

James Van Hise is a dedicated collector of pulp magazines, with a unique knowledge and appreciation of the cover art. He has written on the comics since the 1970s and today writes books and magazine articles on movies, the pulps, television, and comic books. He is the author of the recently published book Pulp Masters.

Tom Lovell: "Dragons of Chang Ch'ien," *Dime Detective Magazine,* April 1934

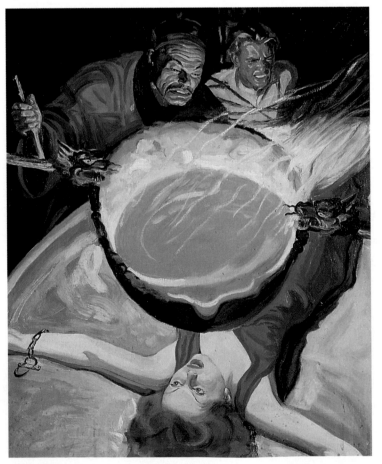

genetic engineering and had a breeding laboratory where he developed obedient helpmates:

"These are my little agents of most powerful death," explained Wu Fang.

Lizards just four inches long, their entire body covered with thick scales each ending in a barbed point. Sharp saber teeth filled the upper and lower jaws. The two longest teeth were hollow inside like the ugly fangs of a poisonous snake.

Green snakes capable of leaping through the air, to quickly fasten its poison-filled fangs into someone's neck in a death bite.

White bats with five deadly teeth, three along the upper jaw, two on the lower that were pointed back. When bitten the victim's skin would turn purple.

A chameleon, just four inches long, slimmer than a lead pencil. The head was that of a miniature adder. In its jaws were two needle-like fangs filled with a deadly poison that could kill quickly....

"You will strike now!" Something slithered without making a sound. It was a little larger than a mouse. It was running swiftly on small legs, yet wriggling like a snake to disappear inside the man's trouser leg. A scream came from his lips. He fell over. Then the tiny little beast scurried back behind the curtain.... They were tiny enough to poke their heads up into a man's nostril and inflict a deadly poison that would instantly paralyze the nervous system.... Death within seconds.

All of these small nightmares were painted in sharp detail with the aid of a magnifying glass by the talented Jerome Rozen. According to his daughter, inspiration turned into obsession and he would get out of bed in the middle of the night to ugly the reptiles and sharpen teeth and claws. Unfortunately all of this fine-line painting was lost to sight in its reduction in size for the magazine's format. Only seven issues, published in 1935–36, of *The Mysterious Wu Fang* were written by Robert J. Hogan. Large, superb cover paintings demonstrating the time-consuming, meticulous technique of fine-line painting resulted in an almost photographic realism and portraits that captured Rozen's delight in the depiction of pure evil.

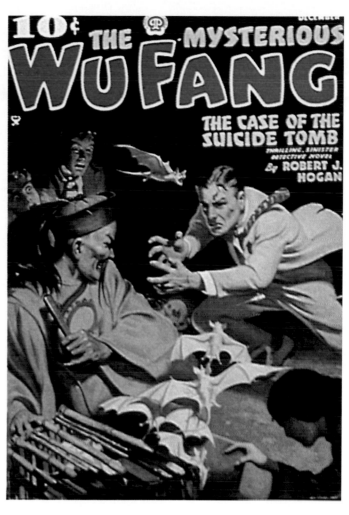

The Mysterious Wu Fang, December 1935 (cover art by Jerome Rozen)

Perhaps the magazine failed for the same reason that the paintings disappeared. These covers are prime examples of Offensive Art. The problem with Offensive Art is that the more you look at it, stroke by stroke, the more offensive it becomes. At a certain point it becomes so painful you must look away. Certainly no 1930s middle-class family would have had a Wu Fang pulp painting hanging in their home. This element of offensiveness exists in varying degrees in much of pulp art—hence, its almost complete destruction.

But by sheer luck one Wu Fang painting by Jerome Rozen has survived, and it is safely preserved in a private collection. It illustrates "The Case of the Hidden Scourge," for the final issue, March 1936. In the center is a beautiful, terrified blonde in bondage. A hangman's noose around her neck suspends her on a torture machine. The right shoulder of her dress has been pulled down, and Wu Fang has given the order: "You will strike her now!" as those deadly little creatures at her feet begin their journey up and under her dress. But all of this is background. It is in the foreground that the artist demands our attention and with his skill commands our eye to appreciate his handsome portrait in full figure of the Asian villain. The wide folds of Wu Fang's yellow mandarin robe appear sculpted by a strong wind, enabling him to move swiftly to the attack. Those long, sharp-nailed fingers suggest aesthetic delicacy and the fan in his hand accentuates the gracefulness of feminine hands. But the face, with its high cheekbones, gaunt and hollow below, the lengthened chin and sharply pointed nose, the twin black strings of his downward-pointing mustache, and especially his sinister eyes—all of these combine to make this a marvelous portrait of extravagant evil. In addition, on the original painting

Remembering Norman Saunders

ZINA SAUNDERS

Growing up the daughter of Norman Saunders has given me a close-up perspective on pulp art. Add to that the fact that I am an illustrator in today's commercial art market, and I guess you could say that pulp art played a very important role in my life.

By the time I was born, pulp magazines had pretty much drawn their last breath, and my father was searching for new markets. Dad always figured that television had killed the pulps, providing the leisure time entertainment that pulps once had, but at no cost and no effort.

I remember poring over my dad's pulp cover paintings, which he had stashed in the basement of our Manhattan brownstone, imagining the fabulous stories they told. What secret was the beautiful girl about to tell on the phone, before the hulking shadow entered the picture? Why did the sophisticated, evening-gowned woman look so smug over the wisps of smoke coming from the barrel of her stylish revolver? Why was the debutante in the long white dress about to be thrown from the roof?

I spent countless hours in my childhood making up stories in my head to go with the paintings, staring at the colors and brushstrokes, trying to create my own pulp covers. My father had told me that he painted the covers having never read the stories they were illustrating; instead he came up with ingenious, arresting scenarios to lure the reader into buying the ten- or fifteen-cent magazine. Many years later I found myself doing precisely the same thing, painting covers for video boxes having never seen the movies.

The goal in pulp illustration, to paint a picture that was eye-catching with a dynamic composition and dramatic color scheme, was not so very different from the goal of modern-day illustration. Pulp illustration was simply more fun.

Zina Saunders is the daughter of the great pulp artist Norman Saunders, and has followed in her father's footsteps to become an illustrator.

(and faintly visible on the smaller magazine cover) is a thin coat of varnish on the face, giving it a reflected glare and causing it to stand out from the rest of the painting.

Wu Fang was merely one among many Asian villains in the pulps. His brother in evil, Dr. Yen Sin, also had his own magazine, and that notorious Master of Death, Doctor Chu Lung, was bent on the destruction of G-8 and His Battle Aces (in the pulp of that name). Operator #5 went gun to gun with Moto Taronago, the Yellow Vulture, who vowed that he would hand over all of

America to the Mikado of Japan way back in 1932. The Shadow was nearly murdered by Shiwan Khan, the Golden Master, who was determined to conquer the world.

In the realm of the pulp cover girl, of the erotic female in terror, one other artist was superior. Starting in 1933 a woman in Chicago began to produce pulp cover art so successful that issue after issue sold out. She used pastel chalks that smudged on touching in an age before fixatives in spray cans, art created on cheap paper so thin one finger could tear it; the artist said: "I had a little boxlike affair for them with cardboard backing to take them to his office.... The rate of pay was always ninety dollars a cover." Today a Margaret Brundage *Weird Tales* original commands a price ranging between forty and seventy thousand dollars. Brundage produced sixty-six covers for *Weird Tales*, including an amazing run of thirty-nine consecutive issues from June 1933 through October 1936. About thirteen of the originals remain in private collections.

Weird Tales began publication in March 1923. The publisher was Jacob Henneberger, whose aim was to bring to the market stories so unusual and daring that no other magazine would publish them. He did. Some were almost fine literature. Tennessee Williams at seventeen was published here. Reprints of *Weird Tales* are alive and at the bookstores now, with stories that are still exciting, darkly imaginative—and great reads.

Sometimes a relationship between artist and editor becomes an amazing merger of different talents, and the result is that the sum is greater than the addition of their separate strengths. The Margaret Brundage–Farnsworth

(Left) Margaret Brundage: *Weird Tales*, December 1935 (Book Sail Collection/John McLaughlin)

(Right) Margaret Brundage: *Weird Tales*, January 1936 (Book Sail Collection/John McLaughlin)

Wright relationship was one such merger. Together they saved *Weird Tales* from certain bankruptcy in the 1930s. Wright inspired and directed Brundage's work, knowing that an eye-catching cover would sell more magazines than anything he could print inside. He didn't care if the cover had a zero relationship to the story as long as the art made the buyer stop and look. As Brundage explained in an interview:

> "I would submit about three different pencil sketches. And he would make the selection of the one I was to do in color. Once in a while I would suggest a little color in my sketches but most of the time...well, they were rough. And yes, he chose the scene.
>
> "We had one issue that sold out! It was the story of a very vicious female getting ahold of the heroine, tying her up and beating her. Well, the public apparently thought it was flagellation. It sold out!"

The results were unsurpassed in style, a new look for ladies in terror. They were slim, sleek, and practically naked. Ancient Greek sculpture sought to portray the male body in perfection; Brundage nudes are the female form striving for the same. This was feminine art. She couldn't or wouldn't paint bug-eyed monsters and didn't care to paint men convincingly. The bodies of beautiful women were her passion in art, and she was not a prude. Margaret Brundage captured the mystery of female beauty that cannot be caught in word or song but only put down in paint. Certainly, her original art deserves to command some of the highest prices of any pulp paintings.

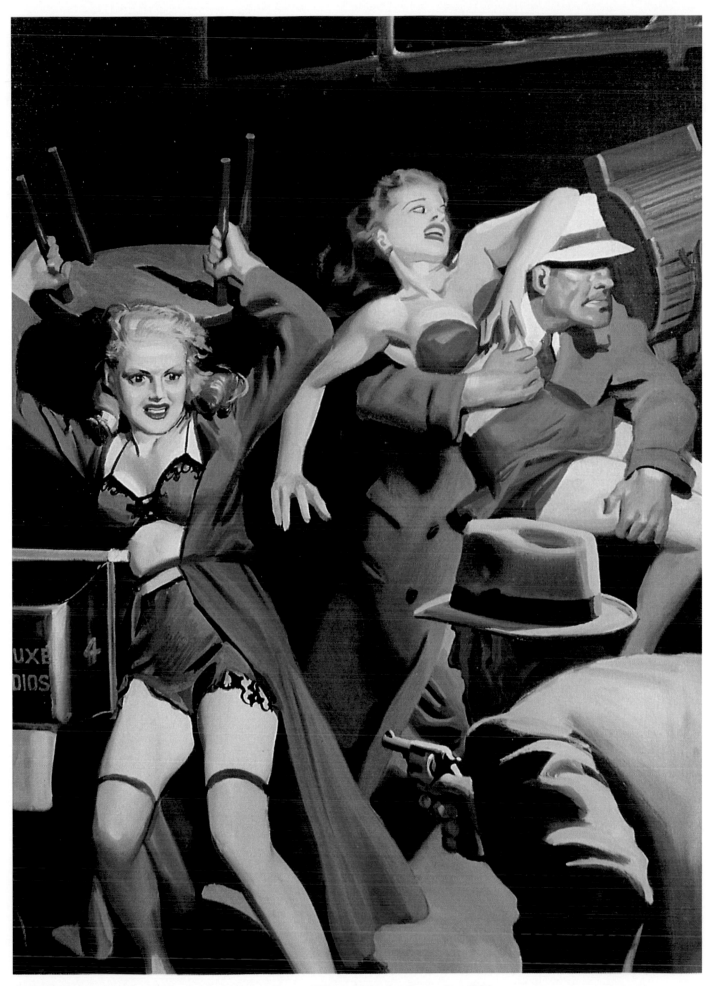

H. J. Ward: "Drunk, Disorderly, and Dead!" *Dan Turner, Hollywood Detective*, September 1934

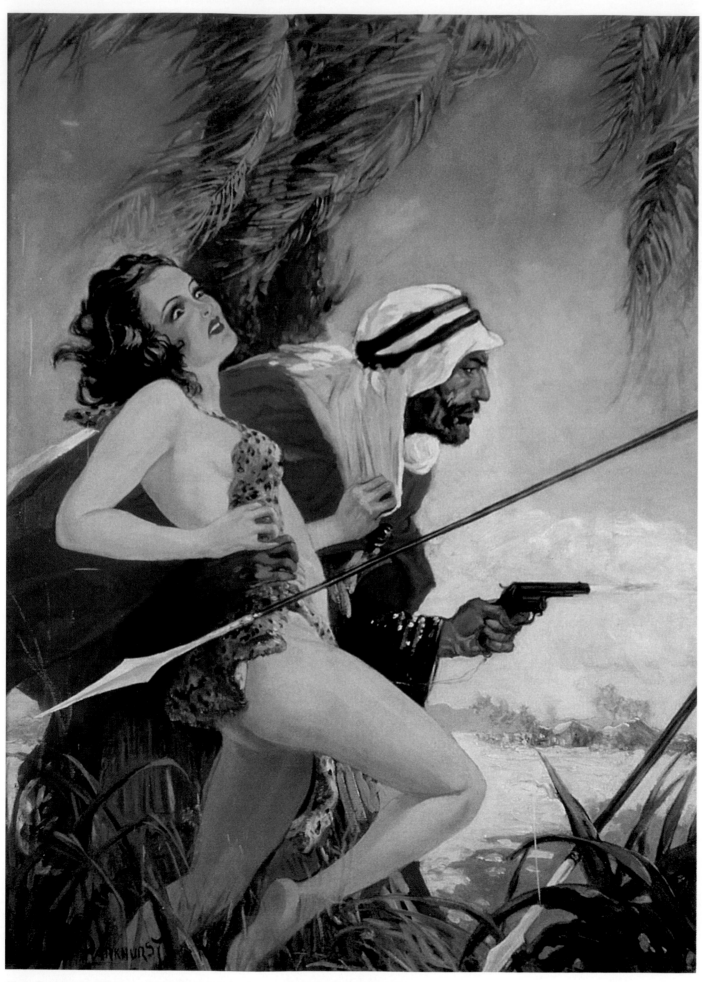

H. L. Parkhurst: "Women of the Shaik," *Spicy Adventure Stories*, December 1934

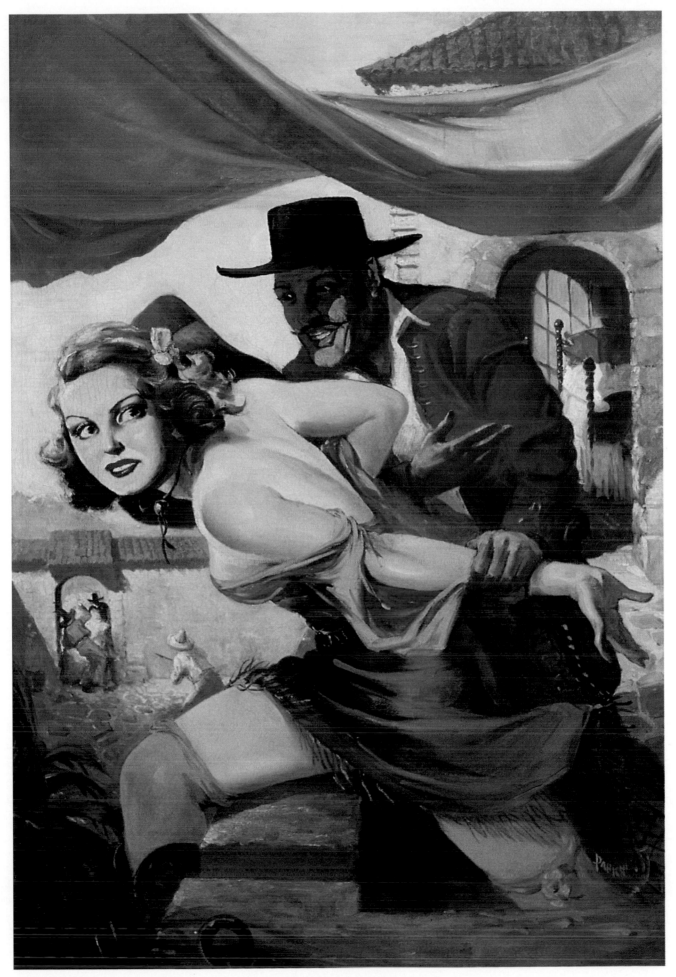

H. L. Parkhurst: "Dear Little Dude," *Spicy Western Stories*, December 1939

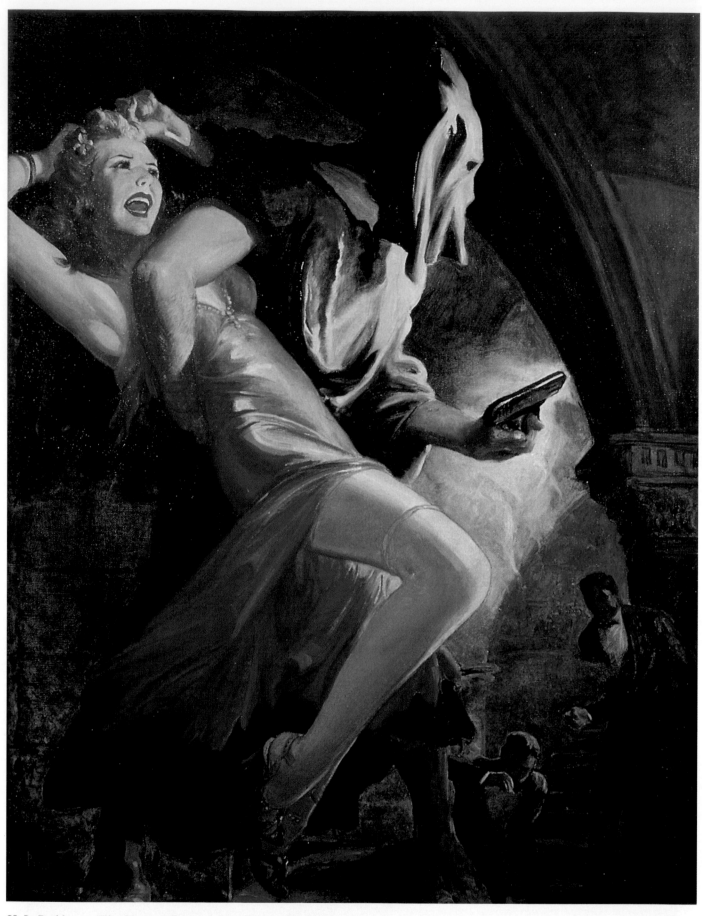

H. L. Parkhurst: "The Monster Fringe," *Spicy Mystery*, May 1941

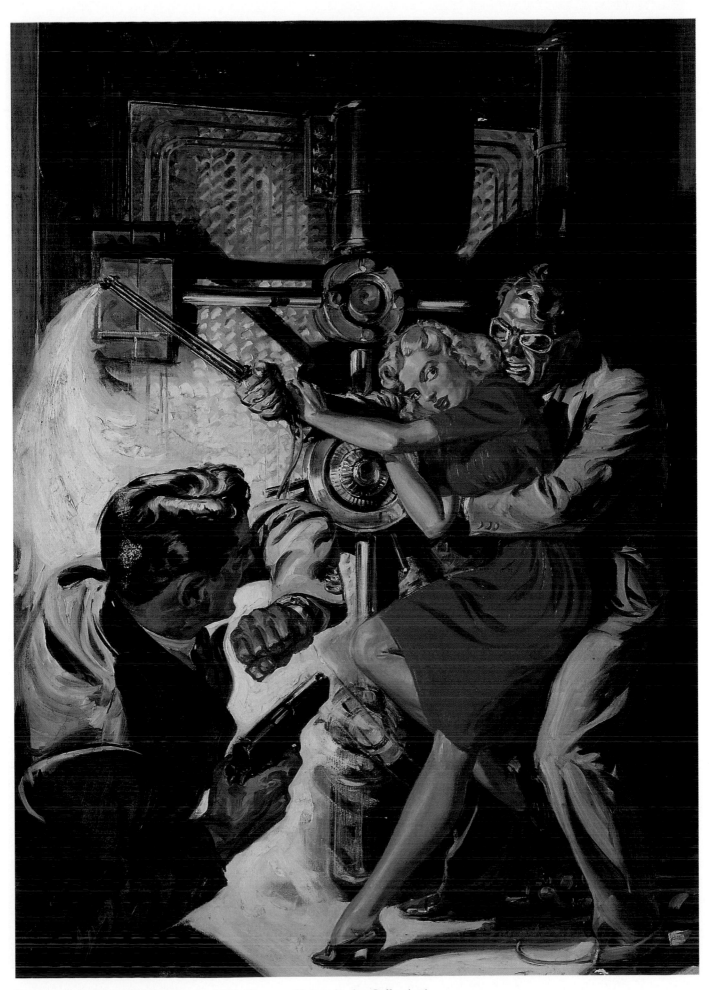

Norman Saunders: *Ten Story Detective*, 1938 (Syracuse University Art Collection)

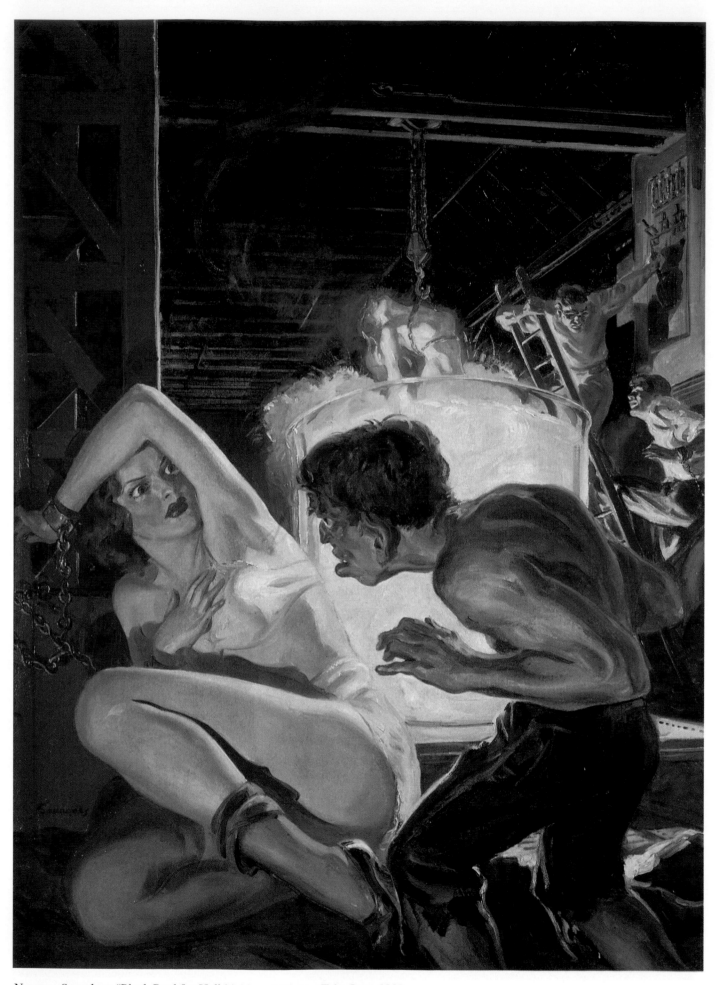

Norman Saunders: "Black Pool for Hell Maidens," *Mystery Tales*, June 1938

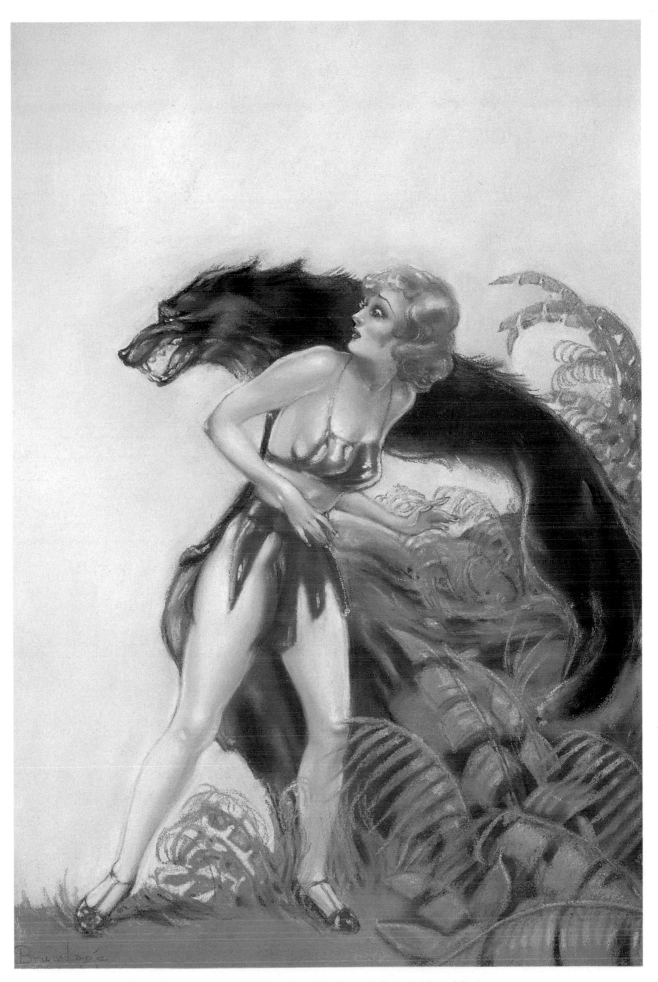

Margaret Brundage: *Weird Tales*, October 1935 (Book Sail Collection/John McLaughlin)

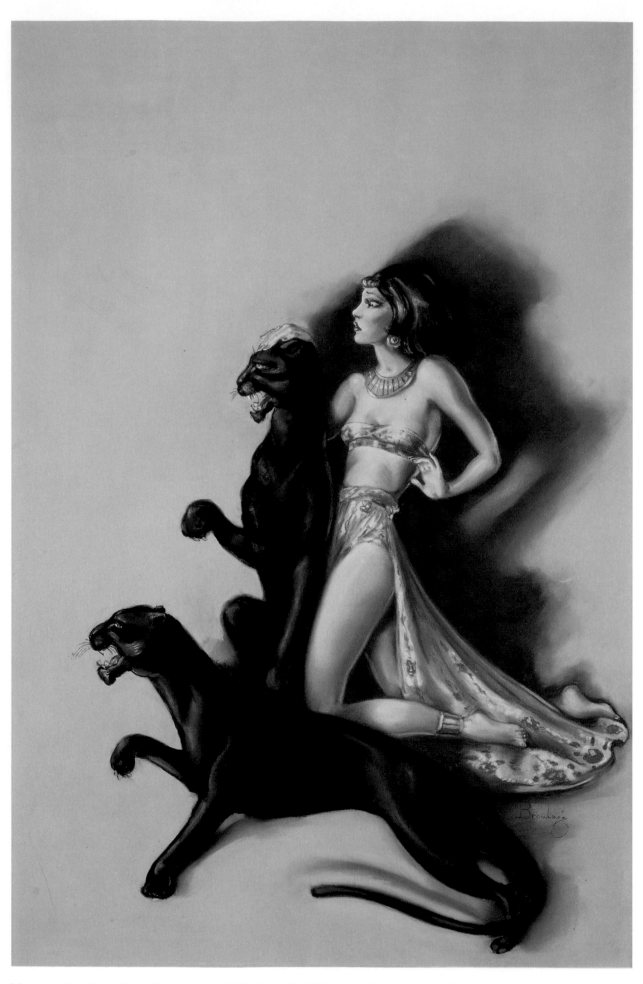

Margaret Brundage: *Weird Tales,* January 1935 (Book Sail Collection/John McLaughlin)

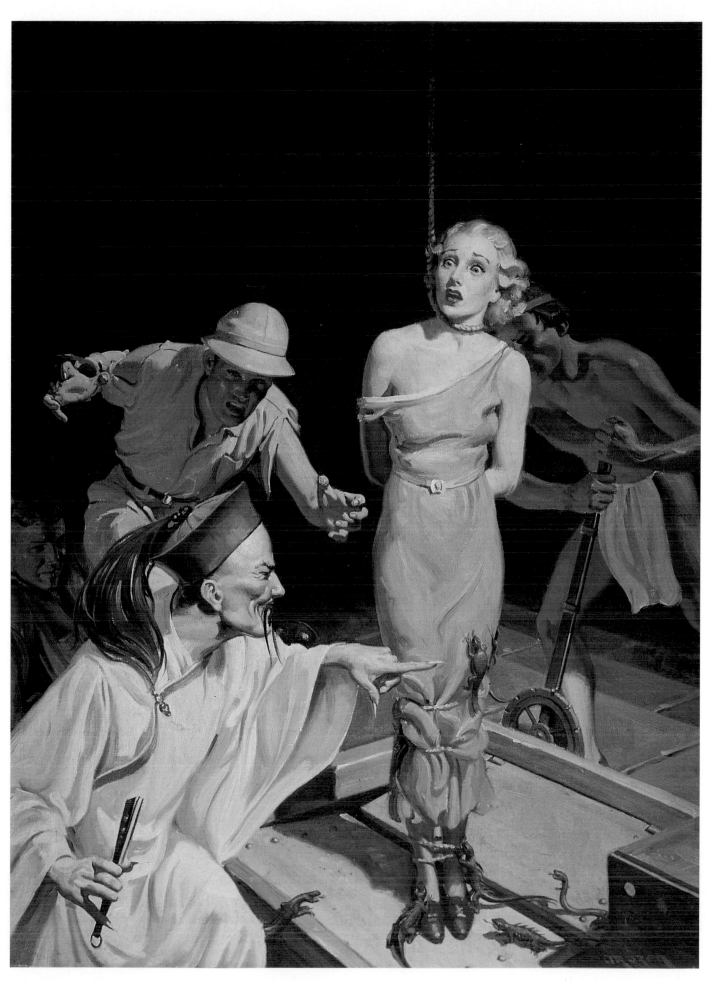

Jerome Rozen: *The Mysterious Wu Fang,* March 1936 (Steranko Collection)

John Drew: *Best Detective Magazine,* February 1932

John Newton Howitt: "River of Pain," *Terror Tales,* November 1934

TO DARE THE DEVIL: AVIATION, WAR, AND WESTERN ART

In life, as in art and literature, there is a difference between hero and daredevil. The hero measures the odds, and if the spread is too wide says no. The daredevil measures the same odds, and if the spread is too wide embraces the added risk, ignores the danger, and springs into action.

Daredevils all:

General George Patton, his forces surrounded by the Nazis, gave a one-word answer to the enemy's demand to surrender or be destroyed: "Nuts!"

Charles Lindbergh, drinking black coffee to keep his eyelids open, fought sleep and defied death during his solo airplane flight over the Atlantic Ocean.

Wyatt Earp and Doc Holliday, outnumbered and outgunned, emerged victorious at the shoot-out at the O.K. Corral.

Admiral Richard Byrd dug a one-man hut in the Antarctic ice and put himself inside to test his powers of survival. He stayed weeks; then his 1927 radio failed and poisonous carbon monoxide from his fast-fading heater filled his lungs. Balanced on the very edge of his life, he willed himself to stay alive. Rescue came, beating his death by hours.

Captain Ahab, in his mad search for the Great White Whale, hailed a passing ship, shouting: "Who are you?" The reply: "Call me a full ship and homeward bound, and you?" Ahab answered: "Call me an empty ship and outward bound."

In nature, the small female hyena stands her ground as the professional hyena killer, a four-hundred-pound male lion, runs toward her, intending to break her neck in the leap. She doesn't flee but

Walter Baumhofer: "Strong as Gorillas," *Adventure,* April 1940

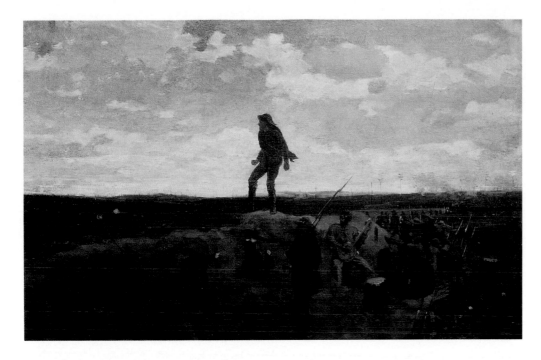

Winslow Homer: *Defiance: Inviting a Shot Before Petersburg,* 1864 (Detroit Institute of Arts, Gift of Dexter M. Ferry Jr.)

waits for death. She dares this devil, hoping to get in underneath and with her sharp teeth manage one bloody bite.

In pulp art and stories, the action must involve daring a devil ten times one's strength—face to face, fist to fist, toe to toe. These daredevils were created from a simple three-part chemical formula: One large dose of adrenaline, a larger dose of testosterone, and the secret ingredient—two teaspoonsful of "being just a little bit crazy." The 1930s pulp buyer really wanted much more than imagining himself rescuing a damsel in distress or helping The Shadow solve a crime and catch a crook. Inside his ten-cent fantasy of danger and adventure he wanted to be a daredevil, to be "just a little bit crazy."

One American painting depicts this secret ingredient in perfection: *Defiance, Inviting a Shot Before Petersburg* by Winslow Homer. It was inspired by a ten-month siege of Petersburg from June 1864 to April 1865; and for the Confederates during that time, boredom had become unbearable. This superb painting, without a single word, portrays the essence of the daredevil better than a thick book. He faces the enemy without fear or a gun in hand, screaming in rage at the unseen enemy, and with only his fists clenched in defiance. In contrast, the other soldiers sit safely below the ramparts, afraid, with rifles clutched tightly and at the ready. The sky is painted neutral and without war, while the land has been ravaged and made barren by inhuman conflict.

The strength of the work shows the artist's emotional involvement. His mother gave an account of his time at the front: "He suffered much, was without food three days at a time, and all in camp either died or were carried away by typhoid fever; plug-tobacco and coffee were the staples.... He came home so changed his best friends did not know him."

Homer's Confederate daredevil didn't die or disappear but remained submerged in the mythic consciousness of the American male, only to be born again in bright colors on the covers of the air-war pulps portraying his descendants fighting and dying in the skies of World War I.

It was a sudden explosion covering the newsstands coast to coast with a blanket of *Dare-Devil Aces, Wings, Battle Birds, G-8 and His Battle Aces,* and *War Birds.*

Over sixty air-war pulps were eventually brought to market. Artists who never saw combat were painting combat, who never saw a Spad or Fokker were painting them accurately. Fiction House publishers in 1930 boasted of sales of 2 million magazines a month. From the late 1920s through the Second World War men stood in line to buy. The cover art was a claw that caught the eye and held on tight: biplanes whirling, rolling, diving down on each other, machine-gun bullets tearing into fabric and flesh. Letters poured in requesting a Belarski, Blakeslee, Tinsley, or Rozen cover painting. Newsstands became art galleries with an audience of millions paying ten cents' admission. And the wrath of the reader descended in fury on a single mistake. Many were pilots who flew in the war, and if a squadron marking, a guy wire, the placement of a machine gun—if one detail was wrong, letters of protest came special delivery or in person with a knuckled knock on the door.

The stories were a good read, written in tough-guy prose, with action as fast as a fighter in pursuit. From *Battle Birds,* July 1933:

The German pilot did not see him coming. Aleck opened up too soon. His Vickers slammed out a wicked burst but missed the target by a foot. Damn! Like an angry hornet Aleck clung to his foe, matching every twist and turn and zoom with a better one. Closer and closer he drew to the German's black crossed tail. The spirit of individual combat seethed in his veins; the thrill of a duel to the death! As the Fokker flipped out of a spiral and tried to zoom, Aleck's guns belched a steady stream of fire and steel; his sights were square on the cockpit. The German plane hung there, inert, while his bullets ripped it mercilessly. Then slowly it pitched forward; as its nose dropped past the horizon the first puff of smoke appeared. His mind had just time to grasp the thought of victory when disaster sprang upon him. From behind it came without warning! While he gave one Boche the death blow another had swooped on his tail! Tuck-tuck-tuck-tuck-tuck! Bullets were crashing through his cockpit. He saw the lower edge of his instrument board shred itself to fragments; at the same time a dozen red hot pokers stabbed his leg. The controls were going limp in his hands.... The horizon was reeling before his eyes; already his leg was throbbing in intolerable agony. He was going down!

Bill Barnes, Air Adventurer newsstand advertising card, mid-1930s (© The Condé Nast Publications, Inc.)

During the Great War there was an immediate need for artists who could paint air combat because the cameras of the day could not. Newspapers and magazines—and their readers—demanded pictures of air battles. At this point a lie was born in paint. Ugly, primitive planes were painted sleek and beautiful; pilots, handsome and heroic—twisting and twirling in blue skies, waving a hand in victory or saluting a gallant enemy shot down in flames. The brutal fact of horrid death was painted over with the fictional colors of deceptive propaganda and patriotism. Worse, it was believed, and thousands died.

Frederick Blakeslee: "Red Wings for Vengeance!" *Dare-Devil Aces*, June 1938, and *Fighting Aces*, May 1941

The formation of the Lafayette Escadrille prior to the U. S. entry into the war was a result. It was a squadron of young American volunteers who called the war "Our great adventure!" and "My path to glory!" All shared the urge to learn to fly and fight.

Manfred von Richthofen, the "Red Baron," excited the public's imagination then and now. He was the Great War's top German ace and has since been pictured worldwide in his red Fokker triplane, an icon still alive in aviation art. He was shot down in flames April 21, 1918, trying for his eighty-first kill. The British honored him with a full military funeral as if he was one of their own.

William Wellman directed the Academy Award–winning motion picture *Wings,* which had the most authentic air-combat scenes of World War I ever filmed. Wellman, who was to become one of Hollywood's greatest directors, was shot down in 1918 by German anti-aircraft fire over enemy lines. His back and head were severely injured; he wore a metal plate for the rest of his life and never had one minute without pain.

Artists, bought and paid for, set up their easels at the airfield edge and

The Cover Art of the Air-War Pulps

GEORGE HOCUTT

Between 1926 and the Second World War over sixty pulp-magazine titles with an aviation theme were published, spurred by Lindbergh's solo flight across the Atlantic. Of course, not all were available simultaneously; but at least fifteen titles were displayed on the magazine stands at any given time. That was a lot of competition for impulse sales. Each publisher fought to get their titles sold off the racks ahead of the competition. An important weapon to achieve this was dramatic and eye-catching cover paintings reproduced in brilliant color. Simply put, the magazine had to sell itself.

The illustrators who worked in the aviation genre had a particular problem with which to cope. A vast knowledge and understanding of the airplanes of the times was a prime requirement. The readers who bought these titles were, in most cases, extremely sharp-eyed and critical. It is no wonder that the longest running, most successful magazines had the most knowledgeable and talented draftsmen/illustrators painting their aviation covers.

Although many of the great cover illustrators (Baumhofer, Anderson, George and Jerome Rozen, etc.) occasionally painted in the aviation/air-war genre, three artists stand out and did most of their work in this specialized field. Each had his own strengths and weaknesses, but all three were extremely talented.

Considered by many the best at air-war scenes was Frederick Blakeslee. Blakeslee had a long career, primarily at Popular Publications with the titles *Dare-Devil Aces, Battle Aces, Battle Birds, Fighting Aces,* and *G-8 and His Battle Aces.* His greatest strength was in his knowledge of a broad range of aircraft—World War I, between the wars, and World War II. His aircraft renderings were a delight to critical readers.

He preferred perspectives that included the land below and the frantic activities taking place there under the equally frantic fighting planes. He had a great love for trains, and an inordinate number of his covers included railroads and engines beneath the air-fighting. In fact, later, after Popular Publications acquired *Railroad Stories* magazine, he painted scores of covers featuring train engines and rolling stock.

He also handled the semi–science fiction covers on *G-8* with the necessary fantastic machines and grotesque monsters fighting the correctly drawn Spads and Camels and other allied fighters of the First World War. In other titles he often painted the covers and also drew all of the interior story-head illustrations.

He was a master at freezing in oil a moment in time. Yet his planes were always in motion. The covers were crowded and busy, and it was obvious that in one more second there would occur a major collision. He would usually have more than one type of aircraft in his paintings.

Artistically close behind Blakeslee was Frank Tinsley. His aircraft drawings were also very accurate. Many of his superbly rendered covers depicted a single aircraft outlined against the sky or two opposing aircraft in a realistic dogfight.

Early on he worked for Magazine Publishers, Inc., on *Sky Birds* and *Flying Aces,* but he is best remembered for his work with Street & Smith on *Air Trails* and *Bill Barnes, Air Adventurer.* He was excellent at hypothetical or futuristic aircraft as well as actual planes of the time.

He sometimes took his inspiration from photographs. He painted a group of World War I dogfight covers based on the legendary—but totally fake—Cockburn/Lang photos. The photos, done with posed airplane models, looked realistic, and Tinsley improved them on canvas without divulging his source. He painted many one-of-a-kind experimental aircraft; some had been announced but never built, and some only built in prototype. In some cases these covers furnish the best information available today on these unique planes.

Today Tinsley's originals are very difficult to find. This is possibly due to the publisher he worked for, who destroyed many original cover-art canvases to avoid paying sales tax on them. Frank Tinsley's contribution to the pulp age deserved a better fate than that. He was truly a giant in his field.

The last in this ultimate trio of aviation cover artists is Rudolph Belarski. Even though he did work for many types of pulps and various publishers, the bulk of his aviation work was done for Glenkel and Fiction House. Their principal air-war titles were *Aces* and *Wings. Wings* ran from January 1928 until April 1953, among the longest periods for the aviation titles.

Rudolph Belarski painted his first *Wings* cover for the March 1930 issue and his last for the March 1949 issue. He was probably the best of them all in the use of color and light. He loved to paint covers of many planes of the same type flying in formation into an infinite background, with every plane a different color. With this concept he produced some extremely effective covers of the gaudy, multicolored German Flying Circus, so well documented during World War I.

Another of his techniques was illumination of the aircraft in his paintings with unusual light sources, such as bright searchlights with their resultant spectacular shadows. At times he would use a ground explosion from a bombing raid to throw varied light on the aircraft. Others would be lit by an adjacent airplane in flames or exploding.

The drama of his works was greater than that of Tinsley, if not quite the equal of Blakeslee. Nor were his aircraft always as accurately drawn as the other two of this trio; but they were superior to most of the other pulp aviation artists'. Like Blakeslee, he often painted both cover and all interior art for a single issue. The long run of *Wings* magazine is an indication of how effective Belarski was.

One other artist deserves mention for at least longevity and loyalty. Eugene Frandzen worked almost exclusively for the Thrilling Group magazines and painted almost every cover for *The Lone Eagle* and *Sky Fighters* up to World War II. His work does not approach the quality of the triumvirate above. The scenes were static and often technically inaccurate, but he had a

certain style that was easy to remember and probably accounts for his long tenure with Thrilling.

Though much maligned, the pulps actually were a very positive influence on young people growing up between the two world wars. Teachers have spoken on the writing skills that reading the pulps could enhance; they were written in simple declarative sentences—subject, verb, object. The magazines had readers from all walks of life. Franklin Roosevelt was a subscriber to western pulps. Air Force general Robin Olds, a World War II fighter ace and victorious pilot in Vietnam, has said he grew up reading *G-8 and His Battle Aces.*

The air-war artwork was closely scrutinized by aviation-crazy young men, and when Pearl Harbor was bombed the young men rushed to the services, many to the air forces. Young men who had read the pulps easily passed aircraft-recognition classes. It was simple for them: they had been schooled by Blakeslee, Tinsley, Belarski, and all the other great aviation-cover artists.

George Hocutt is a collector of air-war pulp magazines of the 1930s and 1940s and has an expert knowledge of this genre. He has a large collection of cover art painted by Frederick Blakeslee and Rudolph Belarski. He is the founder of California Record Distributors.

stayed right through the Second World War. But one color was censored and never emphasized in a painting: red, the color of blood. Nobody bleeds in romantic myth.

Peacetime came and transformed the daredevil. It took away his guns. Now Homer's Confederate became Lucky Lindy, the Lone Eagle crossing the Atlantic all alone, face to face with death down below; Admiral Byrd braving the dangers of the unknown in the Antarctic; Howard Hughes building the fastest planes, then climbing inside and breaking world speed records; Amelia Earhart flying into a death still mysterious; Will Rogers and Wiley Post crashing to their deaths in Alaska; and Jimmy Cagney fighting ice on his wings in the film *Ceiling Zero.* All of them shared the same secret ingredient: they were "just a little bit crazy."

Poet laureate of the madness was the famous pilot Antoine de Saint Exupéry, who describes the romance in his *Airman's Odyssey.*

Each explosion seemed to me not to threaten us but to temper us. Each time it seemed to me that my plane had been blown to bits but each time it responded anew to the controls. I began to relax and a wave of jubilation went through me! Fear was missing! I did not live in the expectancy of death in the next second to come but in the conviction of my resurrection born of the second just passed. Life was granted to me anew. My life became a thing more vivid to me. I was living! I was alive! I was still alive! I was the source of life itself! I was thrilled with the intoxication of living!

The pulp artists were fascinated by the same romantic myth, this zest for adventure, this grace of chivalry in the deadly skies, and these warriors' new

George Rozen: "Eagle Squadron," *Sky Fighters*, November 1941

machines. Rudolph Belarski had accurate airplane models built to guide him. Frederick Blakeslee studied and knew every airplane from both world wars in detail but added new inventions of menace that appeared in surrealist forms. Tinsley designed futuristic fighters and bombers for Bill Barnes to fly to victory. They created "idea paintings": like Belarski's use of a Three Musketeers background for three attacking fighters or a skeleton in the cockpit behind a pilot giving a thumbs-down verdict of death.

Their luck was steady work and high incomes from the beginning of the Depression to its very end and straight through World War II. Hard times never touched them, and all they could paint they could sell.

To understand the times is to find this amazing. So many great artists were homeless and hungry that the New Deal decided to hire artists by the thousands. Between 1935 and 1943 they created a people's art: murals in post offices, airports, hospitals, and office buildings, sculpture in gardens and parks, and the photographs of Walker Evans and Berenice Abbott all startled the nation.

While air-war pulp artists were minting money, Jackson Pollock, William de Kooning, Thomas Hart Benton (who on the federal payroll painted *America*

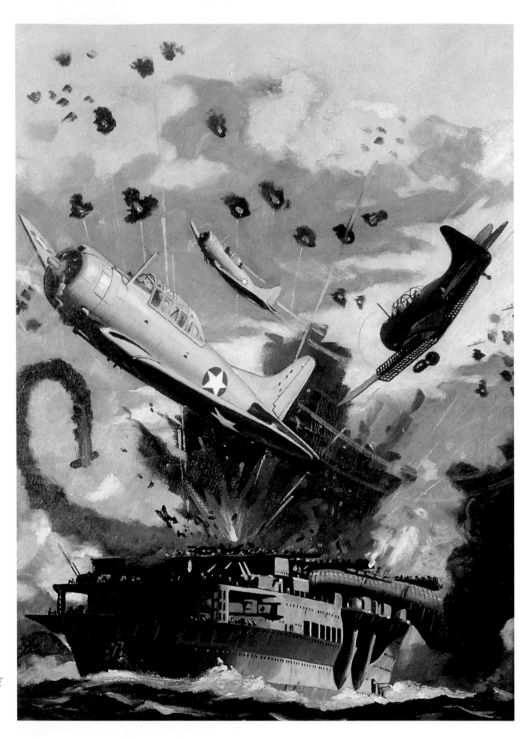

Frederick Blakeslee: "Battle of Midway," *Battle Birds,* October 1942

Today, the most important American mural of the twentieth century), Stuart Davis, David Smith, Milton Avery, Mark Rothko, and Marsden Hartley were being paid twenty-three dollars a week by the Federal Art Project. To keep getting this money they had to stay poor, remain unemployed, and prove that they were unable to provide basic necessities for their families.

The pulp artists knew this safety net was not for them, because they were branded commercial artists and only fine artists could apply. They weren't worth twenty-three dollars a week. But one day after Pearl Harbor their stock went straight up. They were in the right place at the right time. They could paint the outsides of military aircraft and knew the insides from prop to tail. Inspired by patriotism, a new national purpose, and being on the right side in a just war, they painted better than they ever thought they could. They knew all the planes from the First World War and now they learned the looks of a

Grumman TBF, a B-17G, a P-51 Mustang, a P-47 Republic Thunderbolt, and even the enemies' Zero, Stuka Dive Bomber, ME-109, and Junkers Tri-Motor. They knew that a dive bomber should be painted diving at the correct angle to release its bomb and a fighter pilot should be shown trying to get on the tail of his enemy to get him into his gunsights.

Suddenly the pulp artists realized that they were no longer painting fiction but recording fact; they were painting history as it was happening. On the cover of *Battle Birds* for October 1942, Frederick Blakeslee proved the historic value of air-war art by setting in paint that most important minute, the pinpoint center of the fight that would determine winner or loser at the Battle of Midway. We had cracked the Japanese code, and knew they were coming to finish the job they had started at Pearl Harbor. The spearpoint of their attack was to be four aircraft carriers armed with the latest high-tech weapons, far superior to our own. They had to be stopped. All of our Grumman Torpedo Bombers attacked, and every one was shot down. Thinking they

had won, the Japanese relaxed, refueled their planes, and repaired their decks; but hiding in cloud cover directly above were Douglas Dive Bombers with five-hundred pound explosive surprises. Blakeslee recorded on canvas this battle scene, which no photographer could have put on film. It remains today essential art, accurate down to the dive brakes on the trailing edges of the wings.

Alexander Leydenfrost:
Esquire, November 1943

Winslow Homer:
The Gulf Stream, 1899
(The Metropolitan Museum of Art, Wolfe Fund, Catherine Lorillard Wolfe Collection)

Editing the Western Pulps

BRUCE CASSIDY

After leaving the U.S. Army Air Force in 1945 I served a five-year stint at Popular Publications as the editor of two pulp western magazines. There were four of us working for Mike Tilden, who was overall editorial director of from six to eight pulp westerns and two detective pulps. As editors of specific magazines—I had *Big-Book Western* and *New Western*—it was part of our job to meet with illustrators to discuss the pictures that would accompany each short story and novelette. Since each issue of a pulp magazine ran about sixteen stories, that meant there would necessarily be sixteen illustrations to handle. The composition of the pulp paper on which these magazines were printed meant that the illustrations would probably be dry-brush works, or something closely akin. Pen and ink was possible, but few tried it, unless to satisfy some inner challenge.

In the late forties the pulps were actually dying out, but many of the traditions of the pulps' heyday remained. One of these was Illustrators Day, during which all the illustrators of pulp stories published in New York would come into the offices of their publishers to deliver last week's illustrations and to pick up that week's assignments. As editors we handled all these one-on-one discussions—usually having to do with erroneous details in the illustrations, or elements omitted. To prepare for Illustrators Day we would have read and edited the stories and would have jotted down suitable scenes for illustration. If, on the other hand, the illustrator was one of the top professionals in the field, we'd usually let him handle the selection of the scene himself. This was never a hit-or-miss job; pulp readers read slowly, but they read carefully, and the slightest detail would set them off to write in a complaint if the artist had deviated from the story text. Generally most illustrations came in on the mark. After I had okayed a picture, I'd take it in to Mike, our editorial director, for final approval, and that would be it. If there was to be a change, the illustrator would go down to the art department— Alec Portugal ran the art department at Popular—where he could white-out the mistake and fix it right there.

The great thing about the pulps was that not only did they give writers an opportunity to develop their craft, but they gave illustrators the opportunity to develop their craft too. The pulps were not high payers. In fact, some illustrators just did the artwork because they loved it. Nick Eggenhofer was by far the best western artist we had, and he would do most of the "doubles"—two-page spreads—for the so-called novels and novelettes. His research, especially on Indian war regalia, was absolutely first-rate. He was not a westerner at all, but he'd be apt to appear at the office in a cowboy

hat—not looking out of place at all. He did move out West to live when he retired some years later. Much of the best of the illustrative art in the westerns at Popular Publications was Nick's.

Cover art was handled differently. Painted in color, the picture was always a hard sell. Unlike interior art, the cover did not illustrate any specific story inside the magazine, but it did visually interpret its contents. The cover told a simple story and was usually a rather obvious scenario that could be grasped in nanoseconds by the observer: the "good guy" tied up and on horseback, with a hangnoose about to be lowered over his head, or something of that sort. The artist usually had to come up with the picture story. Once the plot idea was submitted, Mike Tilden and Alec Portugal discussed it with the artist.

On the personal side I was lucky enough to share studio quarters on West Sixty-third Street with Rafael de Soto, a cover artist of great talent and ability. He used it for a studio; I used it for living quarters. We split the rent. We were right next to the area where Lincoln Center would eventually rise. I was also a model for a number of his covers. Ralph worked from photos, always. He was a great one for dramatic—what we would now call film noir—poses, with deep shadows cutting across tense faces and hunched bodies. He'd photograph a woman model in the afternoon, photograph my face and whatever part of the body was needed that night, and then he'd go to work painting from the photographs to match the sketch he'd sold to Mike Tilden and Alec Portugal. Like the writing in the pulps, some of the overall ideas were corny—but on the other hand, the craftsmanship was always exceptional. After all, it was the craftsmanship that sold the magazines by the covers they presented to the world, and that made the whole pulp industry a viable one for so many successful years. I still see people I worked with during those years and I'm happy I was able to spend that time with so many talented, creative people.

Bruce Cassidy was an editor of western magazines at Popular Publications from 1945 to 1950. After his pulp experiences, he was for some years fiction editor of the slick Argosy *magazine. He has published a number of books, both fiction and nonfiction. His novel,* Murder Game *(1991), was a national bestseller.*

The Nazis invaded New York and New Jersey in the summer of 1942. Long-range German submarines sunk fifty-five merchant ships and landed gangs of English-speaking spies and saboteurs on Long Island. The subs attacked at night, guided by the bright lights of New York City (which refused to black out because it might hurt the tourist trade). The U.S. Navy fought back with K-type blimps, which could hover silently above their prey and drop their depth charges with deadly aim. German subs were sunk; the blimps could see them submerged seventy-five feet below the surface.

H. Winfield Scott: "San Francisco Flames in the Night," *Click,* February 1941

Alexander Leydenfrost painted this piece of history for *Esquire* magazine in November 1943. It is a candidate for being considered a masterpiece of air-war art. The death throes of the sinking submarine and the drowning men are in motion while the blimp is motionless—like a cobra that has struck, then pulls back and waits. The swastika and the American flag are symbols of good and evil, and the ocean is a neutral menace waiting to take them down and be forgotten forever. It is a nineteenth-century painting in spirit, closely related to Winslow Homer's *Gulf Stream,* in which the sharks circling the boat deliver the same death at sea as does the blimp circling its target below.

H. Winfield Scott, pulp artist and patriot, provided *Click* magazine with a painting that caused a political explosion. The Japanese ambassador and his entire staff stormed the White House and demanded to see President Roosevelt. Refused, they marched to the State Department and met with Cordell Hull's undersecretary; they were waving a copy of the February 1941 issue of *Click,* screaming in English and cursing in Japanese. All masks were off now, because of a painting that predicted what really would happen ten months later on December 7, 1941—accompanied by an article headlined "How Japan Might Attack U.S. in 1941":

This is a story of a war that has not happened. But it is not an imaginary war. The clash of Japan's economic interests with those of the United States is not imaginary....

A war with Japan may be just as real in three months...as the final bid to power of the Imperial Japan, conquest-bent....

If a desperate gamble becomes a stark terror, this war with expanding Japan may well look like *Click*'s artists have depicted it....

There will be no cameras on the scene. So, as eye-witness artists might depict the war with Japan, H. W. Scott, famed illustrator, paints for *Click* readers the horror of a California Concentration Camp for Women under the menacing rifles of Japanese marines.

The caption for the painting reads:

San Francisco flames in the night—American women walk in line to a concentration camp, Japanese marines impale a bleeding California upon their bayonets, as an attack without warning holds the West Coast for ransom.

Gas pedal to the floor, the pulp-trained Scott went at full speed in this painting. One woman, obviously having been sexually violated, holds a remnant of her dress up in late modesty. Another clutches her baby tightly, staring terrified at the Japanese marine. Behind her in line is a handsome young woman coming on to the soldier, suggesting a desperate bargain with her provocative pose. Last, a blonde girl is on her knees in a pool of blood on the ground, and

a nun is beside her trying to help; the bayonet of the camp guard—a brutish, savage hulk—is obviously stained with the blood of the girl. The background of the painting is San Francisco burning, with bare shadows of the Four Horsemen of the Apocalypse threatening a future of War, Plague, Famine, and Death. Scott's painting was exhibited and admired by thousands during the war; it had a special showing at the Salmagundi Club in New York and became quite famous.

The western cowboy of fact, fiction, and fantasy combined the colors of them all—New Knight, Noble Savage, and Daredevil. From this combination came a powerful new image that captured the male imagination and held it in captivity by feeding it courage, adventure, and daring. Its geography was western America; its market was around the world. It doesn't matter that it was false, that the stories were written and the pulp covers painted by New Yorkers who had never been west of the subway. Actually it was better, because truth imposes limits but the imagination has none. Frederic Remington and Charles M. Russell could paint the West from on-site experience, but the western pulp artists were painting people and places they had never seen and were being paid to imagine.

W. C. Tuttle was a writer of western pulp fiction, a real westerner born in Montana who had worked as a cowboy punching cows and riding the range. He describes his western experiences:

Paul Stahr: "The Land of Poison Springs," *Argosy*, April 1932

R.P.A.: *The Spectre of the Sierras*, Buffalo Bill Novels, no. 32, 1917

> What a job! Forty a month plus frostbite. Out of the sack about five o'clock in the morning, the temperature about zero in the bunkhouse; outside ten or twelve below and a wind blowing. You shiver into frozen overalls, fight your way down to the stable, where you harness a team of frosted horses, take 'em out and hitch them to a hayrack wagon.... Man! It was romantic!

It was the romantic West that the East wanted to know about and was willing to buy. First reporting was in the newspapers, made lurid and exciting. Then the western dime novel appeared, published in New York by Beadle and Adams, Street & Smith. The Buffalo Bill Novels were an immediate success, not only in America but worldwide. Buffalo Bill himself toured with his Wild West circus, and his showmanship presold his novels. The excellent cover art, handsomely colored and minutely detailed, depicted

Where Have All the Paintings Gone?

CHARLES G. MARTIGNETTE

As a collector and dealer specializing in original paintings and drawings executed by America's leading nineteenth- and twentieth-century illustrators, I have been fascinated with the challenge of assembling a representational collection of pulp-magazine cover-art paintings.

Although I wasn't even born when the pulps were flourishing in the thirties and forties, I have always been fascinated with the role pulp art has played in the cultural, social, political, and economic history of America during the first half of the twentieth century.

Prior to radio and television, the majority of the U.S. population received much of its entertainment from reading the cheaper magazines that had infiltrated everyday life from coast to coast. Many of America's great artists—from N. C. Wyeth to Norman Rockwell—created fascinating pictures for the mass market.

As has always been the case, any magazine's cover was the ultimate showplace for an illustrator's work. The pulp cover artists had to design and then paint action scenes that clearly told the viewer what was happening, often without any editorial support. These assignments often prepared the artist for his future career painting covers for such national "slick" magazines as *The Saturday Evening Post, Collier's,* and *Liberty.*

The interior pulp illustrations were always reproduced in black and white and were generally executed in the pen-and-ink medium. Dry-brush, wolfe pencil, and charcoal were other favorites for the interior work. The front-cover art was usually painted in oil on canvas. The average size was approximately thirty by twenty-one inches. The better—and better known—cover artists generally spent about a week executing a painting but would deliver more art in less time when a publisher's schedule was tight.

Once the finished art was delivered to the publisher's offices it was reviewed by the art director and then sent on to the photographer's studio so that it could be properly reproduced on the magazine's front cover. What happened once the photo session was completed varied from one publishing house to another, but all too often the story had the same sad ending: the artwork was eventually discarded or destroyed.

Among the small circle of early pulp collectors, it has been agreed for years that the vast majority of original pulp art has been destroyed or was lost long ago. Although we all hope that stray paintings will turn up every once in a while, we also recognize the fact that only several hundred are known to exist in the world today, despite the fact that between fifty and sixty thousand pulp issues were published.

Since 1980 my collections have been the subject of more than a hundred television-news feature segments. My purpose in doing these media projects has been to educate the public about American illustration and also to ferret out original artwork as a result of the publicity.

For example, through this media exposure, I was able to purchase some fantastic original pulp paintings by four great artists: Tom Lovell, Walter Baumhofer, H. J. Ward, and Harry Parkhurst. They were all oils on canvas of western subjects. I purchased them from a sixty-five-year-old nurse who lived in a high-rise condominium in Palm Beach, Florida.

How these paintings ended up where they did is, I feel, quite representative of the kinds of things that happened to much of the lost and missing illustration art of the twentieth century. The way I originally met the woman who owned these paintings was through a television interview I had done in Miami; she called the news department to get in touch with me.

This woman had lived in Manhattan prior to her moving to Florida with her husband. During the 1920s and 1930s her attorney husband maintained a handsome office in a New York City building that housed Street & Smith, one of the most important of the major pulp-magazine publishers. It seems that one day her husband had occasion to go downstairs into the building's basement, where a furnace was located. There he found two men heaving stacks of canvases into the furnace. As he approached them he saw several laying flat on the concrete floor. They were western pictures, and he recognized their images to be like those for the Wild West pulps he enjoyed reading every night after dinner. The men told him they had just finished throwing away about a hundred others and that he was welcome to keep the ones he was looking at.

All too often the original art for the pulps was of little or no value to anyone. Sometimes the printers would keep the best of what went through their hands and then give it away as gifts to their customers at Christmas. Occasionally the magazines themselves would give away a specific front-cover painting to a reader as a contest prize. In most cases a publisher couldn't have cared less what happened to an original once it had served its purpose and appeared in print. Some artists were smart enough to request the return of their paintings, but the majority of illustrators who worked in the pulp marketplace were too busy concentrating on their current and future assignments to worry about what might have happened to their originals.

Arthur Sarnoff began his career in the pulps with work for *Argosy* magazine in the mid-1930s. Mr. Sarnoff told me that within several months of his first art appearing in print in the pulps, he was solicited by the art director of *The Saturday Evening Post*, which marked the true beginning of his legendary career. John Falter, Amos Sewell, Herbert Morton Stoops, Harry T. Fisk, Tom Lovell, and dozens of other famous artists began their commercial-art careers working for the pulps. Eventually the more successful illustrators had their careers handled by personal managers known as artist reps. Norman Rockwell and Arthur Sarnoff were two of the many artists who were represented by American Artists.

Rockwell enjoyed telling the story about how Sarnoff always seemed to

be out on a golf course whenever the editors and art directors were trying to push up a schedule or deadline for one of Arthur's commissions. Actually, Sarnoff—like Rockwell and many other in-demand artists—was booked up almost a year in advance. Most of the time, an art director would give an illustrator a text to read from and the artist could select a scene or moment out of the story for illustration.

I have a close friend, Bill Grefe (Florida's most famous and successful film producer), whose father was one of the great illustrators of this century. As a contemporary of Charles Dana Gibson and Howard Chandler Christy, Will Grefe painted numerous cover images for *The Saturday Evening Post* from 1902 to 1916. He also worked for the early pulp magazines (*McClure's, Munsey's, Popular, Cavalier, Adventure, Argosy*), along with artists like Martin Justice. Will Grefe's studio was located in Coconut Grove, Florida; in the early 1930s, a severe hurricane hit South Florida and completely destroyed his studio and all of the art contained therein. Grefe (like Gibson and Charles Sheldon) actually *did* request the return of his originals, so when his studio was swept away into the ocean, with it went hundreds of paintings he had executed over a period of nearly thirty years!

The most popular pulp-magazine images almost always focused on or included a beautiful, sexy woman. Many of the famous early pin-up artists worked in the pulp market. Peter Driben and Enoch Bolles produced a large number of paintings portraying very provocative and alluring women. Also famous for their scantily clad pulp-cover pin-ups were H. J. Ward, Harry Parkhurst, William Soare, Henry Clive, Edward Eggleston, Gene Pressler, Cardwell S. Higgins, Arthur Sarnoff, Rafael de Soto, and Rudolph Belarski.

In 1985 I did an extensive telephone interview with Robert G. Harris. During the 1940s and 1950s, Bob Harris was one of the top ten illustrators specializing in both front-cover art and story illustrations for the national slicks, especially *The Saturday Evening Post*. Mr. Harris began his career painting western pulp subjects for Street & Smith and Thrilling Publications. In our conversation, the artist commented that the pulps were an excellent training ground for the up-and-coming illustrator and also served as a showplace that showcased the artist's talents to the art directors of the more prestigious national magazines. Even the art directors of magazines that were primarily oriented toward female audiences—*Redbook, Cosmopolitan, McCall's, Ladies' Home Journal*—looked to the pulps as a fertile field of talent from which they often plucked their new contributors and future cover artists.

I began collecting, buying, and selling original American illustration art back in 1978, but it took me more than ten years to discover the true importance and romance of pulp art. I was so focused on the mainstream areas of illustration—art for slick national magazines, pin-ups, calendars, advertising, and paperback novels—that I repeatedly overlooked pulp art. One possible reason was that I almost *never saw* any originals. Without question, the classic art of the pulps is very rare and almost impossible to find anywhere.

The author of this book and I—along with many other enthusiasts and scholars—are obviously very interested in preserving America's important cultural history via its popular artwork. The original pulp paintings are a

wonderful vehicle by which we can all experience much of what our parents and grandparents felt as they gazed upon the newsstands, surveying rows and rows of the brightly colored covers of the magazines we fondly call *the pulps.*

Charles G. Martignette is a scholar and writer and the leading authority and collector of pin-up art. He has the most comprehensive collection of this genre of illustration known, and is the author of the book The Great American Pin-Up.

scenes of Indian attacks, Deadwood Dick duels, stagecoach holdups, and of course, beautiful young women being rescued from bad men, rattlesnakes, Indians, bears, mountain lions, wolves, white slavers, and bordello madams. Although the writers—like Ned Buntline, who wrote the Buffalo Bill Novels— are well known, the artists are not, and their originals are very rare. Recognition is easy because the logo, title, and price were hand-painted by the artist to hasten the printing process and assure accuracy. They are small, interesting vignettes of a time and place inside the imagination.

Newspaper stories and western dime novels were the two parents of the western pulps: the child grew into a giant. At first these cowboy stories were just inserts; but as their popularity increased, so did sales, and magazines that exclusively featured western stories began to appear. From the turn of the century to the early 1950s they were the most popular, the most numerous, and the most profitable of all pulp fiction. Every publisher published, every writer wrote, and every painter painted westerns because it was money in the bank. Franklin Delano Roosevelt's favorite was *Dime Western,* and Adolph Hitler read the western stories of Karl May (a German writer of westerns who never ventured west of the Rhine). There were dozens of titles: *Texas Rangers, The Lone Ranger, Buck Jones, Ace Western, Cowboy Stories, Crack Shot, Frontier Stories, Lariat, Wild West Weekly, Wild West Stories, New Western, Double Action Western,* and on and on.

The artists had a problem: they didn't always know how to draw the West. They were boys from Brooklyn who had gone to Pratt Institute. "A horse? You want me to paint a horse with a western saddle?" "A gun? What's a gun look like?" Rafael de Soto carved a gun from wood and would lend it to his friend and fellow artist

Walter Baumhofer: "Fighting Cabellero," *Wild West Weekly,* October 1941 (© The Condé Nast Publications, Inc.)

Walter Baumhofer. The money inspired them to learn, and Baumhofer went to the Brooklyn Riding Academy and had the horses pose! De Soto dressed as a cowboy with boots, hat, and wooden gun, then posed in front of a mirror and painted himself. Steady work and talent turned Baumhofer into a fine western painter whose valued paintings are in museums and private collections. Tom Lovell also became a fine—and successful—western artist.

Some of their paintings were masterpieces and were meant to be. Long-lost paintings of Baumhofer, de Soto, Lovell, Rogers, Rozen, and others can be glimpsed on the covers of old westerns. Some were glorifications of the western fantasy, others surrealist in style, and a very few were great works of western art.

In June 1936, the publishers and staff of *G-8 and His Battle Aces* printed a declaration that can be considered a credo for all lovers of air-war and western daredevils in pulp fiction and art. This "pulp oath," entitled "Help Yourself," is reprinted here.

Too often, we believe, do the citizens of our fair communities walk about in a daily fog, which cannot be attributed to the weather, nor to any gushing smoke stack. Obviously, too many people are bored. Of course, they may be suffering earnestly, and towards that we can only offer our sympathies. But why, we ask insistently, why must people be forever bored?

Not to swell our chests, nor to in any way inflate our heads, the publishers of G-8 and His Battle Aces wish to point with pride. We are staging a war against boredom—a peacetime battle which fortunately, does not call for the use of lethal weapons.

From the constant flood of communications we carry on with readers, we believe we are giving them a thrill. That in the reading of this magazine, some small refuge has been found from the relentless forces of boredom.

To all of you who have written in this single message—that you have here escaped boredom and found adventure—we solemnly say "Amen." May your reading thrills increase, and may your cares be cast by the wayside.

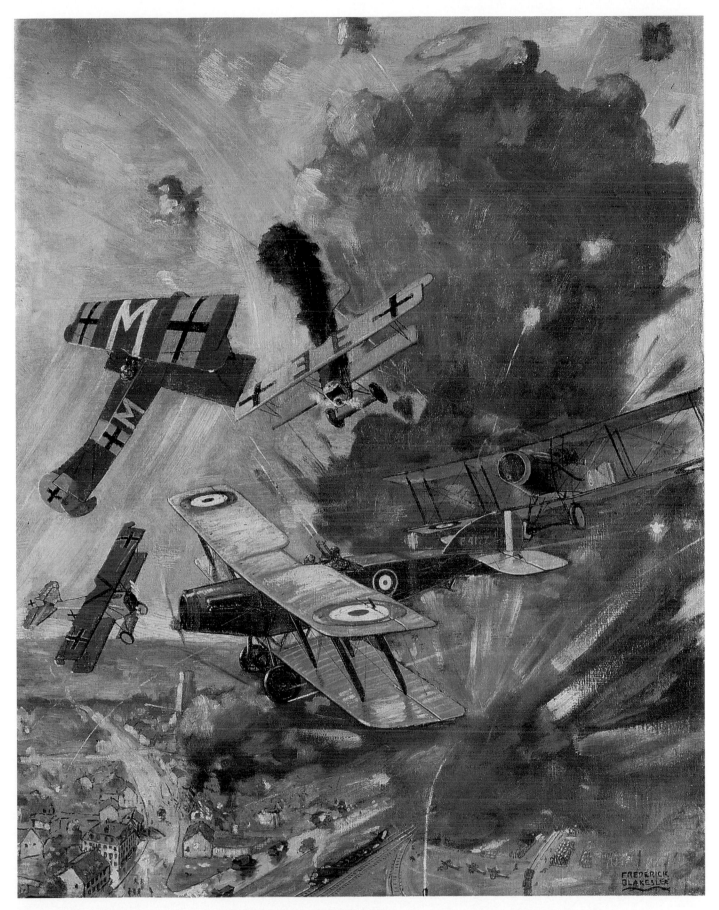

Frederick Blakeslee: "The Cyclone Ace," *Dare-Devil Aces,* October 1934

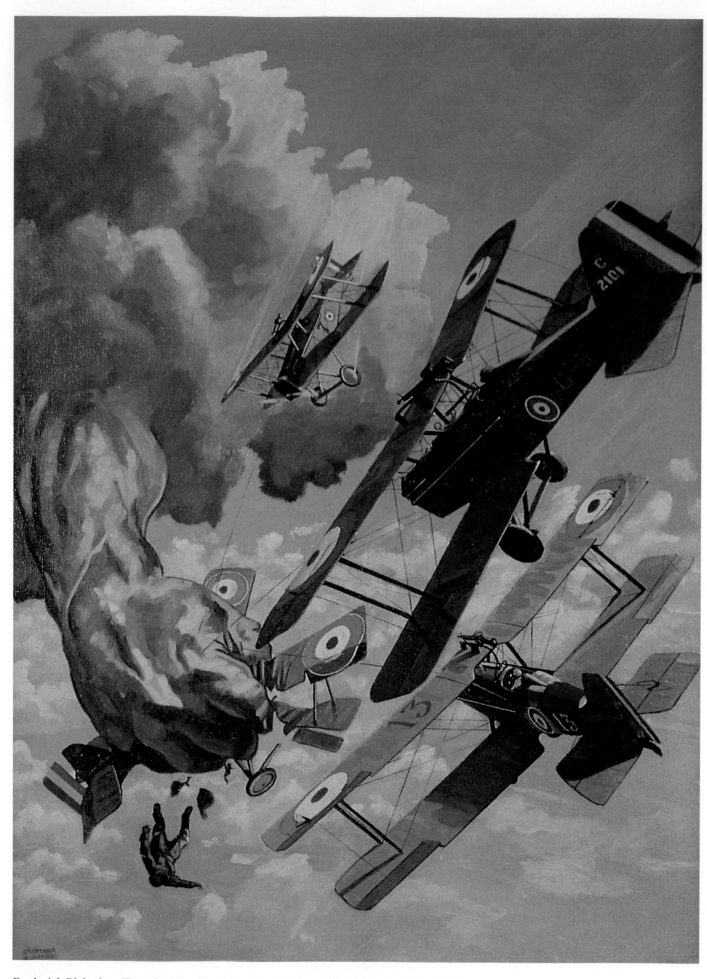

Frederick Blakeslee: "Patrol of the Cloud Crusher," *G-8 and His Battle Aces,* June 1936

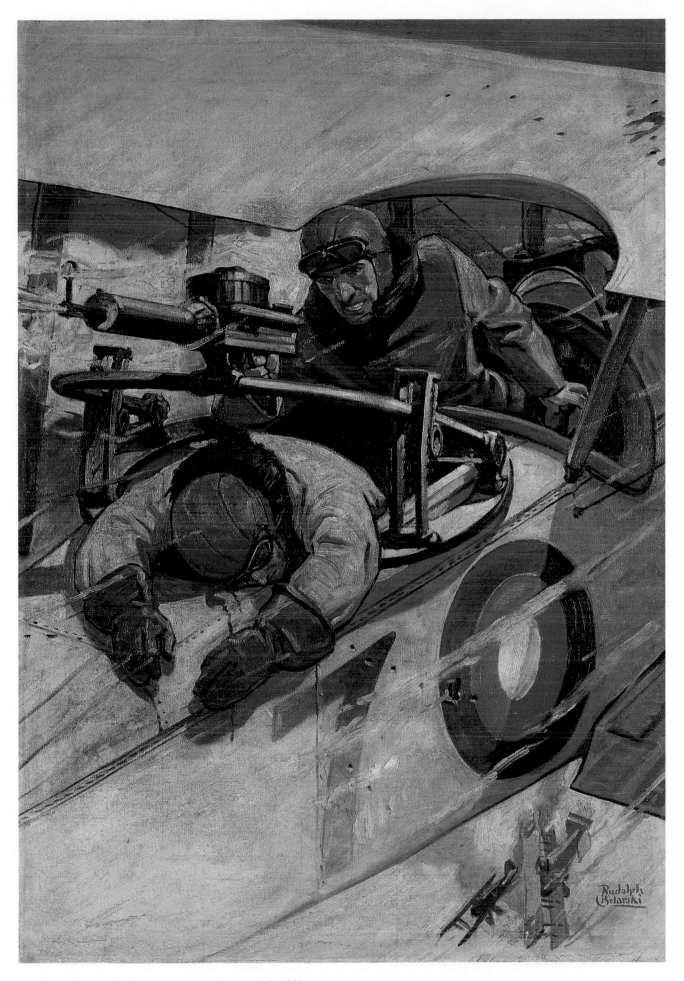

Rudolph Belarski: "Brothers in Blood!" *Aces*, July 1930

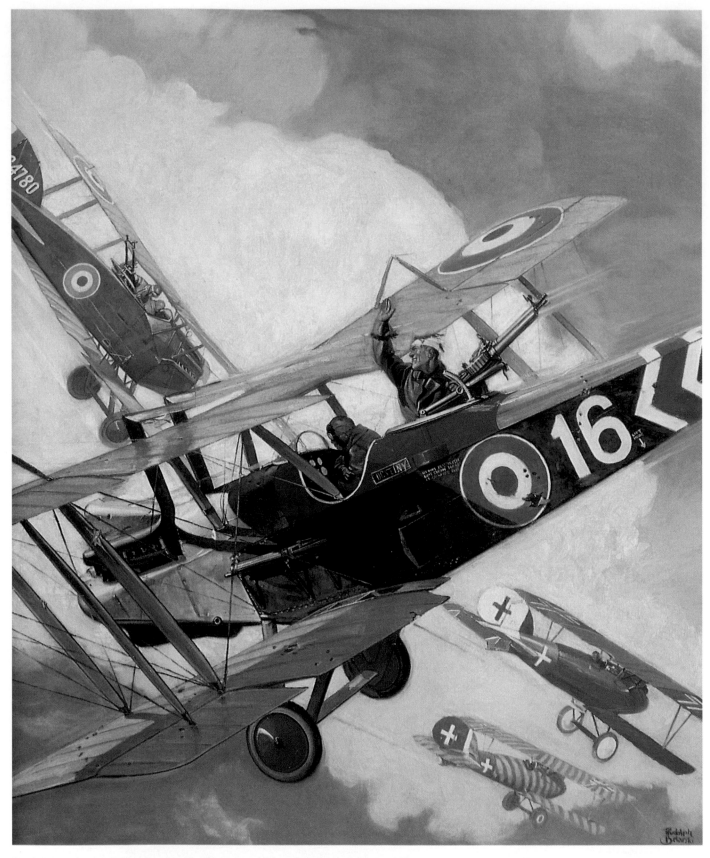

Rudolph Belarski: "O'Leary, the Devil's Undertaker," *War Birds*, January 1936

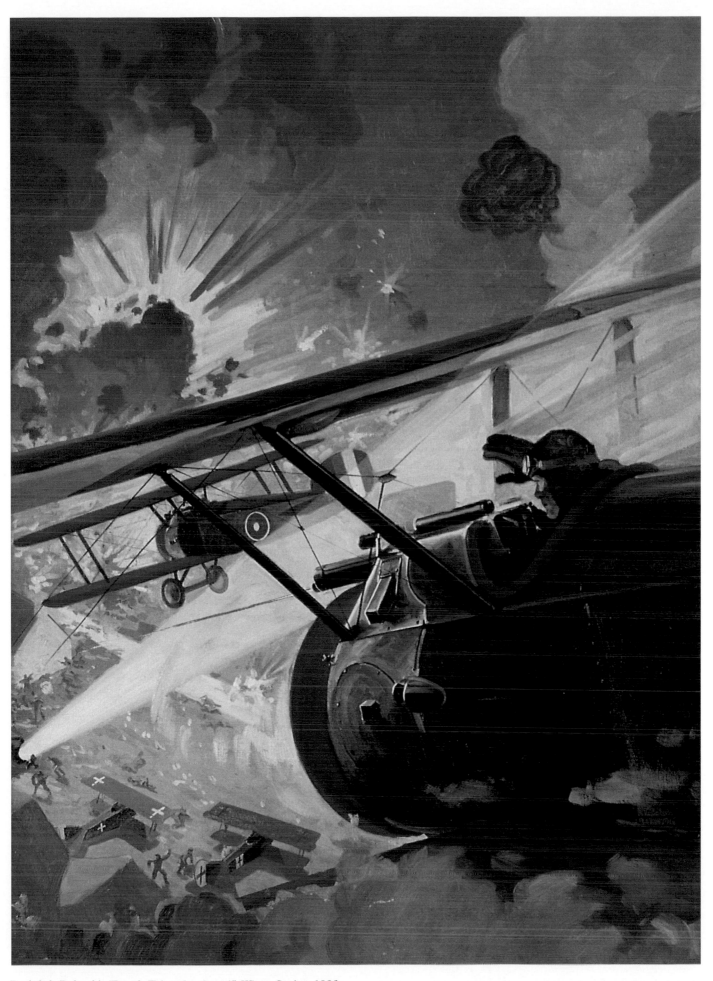

Rudolph Belarski: "Death Trips the Guns!" *Wings,* Spring 1936

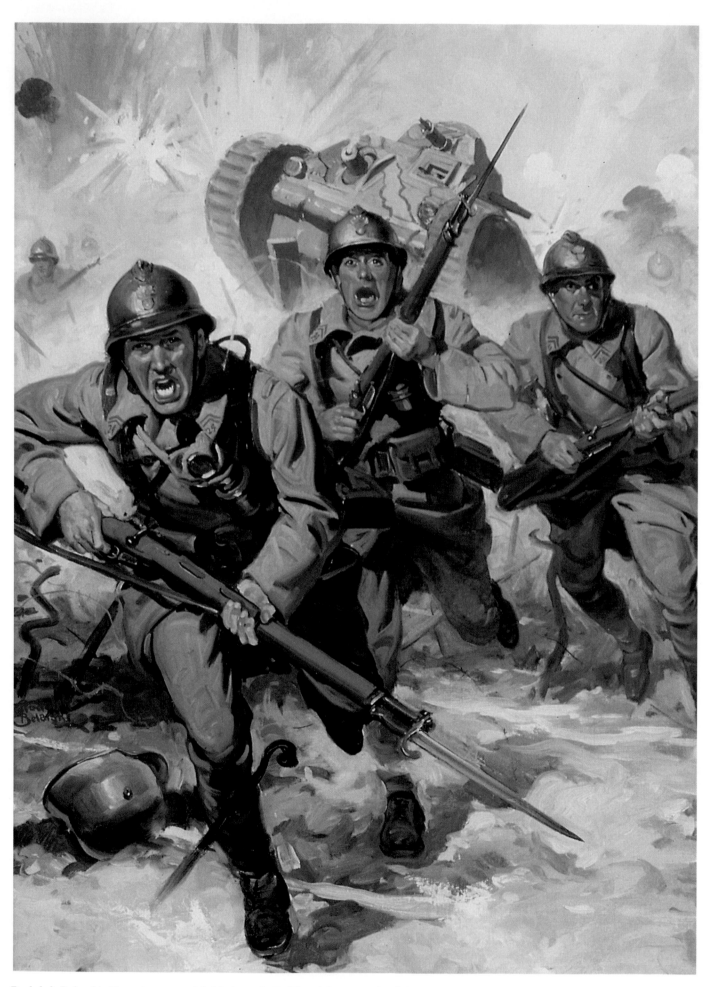

Rudolph Belarski: "Appointment with Madness," *Thrilling Adventures,* April 1939

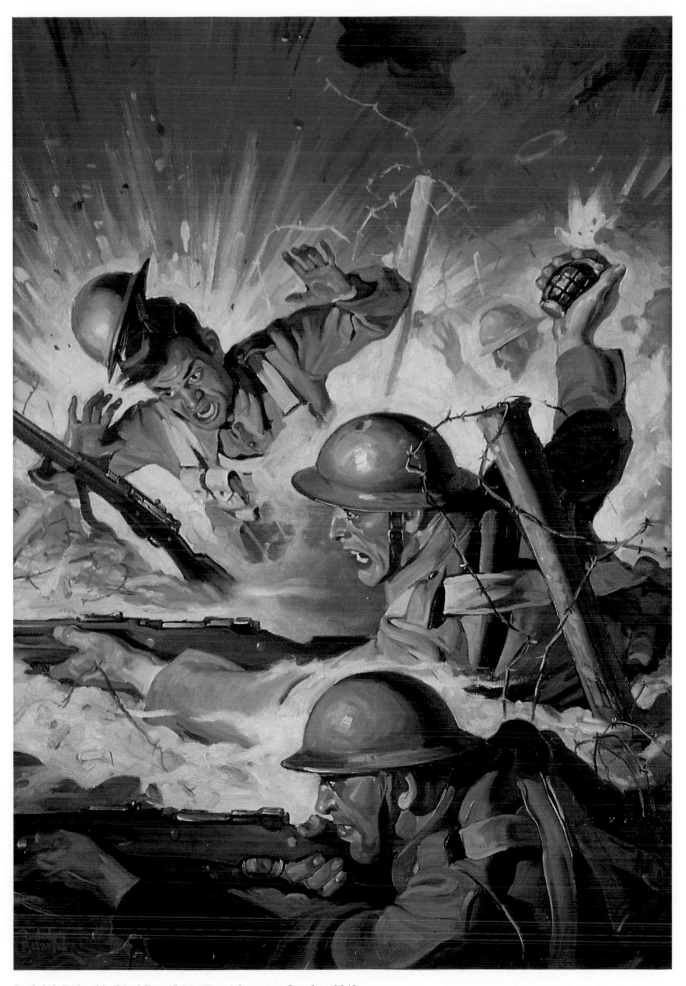

Rudolph Belarski: "Nazi Fury!" *Thrilling Adventures,* October 1940

N. C. Wyeth: "Ambushed on the Trail," *All Around Magazine*, March 1916

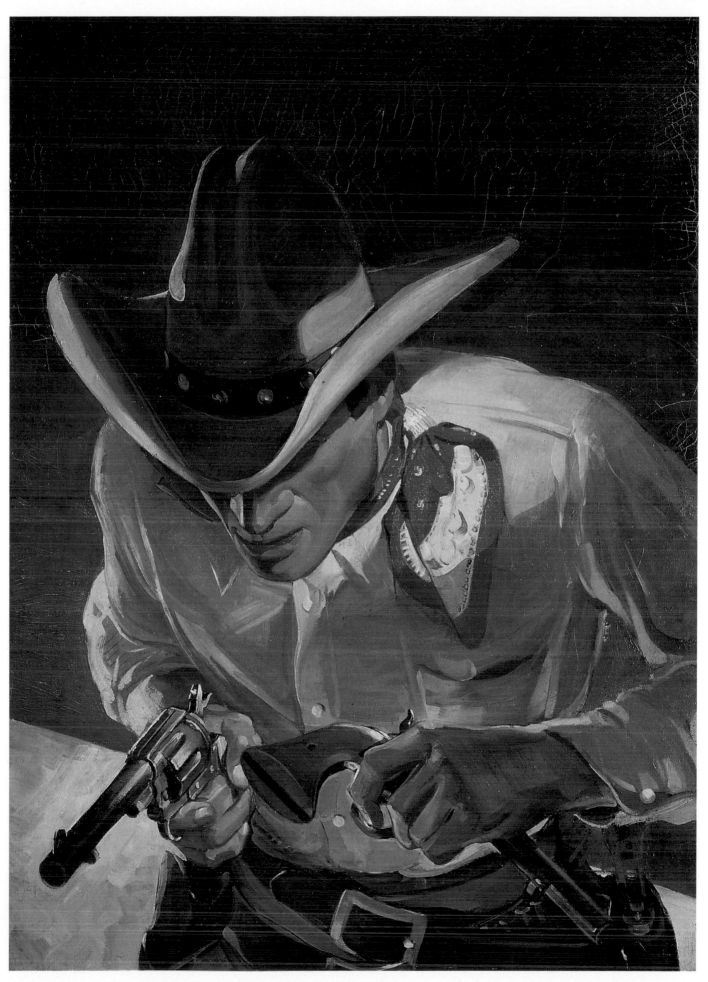

H. Winfield Scott: "The Oklahoma Kid," *Wild West Weekly,* December 1938

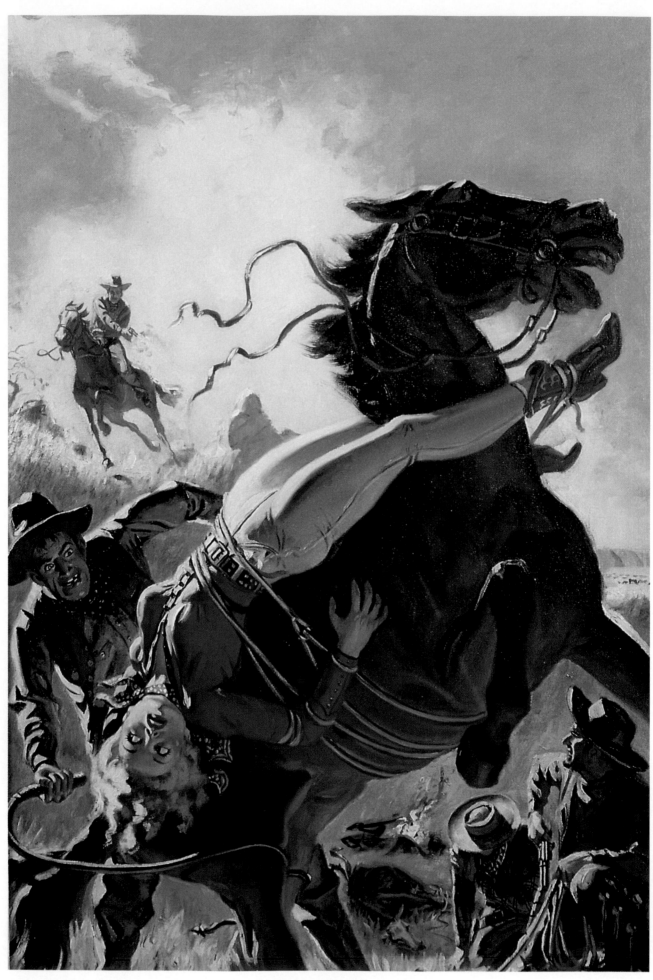

Allen Anderson: "Trigger Man from Texas!" *Lariat Story Magazine,* November 1944

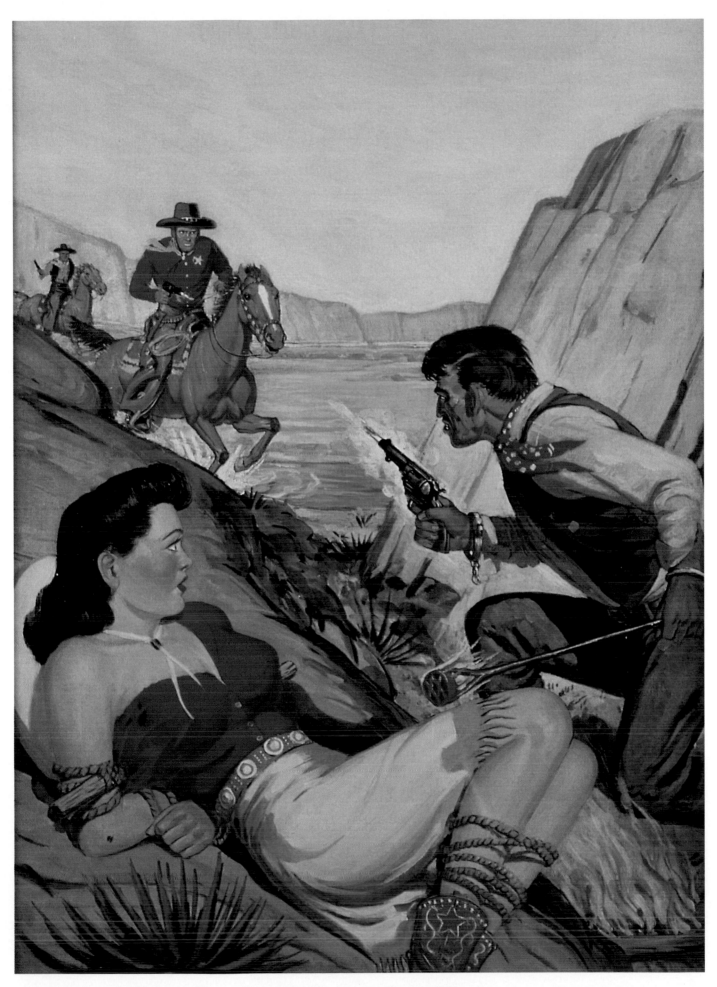

Allen Anderson: "Six-Gun Saga of Blue Strange," *Lariat Story Magazine,* January 1946

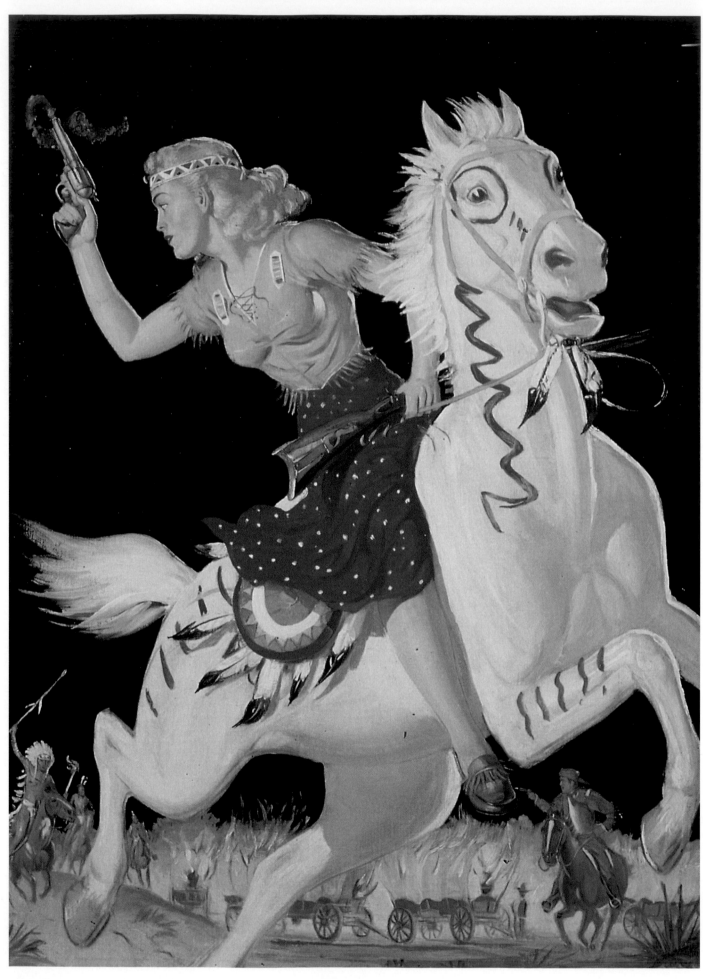

Allen Anderson: "Apache Flame!" *Frontier Stories,* Summer 1950

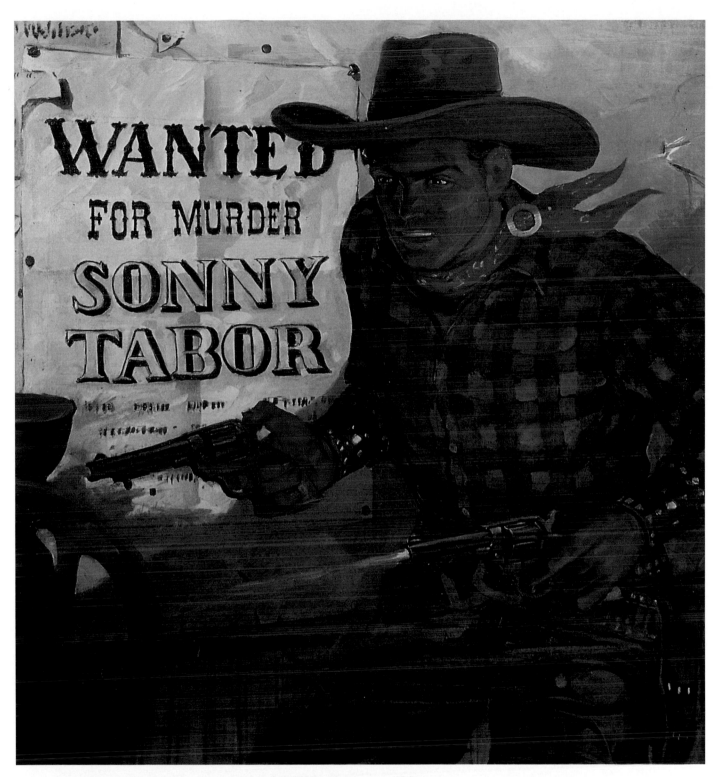

Sidney Case: "Wanted for Murder: Sonny Tabor," *Wild West Weekly,* June 1940

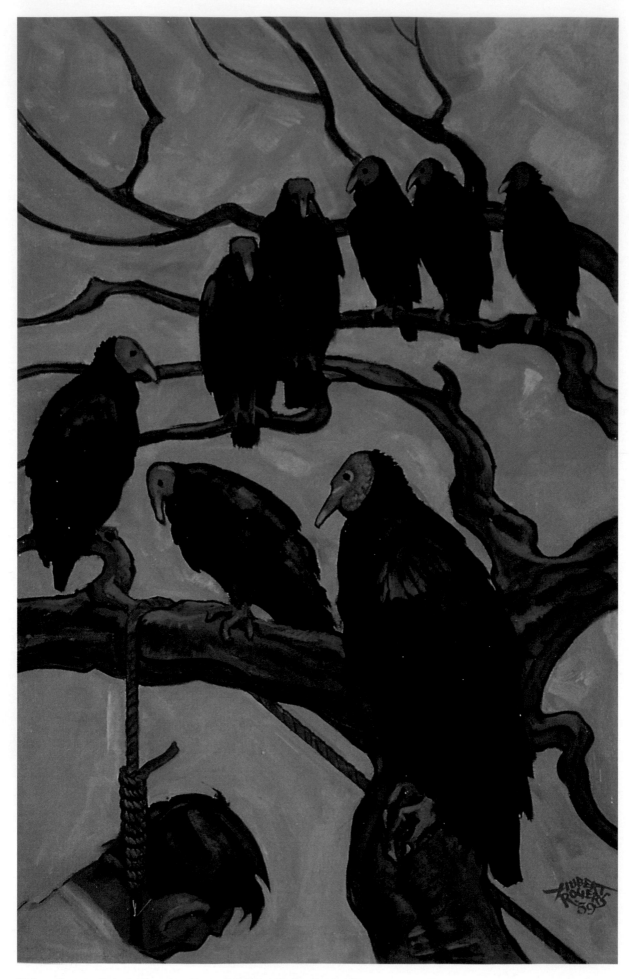

Hubert Rogers: "Black Thunder Trail," *Wild West Weekly*, April 1939

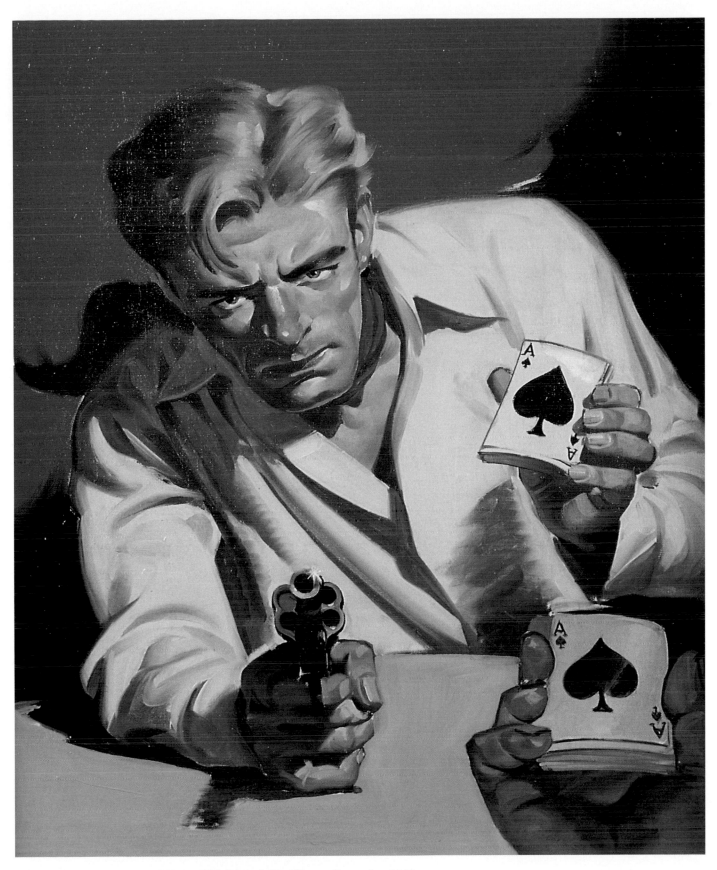

George Rozen: "The Son of Horse Thief Britt," *Star Western*, December 1943

APPENDIX I

VOX POPULI: LETTERS TO THE PULPS' EDITORS, 1929–46

Science Wonder Stories, August 1929

First, let me congratulate you upon the improved appearance of your new magazine. The cover of the first issue is a work of art and science combined; an infinite improvement upon the covers of your former publication. Artist Paul certainly does deserve a lot of credit. The spacing and wording of the title are also much more pleasing than previously....

B.C., New Mexico

Science Wonder Stories, September 1929

I have the July issue of your new *Science Wonder Stories,* the one with the ship on the cover. May I comment on it?... (1) The Cover. It is very misleading, as it does not have a bearing on any story, and not much on the article (as I can see). An editorial doesn't warrant an illustration, even if it is by you (praise). Besides, the cover is too...well, too ordinary—commonplace. Oh! Mr. Gernsback, don't do it again. Wouldn't "The Alien Intelligence" have made a much finer illustration? Wouldn't it now?

So Paul, here's to more fantastic and startling cover drawings. The more daring the better. That's what we all (most of us) want. Your illustration for "The Moon Pool" long ago was marvelous. And, Mr. Gernsback, I hope that formidable array of scientists you have as associate editors won't influence you otherwise. You probably know what you're about, though, but remember you have competition....

L.A., California

Amazing Stories, 1929

I have read your very interesting magazine for almost two years but this is the first time I ever tried to invade your sanctum with a letter. I find the letters from your readers most interesting, for they show what a wide range of tastes prevails among the patrons of *Amazing Stories.*

First, I want to say that your cover designs are original, striking, usually artistic, and just what your magazine needs to attract new readers. With the newsstands so cluttered up today with Sexy Stories, Smutty Stories, Western Stories, War Stories, and the like, the contents of which are as alike as peas in a pod, it is necessary for a magazine of the type of *Amazing Stories* to have a cover design that gives the prospective buyer an immediate idea of its contents. I well remember it was the cover design that led me to buy my first copy of *Amazing Stories*. Had it not been for the picture on the cover, I would have passed it up as "just another one of those magazines" and so missed some delightful hours spent in the perusal of your pages....

F.W.S., West Virginia

Wonder Stories, October 1930

The interest of a story depends greatly on the illustration. The illustrations of the *Wonder Stories* type of fiction claim accuracy and grandeur. There is only one artist that can supply this importance, and that artist is Paul. I am sure that every reader, and you too, will agree with me there. The illustration on the cover of your August issue of *Wonder Stories* is one of the most spectacular pieces of work I have ever seen. This illustration of the "Radium Master" by Jim Vanny actually "illustrates." It gives us the entire story in very few lines. The elemental colors, being only four, give it a vivid contrast upon the sight. Consequently, more people will like the magazine and help the editors to give scientific fiction to the world.

There is all of mystery-adventure-romance in *Wonder Stories*, but there is a great deal more. There is science. It is truly a magazine of prophetic fiction. It prognosticates the future.

J.B., California

Amazing Stories, 1930

The February issue of *Amazing Stories* is the best number you have published for some months.

I suppose you expect me to jump on Morey's illustrations again. You will probably be surprised to know that I liked them. Morey can be good at times, also just the opposite. His cover on the February issue was more colorful than is usually the case. Colorful covers attract the eye.

Amazing Stories discovered Wesso as a science-fiction artist. Wesso is very popular as such. Since you seem to like Wesso yourself, why do you not let him do more illustrating for the monthly? At least a cover every other month besides drawings.

J.D., Illinois

Wonder Stories, February 1934

The "Horrid" Baron Von Elmer Schuopavitch expressed my sentiments exactly. Paul is an artist, that I can see, but as in "The Fatal Equation," he gave the men all the appearance of crooners!....

I appreciate the fact that with too much science your subscriptions would

fall off, but why not put in at least one good science story? Yes, I said science. Is that word so strange to you? Also, if it isn't asking too much, would you mind keeping out all those lurid stories?

Looking over the ads makes one think that the advertiser expects readers with very poor taste. The only good ads are your own. Yes, I am beginning to think that I am not reading the kind of literature that does me any good.

So, a reader that is slowly becoming disgusted says: "Ou Wah!"

N.H., New Jersey

You complain about Paul's lack of ability to draw people properly. You will notice that Winter is now doing most of the figure work, and most of our readers seem to appreciate his ability. Of course, we shall still let Paul draw his imaginative illustrations of alien monsters, space-ships, and other futuristic and fantastic subjects, including the cover picture. Our readers are almost unanimous in the opinion that no one can rival him in this kind of work....

The Publishers

Wonder Stories, November 1934

The September cover was wonderful. Paul sure knows how to draw a good cover. I am glad that I am not color-blind, for then I could not enjoy looking at his covers. However, the effect is somewhat spoiled by the many labels on the front. The price tag should be placed where it could be seen. As it is now, it is lost in the picture. And please take the label off the top. It is not true and therefore it doesn't belong there.

The stories were all good. "The Fall of the Eiffel Tower" surprised me. Most of the French science-fiction stories have been very uninteresting. This story began with vigor and I am waiting anxiously for the next installment.

N.C.

Wonder Stories, November 1934

I suggest that you have the title of the magazine placed directly on the background of the cover illustration, as it takes up too much space in its present form. I think that it would be a good idea for you to take the band off the top cover and allow the picture to take up the whole space. I am glad that you are retaining the modern make-up. I would prefer that all the illustrating were done by Paul, unless you could obtain some by H. W. Wesso.

J.D.

Amazing Stories, May 1939

Cover: superb! Absolutely the best work Fuqua has done for you—and I don't think I'd be too enthusiastic even if I said it was the most beautiful cover to appear on any *Amazing* since 1936! Back cover: very good indeed. Next to letters, this feature is tops....

J.A., Maine

Amazing Stories, May 1939

Your artists, Fuqua and Krupa, are unquestionably among the finest illustrators to be found in any pulp magazine—by all means keep them. Even Paul and Wesso are not superior to them. The covers especially seem to be better and better with each issue—those for February and March are superb. The only letdown was in the cover painting for the December number. I guess it's pretty well established now that the painted covers are superior to the color photos....

L.P.W., California

Fantastic Novels, January 1941

Who wants a green bottle? Well, seriously now, I don't know. But if you asked me who wants Hannes Bok in *Fantastic Novels,* I would be one of the first to exclaim all of we readers would like to see Bok doing more work for your splendid mag in the future.

Bok's illustration for Tod Robbins's yarn, his first artistration for your publication, was more than good—it was positively Brobdingnagian, if I may stutter such a big word and live through it. Bok's rat creature certainly was an interesting thing to look at, rather cute, even though I detest that word, but certainly well balanced and nicely drawn.

Can we look forward to more Bokian creations in the near future? Let's hope so. He and Finlay are the only two artists in fantasy fiction today who have managed to capture the *outre* tone that is necessary to this art form. Why not Bok on a cover? He has a splendid color sense and is a genius of placement and balance.

In case you haven't discovered what this letter is about by now, I guess I might as well add his name once again. Boy, do I like Hannes Bok's work! Don't lose him! Use him!

Ray Bradbury
Editor, *Futuria Fantasia*
Los Angeles, California

Fighting Aces, May 1942

Well, well, not all Supermen are in the comic books. I see that we have one in the July issue of *Fighting Aces* by the name of Tim Craig....

How about starting something so we can get colored Blakeslee originals? Hurry my original, as I punched a hole in our wallpaper after reading your column, and my mother said I must either get the whole room papered or cover the hole with something—preferably a Blakeslee!

R.W.Y., Pennsylvania

Your sad case touches my heart, and your Blakeslee is winging its way on down to you. If you want it colored, take out your crayon set and color it yourself!

The next and last Blakeslee I'm going to part with this month goes to the lucky lad selected as our Honorary Editor for the issue.

The Publishers

Battle Birds, October 1942

As one greaseball to another, I would like to tell you I've been reading *Battle Birds* for about five years and find it the tops in air-war fiction. However, now that I am a mechanic in the air forces, I would like to see a story about us ground-huggers that really Keep 'Em Flying. We have a swell bunch of men in our ground crews, and I am sure they would like to read a story with themselves as heroes for a change. And they do read B.B.—almost all of them— 'cause I have the darndest time trying to hang on to my copies until I have finished them.

Last but not least—if you could possibly spare us a Blakeslee, I promise it would occupy a prominent space on our barracks wall. Undoubtedly it would be an incentive to all the men within, and might even be the crucial thing that helps us to win the war by spurring us all on to do our best. How about it ?

<div align="right">Pvt. A.E.F., Georgia</div>

Far be it from the Great Greaseball to sabotage the nation's war effort by being tight-fisted with the Blakeslees. Keep your eyes on the company mailbag, soldier—there's a big, beautiful Blakeslee coming right at you!

<div align="right">The Publishers</div>

Planet Stories, Fall 1944

In general, this last issue of *Planet Stories* was good. The cover was—as seems to be customary—very inaccurate. Ingels isn't a bad artist, but he doesn't begin to compare with Rozen. Just notice the difference between this cover and the cover for the Fall 1943 issue; the themes were almost identical, but look at the difference in execution! It's too bad that Rozen has been ill; his work is really excellent.

"The Monster Maker" by Ray Bradbury was really interesting. Perhaps the author might write a sequel; his characters were three-dimensional—and human. Doolin's drawing—he uses shadow rather heavily, doesn't he?—neither made nor marred the story....

R.J.

Planet Stories, Fall 1944

In the spring a young man's fancy turns to *Planet Stories*—but not if the cover is like the one for Spring 1944. Once again the Guy, the Gal, and the Goons, and such a smeared job that they all resemble goons of one kind or another. Especially the girl. Do you honestly think she would attract any new readers? That too-heavily made-up face, that expression, that—shall we exaggerate and call it hair? Arrraagh!

Artwork: Gifford's cartooning ability continues to amaze. Ronald Clyne does a neat job, and your new import—Ingels—has an odd and interesting style that will be quite refreshing if you don't use him to much....

I miss the planets on *Planet*'s covers, regardless of what others think.

Anderson's cover for the Winter 1942 *Planet* is super but Ingels's cover for the Spring 1944 issue looks too much like cheap jungle/Wild West stuff....

J.W. Jr., Idaho

Famous Fantastic Mysteries, February 1946

A day or two ago I received from you a copy of the *Lawrence Portfolio No. 1*. I can hardly say how pleased I was! They are certainly excellent reproductions and quite suitable for framing. I wish Lawrence would do all his major illustrations with a border, as with ones from "Lost Continent" and "Day of the Brown Horde." It seems to add dignity to the magazine. One of these days, in the far future, how about a portfolio of the cover illustrations from past issues, without titles? It would certainly be very expensive but I think it would justify the cost....

K.S.M.

APPENDIX II

ORIGINAL PULP PAINTINGS: A COLLECTOR'S GUIDE

Is It Still Possible to Find the Art?

Very possible. At this date the hunt for original pulp paintings is just beginning. There are few specialized dealers and auctions, even collectors. Best of all, there is yet to be a price guide. About fifty thousand magazines were published. If 5 percent of the cover paintings were saved, that means that there is a supply of twenty-five hundred waiting for you—out there, somewhere.

Where Are They?

Large flea markets are a surprisingly lucky place. Book dealers traditionally acquire illustrations with collections of books. Since their business is books, not art, their prices are often reasonable. Comic book conventions are sometimes a treasure chest because there is a strong visual relationship between the two areas. Hounding art dealers would be a waste of time, because most consider commercial illustration beneath their dignity and almost certainly know nothing about pulp art. But antique dealers who buy the entire contents of an old home are a good bet—the art may be offered at a low price since they usually must sell everything quickly. To stay in continuous contact with these dealers, place an inexpensive ad in your local telephone company's Yellow Pages. And then there is the possible good fortune of having been born under a lucky star!

Buying Strategy?

Take a good acting class and learn to project convincingly: the Believable Victim, the Easy Pushover, the Fool with Money to Burn. One technique involves establishing a reputation: at the first sale, pay the dealer's asking price, usually twice what it's worth (but in a rising market). The next painting will come to you in a straight line, with no competition, because you are now recognized as willing to pay the highest prices—the Ultimate Buyer. Amazed by greed fulfilled, the dealer becomes an enthusiastic slave, working morning, noon, and night to get you more. Other dealers will hear and join

in the feeding frenzy; and other collectors will want to sell to you before your bankruptcy sets in. If this military strategy works, you will have acquired a large collection in a short time at the bottom of the market and ahead of the curve. All the while a big sign should be prominently displayed in your home to continually remind you: "Buy the Best and Leave the Rest!"

Magazine or Painting?

There are two types of pulp collectors: Word People and Art People. Word People are the 99 percent majority who collect the magazines and are concerned with what is inside only—famous authors and favorite stories. The importance of the cover art to them is the story it illustrates. If they are selling a painting to you their sales point is the rarity of the pulp; and if it depicts The Shadow, Doc Savage, The Spider, or another well-known character, the selling price zooms skyward.

The Art Person doesn't read; he looks. He sees the cover on the outside only and buys a painting according to three most important rules: Quality! Quality! Quality! But it is necessary here to tell the truth: much of pulp art is not worth buying at any price. It's awful because it had to be awful—"slapdash art" painted quickly, incomplete, sent to the printer prematurely to meet a deadline of three days before yesterday. And much slapdash art appeared on the covers of the rarest magazines because they were one-shot publications that had low-quantity press runs. Judge the painting as a painting—ignore the propaganda. Beware of paintings that have bare, unpainted, white backgrounds: colors, scenes, and figures were eliminated to cut the cost of the painting and the printing, and it resulted in poor, incomplete cover art.

What About Black-and-White Interior Art?

To buy or not to buy: that is the question. Yes, if it's good, no if it's bad. Usually yes if it's Frank R. Paul, Virgil Finlay, Edd Cartier, Hannes Bok, or Tom Lovell; usually no for anyone else. Each magazine had one cover but often a dozen interior black-and-white illustrations. The ratio of rarity is at least 10 to 1. Virgil Finlay did at least twenty-five hundred interiors. Jon Flemington Gould, who specialized in interiors, was paid four dollars each—he worked fast, as did all the other interior artists, and the quality suffered.

TM/© The Condé Nast Publications, Inc.

A Whole Collection?

No, don't do it. If you buy a whole collection all at once you're buying some garbage with the gold. No collection is perfect and your eye may become overwhelmed by mass. Buy one painting at a time; that way you can only make one mistake at a time! (It takes ten seconds to buy, ten years to sell.)

Restoration?

Absolutely yes. Your painting will be approximately twenty-one by thirty inches, oil paint on canvas, mounted on a wood stretch frame, and possibly in good condition. But it is about sixty years old. Dirt has worked its way into the canvas, and it should be cleaned. It never received a protective coat of varnish because that would have reflected light and caused glare in the reproductive process. Hold it up to the light, and if it shines through that means the canvas has aged and thinned and must be relined. On the paint, restoration will be needed in those areas that have been skinned. In remounting it on a new stretch frame, check the edges of the canvas that overlapped the old frame and were nailed to the sides; they may have additional painting that will require the canvas to be flattened to gain all of the original picture.

It is important to obtain the pulp magazine itself. The cover is a color and content guide for the restorer and necessary for restoration accuracy. Send photos of the painting to magazine dealers and they will identify its pulp and sell it to you (at a high price, of course). In framing, mount the magazine with the painting and it becomes the painting's title. Even a ten-year-old can understand the relationship and explanations become unnecessary. After restoration has been completed a light coat of varnish should be applied for future protection.

Always check the back of the original canvas because the magazine's title and month and year of publication often appears. This will ease your task of obtaining the matching pulp. Hopefully, the artist signed the painting, sometimes faintly, sometimes just an initial. The signature is important for identification and because it increases its value.

What to Collect?

It must be love at first sight. Like a marriage, you may have to live with your choice for a very long time. Lust should produce a firm yes or no in the first ten seconds. Your decision to buy should be based upon intoxication from immediate joy, not on the tyranny of money. Art and money have no relationship. Art outlives the money that bought it, and money is asleep until you spend it! Try not to take it to heart if you should awake at 2 A.M. out of a nightmare into a panic attack, drenched in sweat: "Oh no, I've done it again! I paid that damn art dealer three times more than that pulp painting is worth! I can't stop! I'm out of control!" Recognize that such pain can signal that you made the right decision. You trusted your intuition and bought a painting you fell in love with at first sight—possibly a masterpiece. The hard lesson: Always buy better than you can afford; that way you do not become a gatherer of the mediocre. Besides, the true collector has a built-in mental "forgetter" that shelves past prices in the amnesia section of his brain and leaves him guilt-free to spend again.

Who to Collect?

There is a mystery in collecting that always begins at the birth of the new. Its visual keystone is Charlton Heston descending from Cecil B. DeMille's celluloid Mount Sinai with the Ten Commandments carved in stone. The mystery is this: Who carved the collecting commandments into stone? The top ten Golden Age comic book titles were determined in the early sixties and remain the same today. As new collecting areas appear, their commandments somehow get carved. In pulp art, the chisel and the hammer are still at work, but we can already make out the names of the artists we are commanded to collect:

J. Allen St. John	Rudolph Belarski
Rafael de Soto	Hannes Bok
Frank R. Paul	Norman Saunders
George and Jerome Rozen	Walter Baumhofer
Virgil Finlay	John Newton Howitt

Why these? Because they were the best. You can blindly build a collection around these signatures on paintings. These artists had talent for this type of art and plenty of Depression time to do their best. Theirs were finished paintings, magnificent works of figurative art that reveal integrity and seriousness of purpose. They recognized and applied the necessary elements of this special art form. They are the Ten Commandments of Pulp Art.

APPENDIX III

ARTISTS' BIOGRAPHIES

James Allen St. John (1872–1957). Among many collectors St. John is rated first, and his paintings for pulp covers and illustrations for Burroughs books are very expensive and difficult to find. He was born in Chicago. He was eight years old when he was taken to Europe, where he visited all the major museums. He began to draw and paint before he could read and write.

He studied at the Art Students League of New York under William Chase, Carol Beckworth, and Kenyon Cox. Later he studied in Paris with Jean Vierin. He returned to Chicago early in his career and lived there for the rest of his life. For twenty years he was instructor of painting and illustration at the Art Institute of Chicago. He then became professor of life drawing and illustration at the American Academy of Art.

He was personally selected by Edgar Rice Burroughs to illustrate his books. The first was *The Beasts of Tarzan,* published in 1916, for which St. John provided the cover and thirty black-and-white interior illustrations. Next was *The Son of Tarzan* (1917), and again he supplied all of the art. At the books' publisher, A. C. McClurg, he became known as the Burroughs artist. But he also worked for other publishers, and his talents were in great demand.

St. John was a superb artist and could create in any medium. The majority of his paintings were oils, but some were watercolors. He used pen-and-ink and gouache techniques for his interiors. Some of his finest creations were his covers for *Weird Tales,* which were smaller and delicately detailed. In general, today he is considered to be the greatest of all of the fantasy artists.

Rafael de Soto (1904–1987). Born in Spain, Rafael de Soto moved to Puerto Rico at the age of seven. He came to New York to study archaeology but always wanted to be a priest; he became an artist instead. De Soto started by illustrating interiors for *Top-Notch* magazine, using the public library to research his western covers. He worked for Street & Smith, Pines Publications, and *Ace* Magazines. But the main body of his work was produced during a sixteen-year relationship with Harry Steeger at Popular Publications. After John Howitt left, de Soto created cover art for *The Spider,*

Rafael de Soto posing for an illustration, c. 1934 (courtesy John de Soto)

many from his own concepts, which were so interesting that the stories were written *about* the cover art itself. His covers numbered approximately eight hundred—he was a fast artist, spurred into speed by need, the Depression, and his family responsibilities.

Like most artists of the period de Soto never requested the return of his art and unfortunately most of it was stored at Popular's warehouse, which burned to the ground. He used live models—himself in front of a mirror, his wife, paid models—and New York City scenes for backgrounds. Besides the pulps he also worked for the "slick" magazines like *American Weekly* and *Collier's*. His highly realistic art told a story on the cover and sold the magazine at first sight. As much as he disliked the medium and wanted to become a fine artist, he was a commercially successful artist during hard times.

Many of the pulp painters were inspired by patriotism during World War II to do their best work. De Soto's illustrations during this period were his finest and remain with his family. He was a close friend of Walter Baumhofer and they exchanged ideas, techniques, props, and good times, but his relationship with Steeger was purely business.

His regrets were many; he hadn't become a priest or a fine artist, or had his works hung in a New York City art gallery. Only at the end of his life was his lifelong ambition realized in creating religious art and teaching the Bible with paint.

Frank R. Paul (1884–1963). Born in Austria, Paul studied art and architecture and continued his education in Paris and New York. In 1926 Hugo Gernsback published the first science fiction magazine, *Amazing Stories*. Paul was hired to paint the cover and all the interior art. From 1926 through 1929 he continued to provide all of the art for *Amazing Stories*, while also illustrating textbooks. Other magazines that utilized his talents were *Science Wonder, Science and Invention, Air Wonder,* and *Astounding Stories*.

The art of Frank Paul has always been popular and in demand; his originals have become very expensive. Perhaps his best work was the back-cover paintings that depicted cities on other planets; these allowed him to display his mastery of architectural styles and details. He used bright colors, especially red and yellow, and the scenes were both lavish and threatening. His black-and-white interior illustrations had the same architectural emphasis and fine lines as his back covers for *Amazing Stories* and *Fantastic Adventures*. Around 1953 Paul ended his work in the field of science fiction. His last painting was for a special reprint issue for the twenty-fifth anniversary of *Amazing Stories:* it was an exciting scene of life on a distant planet, and he had lost none of his skills in retirement.

Donald Tuck, in his *Encyclopedia of Science Fiction and Fantasy,* has said of Paul: "He was a master of science fiction art and his work most appropriately portrayed the ideals and wonder of the field in its magazine infancy."

George Jerome Rozen (1895–1974) and **Jerome George Rozen** (1895–1987). George and Jerome Rozen were twin brothers, and both were inclined toward art from an early age. Because of health reasons, the entire family, including three older sisters, moved to Flagstaff, Arizona. Jerome went into the army in World War I and in France visited the museums and galleries; George was placed in the Signal Corps and stayed in the States. After the war Jerome was determined to become an artist and enrolled in the Art Institute of Chicago. His talent received instant recognition and he became an instructor. George followed a year later and had Jerome as one of his teachers.

Jerome's first illustration was for the Fawcett magazine *Excitement!* He married Della Kretchmar and moved to the Bronx, opened a studio at 163 West Twenty-third Street, and became a pulp artist. George married Ellen Mason and followed him to New York. Both brothers found steady work.

Street & Smith's *The Shadow* was an instant success, and Jerome was assigned the first few covers. His most handsome paintings were possibly the covers for *The Mysterious Wu Fang* and *Dr. Yen Sin.*

Jerome (left) and George Rozen, 1943 (courtesy Helen Palwick)

George Rozen produced Shadow covers from 1932 to 1939 and again in 1941, 1942, and 1949. A good, fast pulp artist, he also provided the covers for *The Phantom Detective, The Masked Rider, Sky Fighters,* and countless westerns. As early as 1935 Madison Avenue was aware of Jerome's talents, and he was assigned art chores for Mail Pouch Chewing Tobacco and the Pennsylvania Railroad, and he even did covers for *Redbook* magazine.

Both brothers were so busy they never knew the hard times of the Depression. With the pulp era behind them, George and Ellen moved to East Williston, Long Island; Jerome was severely injured in an auto accident, and his wife was killed. George stayed with the pulps after World War II and worked with Street & Smith, trying to revive *The Shadow* and *Doc Savage.* In 1964 Jerome closed his studio, as photography was replacing illustration in the print media. Together, the Rozen brothers had produced hundreds of pulp cover paintings of the highest quality.

Virgil Finlay (1914–1971). There was an intensity in Finlay's art and a devotion to his work that brought great beauty to the pulps. Many bought the magazines for his illustrations, and letters poured in to the editors praising Finlay's art. He was born in Rochester, New York, the son of Warden Hugh Finlay and Ruby Cole. In high school he was an athlete and studied art.

In the Depression years he went to art school at night and studied anatomy, portrait painting, and figurative art at the WPA. To stay alive his day jobs were anything he could get: house painter, worker on a radio assembly line, and stockroom clerk. He was a devoted fan of *Weird Tales,* and in 1935 he submitted a group of his illustrations to the magazine. The positive response was immediate. Farnsworth Wright, the editor of *Weird Tales,* knew that this would provide better illustrations for the stories and would increase sales.

Finlay was directly influenced by the art of Gustave Doré and imitated his labor-intensive techniques, expensive to reproduce. He used a 290 lithographic pen and india ink to produce stipple art—one dot at a time. An interior black-and-white was the result of hundreds of precise groupings of tiny black dots achieving an almost photographic result. Although difficult, a method was found to print it satisfactorily. His art had a tremendous effect on the fans, and his career flourished.

Finlay was paid about ten dollars for an interior black-and-white and one hundred dollars for a cover painting. As his popularity increased he contributed art to the *American Weekly, Amazing Stories, Famous Fantastic Mysteries,* and *Fantastic Novels.* In 1938 he converted to Judaism and married Beverly Stiles in New York City. During World War II he was in Okinawa and saw fierce combat, rising to the rank of sergeant. After the war his work was in heavy demand and he was able to purchase a home in Westbury, Connecticut, where he remained to the end of his life. Here, he began a new career painting large abstract paintings that sold very well. Some were hung at the Metropolitan Museum of Art, the Library of Congress, and other prestigious institutions. Finlay died in 1971, just as this new career was getting started. He remains the most popular interior illustrator ever to work in science fiction and fantasy magazines.

Rudolph Belarski (1900–1983). Belarski was born in Dupont, Pennsylvania, into a large family that had emigrated from Poland. At the age of twelve he became a slate picker and a mule driver in a coal mine. He drew a picture on a white-washed wall, the mine boss noticed it, and he was put to work painting safety posters. This was the beginning of his career as an artist.

At nineteen he went to New York, where he studied at Pratt Institute and during the summers returned to elementary school to continue his education. After graduating from Pratt he stayed on as a teacher and sought work as a magazine illustrator. During the late 1920s there was an explosion of air-war pulps based on the mythical heroism of World War I fighter pilots, especially the *Lafayette Escadrille. Wings, Aces, War Birds, Dare-Devil Aces, Battle Birds,* and *G-8 and His Battle Aces* flooded the newsstands. Belarski was the best and became known as the Dean of the Aviation Pulp Artists. He was fast and could produce a cover overnight. He could create "idea pictures" that depicted symbols of death, ghosts, or the Four Horsemen of the Apocalypse in the background watching a plane going down in flames. He also created action-packed black-and-white interiors and gouache paintings.

One of his finest covers was for the September 1934 *Wings:* a Sopwith camel is going down in flames wingtip to wingtip on a background of the ghostly figures of German, French, British, and American fliers. He also excelled in science fiction art, as seen in the covers for "Minions of the Moon," "Synthetic Men of Mars," and "Escape on Venus." During World War II he joined the USO and sketched portraits of the front-line soldiers. As the pulps were dying, he made the successful transition to the paperbacks; he created fifty covers for Popular Library. But he also was a teacher of art, and in 1957 he joined the faculty of the Famous Artists School in Westport, Connecticut, where he remained until his retirement in 1973.

Belarski's working methods changed from decade to decade. In the 1920s his paintings were done on large canvases and were more "complete" paintings, rather than compositional compromises to fit a total cover scheme. In the 1930s they were smaller, with tightened detail and less explosive shock. His paperback covers were painted on assignment, and he complained about the limits placed on his creativity. He died on Christmas Eve at the age of eighty-three. He had not a single one of his paintings in his possession.

Hannes Bok (1914–1964). Bok was born Wayne Woodward in Duluth, Minnesota. His professional name is derived from his favorite composer, Johann Sebastian Bach. He was a self-taught artist, a science fiction fan, and an admirer of Maxfield Parrish, and he used the Parrish techniques of composition and glazing. In 1939 his friend Ray Bradbury submitted Bok's artwork to Farnsworth Wright, the editor of *Weird Tales*, who was enthusiastic. Bok moved to New York City and pursued the career of an illustrator, also working for other magazines. But he couldn't conform, meet deadlines, or accept the changes editors demanded. He was caught between needing the money the magazines would pay and an artist's desire and need to be free to paint what he wanted to paint. During the early 1940s he created masterpieces of fine art that were never intended for commercial publication. They were very large paintings utilizing his imagination, techniques, and talents to the fullest: *Martian Picnic* is his chef d'oeuvre, followed by *Out of the Storm* and *Lunar Landscape*.

Bok's contributions to pulp art were of a different style from anything seen before, but some of his best work was jacket art for Arkham House and Shasta Books. His jacket designs for *Slaves of Sleep, Kinsman of the Dragon,* and *Sidewise in Time* were artistic inventions. He became a partner in the New Collectors Group, which published two A. Merritt novels that Bok completed and illustrated. Bok was basically cheated out of his real earnings. And although his art was in demand and he continued to work for many science fiction magazines, the pay was so low and getting paid so difficult that he left illustration and became an astrologer. He created an amazing group of astrological paintings that remain with the heirs of his friend Charles Peacock. Also remaining are religious paintings of the Madonna using a new method of gilding outlines that is inspiring.

He combined the bizarre, horror, and fantasy with a pixieish sense of humor. True, he didn't draw believable people or accurate machines—that wasn't his metier; but he did create the finest fantasies in a free-flowing style, each detail augmented by his imagination and time-consuming glazing techniques that are unsurpassed to this day. He was a master.

Norman Saunders (1907–1989). Saunders was a pulp artist of great talent who worked from the beginning to the end of the era, then made a smooth transition to the paperbacks. Born in 1907 in Minneapolis, Minnesota, his introduction to his eventual profession was a mail-order art course. He soon landed at Fawcett Publications, where he was employed from 1928 to 1934. He decided he wanted to be a freelance pulp artist, moved to New York, and studied under Harvey Dunn at the Grand Central School of Art. He painted for all

of the publishers and was known for his fast-action scenes, his beautiful women, and his ability to meet a deadline. He could and did do it all—westerns, weird menace, detective, sports, and even the Saucys (under the name of Blaine). Some of his finest paintings were in science fiction: his covers for *Mystery Adventures* were imaginative and superb in detail. Even though he was fast, producing one hundred paintings a year—two a week from 1935 through 1942—they were complete and without any compromise in quality.

After service in the Second World War he returned to the pulps but also tackled paperbacks: he worked for Ace, Bantam, Dell, Ballantine, Lion, and Popular Library. He had pride in his work, loved pulp art, and had no misgivings. Each painting conformed to his highest standards, and he did the very best work he could within the time and monetary constraints. Some of his best paintings are preserved in a pristine state in a collection at Syracuse University. They were donated by A. A. Wyn of Ace Publications in the 1930s and include his finest detective, western, and sports covers. The baseball covers are exciting scenes, using unusual foreshortening and perspective techniques (for example, a giant foul ball coming straight at the viewer). He had steady work from 1935 to 1953, when the pulps stopped.

The Topps company employed Saunders's talents for their line of bubblegum cards. The artist created one of the most successful nonsports-card sets in history: Mars Attacks. They were so "successful" that letters of protest poured in from parents, and Topps had to use a different brand name. An original set today costs thousands. His Wacky Packs cards were even more of a winner: the series lasted from 1970 to 1977, making millions for Topps.

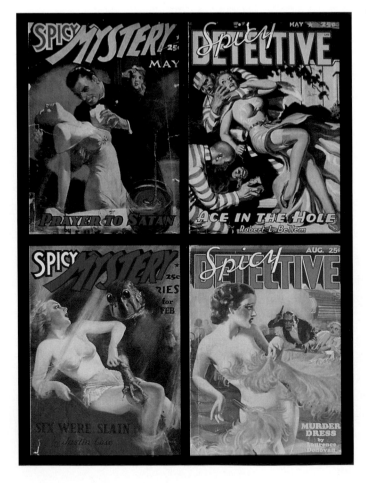

Walter M. Baumhofer (1904–1987). Born in Brooklyn, New York, Baumhofer attended Pratt Institute on a full scholarship and decided upon a career of illustration. He was an immediate success; upon presenting two samples to the editor of *Adventure* magazine, he was given the entire next issue, cover and interiors, to do. This was in 1925; it was the beginning of a career that would span his entire life. From Street & Smith to Clayton Publications to freelancing for all of the pulp publishers, Walter Baumhofer was in demand. He became known as the King of the Pulps. Westerns, detective, weird menace—any type of illustration assigned to him was professionally painted, dynamic in action, and among the best cover art of the time.

March 1933 marked the birth of a new Street & Smith pulp, *Doc Savage Magazine*. Walter Baumhofer became the cover artist, and he dipped his brush into the colors of threat, violence, and evil. Dr. Clark Savage, the Man of Bronze, was a scientific criminologist, a crime-solving detective, a man without a fault or fear. Doc Savage was man made perfect. Lester Dent was the author and

Walter Baumhofer was the artist of choice—forty-three covers from March 1933 to October 1936. This was his finest body of work, and any one of them that could be found today would be a treasure, and very expensive. Perhaps his best Doc Savage is his painting illustrating "Pirate of the Pacific": his aggressive use of paint and free-flowing style, creative use of perspective, and masterful lighting of the background combine to make it his masterpiece.

His covers total approximately fifteen hundred, according to an interview, but almost all are lost and only a few remain in private collections. He admired N. C. Wyeth, Harold von Schmidt, and Dean Cornwell. Many of his classmates at Pratt Institute also became successful pulp artists—Rudy Belarski, H. Winfield Scott, Bob Harris, Tom Lovell, and Nick Eggenhofer—and they remained steadfast friends. Baumhofer aspired to illustrate for the slicks and to be given more time and money to do better work. He did, and he was; and he was amazed to find that an art dealer could sell 114 of his paintings at high prices in less than nine months. Summing it all up he said: "Sure it was demanding work but it was fun. We were paid while we learned to paint. I tried to do the best damn job I was capable of.... I loved to paint action,...animals, and men."

John Newton Howitt (1885–1958). Howitt was born in White Plains, New York. An attack of polio left him with partial paralysis of his right leg requiring a metal brace. He could not participate in sports and instead decided to put his time and energy into becoming an artist. After high school he enrolled in the Art Students League, which counted among its students Winslow Homer, Charles Dana Gibson, and Howard Pyle. His education followed that of many illustrators of the time, and among his instructors were George Bridgman, an authority on anatomy, and the famous illustrator Walter Clark. After graduation, he established a studio in New York City, where he maintained it for more than fifty years.

Up until the crash of 1929 he made a solid living with portrait painting, landscapes and illustrations. But suddenly it stopped, and he was forced to find support elsewhere. He entered the world of the pulps, and from somewhere deep inside he mined into his dark side. Howitt painted nightmares, violent scenes of torture and horror. Most were created for Popular Publications, and his cover art sold their magazines—well. He was called at the time the Dean of Weird Menace Cover Art. He made money producing as many as seven covers in a single month. Despite his success in this field, other artists said that he despised pulp work. One of the great mysteries is that almost none of his several hundred covers has surfaced. Did he destroy them? Did Popular's warehouse fire destroy them? Could they be in storage somewhere waiting to be found?

Howitt signed his paintings in an individualistic manner with a slashing *H* set down in a lower corner, done with flourish. A partial checklist follows to aid in the search for the lost paintings.

Adventure: November 1, 193–, September 1, 193–, April 15, 193–, August 1934, April 1945; plus issues dated May 1 and November, and one other from 1945.

Clues Detective Stories: December 1936.

Dime Detective: February 15, 1934, June 15, 1934, July 15, 193–, April 193–, May 1, 193–, and one other in 1934.

Horror Stories: Various issues, 1934–39, including January 1935, July 1935, August 1935, September 1935, October 1935, February/March 1936, April/May 1936, October/November 1936, August/September 1937, and possibly June 1941.

Love Story: July 22, 1939.

Lovers Magazine: January 193–.

The Octopus: February/April 1939.

Operator #5: various issues, May 1934–September/October 1939, including December 1934, May 1935, September 1935, October /November 1936, May/June 1937, March/April 1938, plus thirteen covers for the "Purple Invasion" series, the last of which appeared on the September/October 1939 issue.

The Scorpion: February/April 1939.

The Spider: November 1933, August 193–, January 1936, September 1936, April 1937, October 1937, June 1938, October 1938.

For Street & Smith: Sixteen covers, 1935–37.

Terror Tales: Various issues, 1934–39, including November 1934, March 1935, June 1935, August 1935, September 1935, October 1935, July/August 1936, September/October 1936, and possibly March 1940.

Top-Notch: Various issues.

Western Story Magazine: February 25, 1933 (if this cover was indeed painted by Howitt, it would be his first pulp cover).

The Whisperer: Eleven covers, 1937, including February 1937, March 1937, April 1937, June 1937, July 1937, October 1937.

BIBLIOGRAPHY

GENERAL

Croce, Benedetto. *Guide to Aesthetics*. Indianapolis, Indiana: Hackett Publishing Co., 1995.

Goodstone, Tony, compiler. *The Pulps: Fifty Years of American Pop Culture*. New York: Chelsea House, 1970.

Goulart, Ron. *Cheap Thrills: An Informal History of the Pulp Magazine*. New Rochelle, New York: Arlington House, 1972.

Kery, Patricia Frantz. *Great Magazine Covers of the World*. New York: Abbeville, 1982.

Krystal, Arthur. "Buy Me! Read Me!: Market for Pulp Magazines and Their Cover Art." *Art & Antiques* 17 (March 1994): 23–24.

Larabee, John. "Trash Books of Yesterday, Collector's Items Today." *Detroit News*, December 8, 1995, C5.

Levin, Jo Ann Early. *The Golden Age of Illustration: Popular Art in American Magazines, 1850–1925*. Ph.D. diss., University of Pennsylvania, 1980.

Pitz, Henry Clarence. *200 Years of American Illustration*. Foreword by Norman Rockwell. New York: Random House, 1977.

The Pulp Era. Wauseon, Ohio: Lynn A. Hickman, c. 1950.

Reed, Walt, and Roger Reed. *The Illustrator in America, 1880–1980: A Century of Illustration*. New York: Society of Illustrators/Madison Square Press, 1984.

Tefertillar, Robert L. "Clandestine Reading: The Gone but Not Forgotten Pulps." *Antiques & Collecting Magazine* 99, no. 3 (May 1994): 47, 58.

Vintage Collectibles. Chattanooga, Tennessee: Rarities, c. 1983.

ADVENTURE, WAR

Bleiler, Richard. "Forgotten Giant: A Brief History of *Adventure* Magazine." *Extrapolation* 30, no. 4 (Winter 1989): 309–23.

MYSTERY, DETECTIVE, AND SUSPENSE FICTION

Cook, Michael L. *Mystery, Detective, and Espionage Magazines* (Historical Guides to the World's Periodicals and Newspapers). Westport, Connecticut: Greenwood Press, 1983.

Haining, Peter. *The Art of Mystery and Detective Stories: The Best Illustrations from Over a Century of Crime Fiction*. Secaucus, New Jersey: Chartwell Books, 1986.

Server, Lee. *Danger Is My Business; An Illustrated History of the Fabulous Pulp Magazines*. San Francisco: Chronicle Books, 1993.

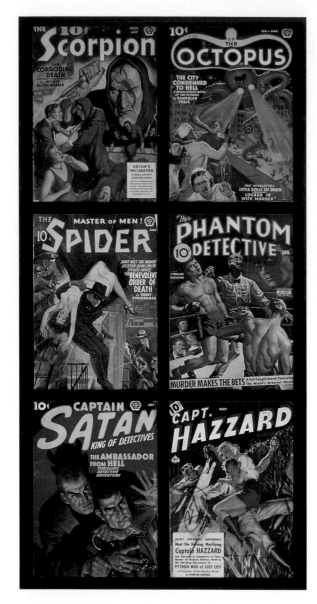

SCIENCE FICTION, FANTASY, HORROR, AND WEIRD FICTION

Ash, Brian, editor. *The Visual Encyclopedia of Science Fiction: A Documented Pictorial Checklist of the Sci-Fi World*. New York: Harmony Books, 1977.

Del Rey, Lester, editor. *Fantastic Science Fiction Art, 1926–54*. New York: Ballantine Books,1975.

Frewin, Anthony. *100 Years of Science Fiction Illustration, 1840–1940*. London: Panther, 1975.

Gunn, James. *Alternate Worlds: The Illustrated History of Science Fiction*. A&W Visual Library, 1975.

———, editor. *The New Encyclopedia of Science Fiction*. New York: Viking, 1988.

Haining, Peter. *Terror! A History of Horror Illustrations from the Pulp Magazines*. A&W Visual Library, 1976.

Jones, Robert Kenneth. *The Shudder Pulps: A History of the Weird Menace Magazines of the 1930s*. West Linn, Oregon: Fax Collector's Editions, 1975.

Nicholls, Peter, editor. *The Science Fiction Encyclopedia*. Garden City, New York: Doubleday, 1979.

Rogers, Alva. *A Requiem for Astounding*. Chicago: Advent Publishers, 1964.

Tymn, Marshall B., and Mike Ashley. *Science Fiction, Fantasy, and Weird Fiction Magazines* (Historical Guides to the World's Periodicals and Newspapers). Westport, Connecticut: Greenwood Press, 1985.

Weinberg, Robert. *A Biographical Dictionary of Science Fiction and Fantasy Artists*. New York: Greenwood Press, 1988.

Weird Tales: A Magazine of the Bizarre and Unusual. Indianapolis, Indiana: Popular Fiction Publishing Company, 1937.

"SPICY"

Brown, Robert A., editor. *Spicy Postcards*. Princeton, Wisconsin: Kitchen Sink Press, 1992.

Spicy: Naughty '30s Pulp Covers. Princeton, Wisconsin: Kitchen Sink Press, 1992. Set of 39 trading cards.

Spicy: More Naughty '30s Pulp Covers. Princeton, Wisconsin: Kitchen Sink Press, 1992. Set of 39 trading cards.

WESTERN

Dinan, John A. *The Pulp Western: A Popular History of the Western Fiction Magazine in America* (I. W. Evans Studies in the Philosophy and Criticism of Literature, no. 2). San Bernardino, California: Borgo Press, 1983.

Pro, Julio J. "Zane Grey and His Illustrators." *Southwest Art* 16 (March 1987): 76–81.

Samuels, Peggy, and Harold Samuels. *Contemporary Western Artists*. Southwest Art Publications, 1982.

INDIVIDUAL ARTISTS

Rudolph Belarski

Taraba, Frederic B. "Rudolph Belarski: Paperback Master." *Step-by-Step Graphics* 10, no. 5 (September/October 1994): 110–19.

Hannes Bok

Beauty and the Beasts: The Art of Hannes Bok. Saddle River, New Jersey: Gerry de la Ree, 1978.

Bok: A Tribute to the Late Fantasy Artist Hannes Bok, on the 60th Anniversary of His Birth and the 10th Anniversary of His Death. Saddle River, New Jersey: Gerry de la Ree, 1974.

Brooks, Cuyler Warnell. *Hannes Bok Illustration Index*. Newport News, Virgina: C. W. Brooks Jr., 1970.

———. *Revised Hannes Bok Checklist*. 2d edition. Baltimore: T-K Graphics, 1974.

A Hannes Bok Showcase. Lancaster, Pennsylvania: Charles F. Miller, 1995.

A Hannes Bok Sketchbook. Saddle River, New Jersey: Gerry de la Ree, 1976.

A Hannes Bok Treasury. Novato, California: Underwood Miller, 1993.

Petaja, Emil. *And Flights of Angels: The Life and Legend of Hannes Bok*. San Francisco: Bokanalia Memorial Foundation, 1968.

———. *The Hannes Bok Memorial Showcase of Fantasy Art*. San Francisco: SISU Publishers, 1974.

———, editor. *A Memorial Portfolio, Hannes Bok, 1914–1964*. San Francisco: Bokanalia Memorial Foundation, 1970.

Chesley Bonestell

Fortier, Edmund A. "The Mars That Never Was." *Astronomy* 23, no. 12 (December 1995): 36–43.

Miller, Ron. "Chesley Bonestell's Astronomical Visions." *Scientific American* 27, no. 5 (May 1994): 76–81.

Patton, Phil. "To the Moon, Chesley." *Esquire* 117, no. 1 (January 1992): 40–41.

Margaret Brundage

Russell, Ray. "Of Human Brundage." *Playboy* 38, no. 2 (February 1991): 106–09.

Taraba, Frederic B. "The Weird Tales of Margaret Brundage." *Step-by-Step Graphics* 11, no. 5 (September/October 1995): 118–29.

Virgil Finlay

The Book of Virgil Finlay. New York: Avon Books, 1976.

The Fifth Book of Virgil Finlay. Saddle River, New Jersey: Gerry de la Ree, 1979.

Finlay's Femmes. Science Fiction Graphics, 1976.

Finlay's Illustrations for Weird Tales. Showcase Art Productions, 1976.

The Fourth Book of Virgil Finlay. Saddle River, New Jersey: Gerry de la Ree, 1979.

The Second Book of Virgil Finlay. Saddle River, New Jersey: Gerry de la Ree, 1978.

The Sixth Book of Virgil Finlay. Saddle River, New Jersey: Gerry de la Ree, 1980.

The Third Book of Virgil Finlay. Saddle River, New Jersey: Gerry de la Ree, 1979.

Virgil Finlay: An Astrology Sketchbook. West Kingston, Rhode Island: Donald M. Grant, 1975.

Virgil Finlay Remembered: The Seventh Book of Virgil Finlay, His Art and Poetry. Memoirs by Lail Finlay, Robert Block, Stephen E. Fabian, Sam Moskowitz, Harlan Ellison, Robert A. W. Lowndes. Saddle River, New Jersey: Gerry de la Ree, 1981.

Virgil Finlay's Far Beyond. Lancaster, Pennsylvania: Charles F. Miller, 1994.

Virgil Finlay's Phantasms. Novato, California: Underwood Miller, 1993.

Virgil Finlay's Strange Science. Novato, California: Underwood Miller, 1992.

Virgil Finlay's Women of the Ages. Novato, California: Underwood Miller, 1992.

Tom Lovell

Hodgepeth, Don, and Walt Reed. *The Art of Tom Lovell: An Invitation to History*. Trumbull, Connecticut: Greenwich Workshop, and New York: William Morrow, 1993

Frank R. Paul

Ackerman, Forrest J. "A Brush with Genius." *Omni* 13, no. 9 (June 1991): 65–69.

James Allen St. John

Cape, Stephen. "J. Allen St. John, 1872–1957." *Private Library* 6, no. 4, ser. 4 (Winter 1993): 168–78.

Richardson, Darrell C. *J. Allen St. John: An Illustrated Bibliography*. Memphis, Tennessee: Mid-America Publishers, 1991.

INDEX

Ace Detective, 101
Ace-High Western, 99
Ace Publications, 11
Aces, 143
Adventure, 9, 122
aesthetics, 15–16, 18–19, 22–23, 107.
 See also censorship
Air Trails, 127
Air Wonder Stories, 34
All Around Magazine, 148
All Detective Magazine, 105
All-Story, 9, 76, 96
Amazing Stories, 35, 106
 illustrations, 15, 24, 38, 39
 letters to the editors, 157, 158, 159,
 160
Anderson, Allen, 13, 150–52
Argosy, 9, 26, 37, 98, 105, 135, 137
Armer, Frank, 97
art. *See* paintings
artists
 biographies, 167–74
 New Deal and, 129
 payment of, 51, 97, 109, 130
 training of, 6, 51, 80, 102
Astounding Science Fiction, 35
Astounding Stories, 35
Astounding Stories of Super Science, 34
aviation, 124, 125–31, 141–45

Bacon, Francis, 22
Battle Aces, 20, 126
Battle Birds, 123, 126, 131, 161
Baumhofer, Walter M., 13, 21, 55,
 105, 140
 biography, 172–73
 illustrations by, 52, 53, 69, 122, 139
Beadle and Adams, 135
Beckett, Sister Wendy, 22

Belarski, Rudolph, 13, 14, 51, 99, 127,
 129
 bibliography on, 177
 biography, 170–71
 illustrations by, 41, 143–47
Bergey, Earle, 13, 46, 75, 99
Best Detective Magazine, 118
bibliographies, 175–78
Bill Barnes, Air Adventurer, 124, 127
biographies, 167–74
Blakeslee, Frederick, 13, 21, 160, 161
 on aircraft depiction by, 126, 129,
 131
 illustrations by, 5, 125, 131, 141–42
Blue Book Magazine, The, 11, 26, 85,
 89, 93–94, 105
Bok, Hannes, 29, 31–33, 63
 bibliography on, 177
 biography, 171
 illustrations by, 31, 32, 40
Bradbury, Ray, 160
Brown, Howard V., 44
Brundage, Margaret, 26, 104–05,
 109–10
 bibliography on, 177
 illustrations by, 109, 117–18
bubblegum cards, 105
Buffalo Bill Novels, 135
Burroughs, Edgar Rice, 8, 76–77, 78,
 79, 80 *See also* Tarzan

Campi, Vincenzo, 19, 22
Captain Hazzard, 176
Captain Satan, 176
Cartier, Ed, 37, 45
Case, Sidney, 153
Cavalier, 9
censorship, 97, 100–102. *See also*
 aesthetics

Chandler, Raymond, 17
Clayton, Frederick, 15. *See also* Argosy
Clayton Publications, 34
Click, 134
Clyne, Ronald, 162
code of chivalry/honor, 48, 49, 53
collector's guide, 163–66
comic books, 52, 102
Copley, John Singleton, 89
Cornwall, Dean, 56
Coughlin, John, 49, 59
Croce, Benedetto, 18, 81
Cultural Anarchy, 3–4, 8
Culture Productions, 97, 100, 101–02
Curry, John Stuart, 30

Dan Turner, Hollywood Detective, 111
Dare-Devil Aces, 123, 125, 126, 141,
 161
daredevils, 122–55
Dell, 20
Depression. *See* Great Depression,
 The
De Soto, Rafael, 12–13, 55, 60–61,
 105, 133, 139–40
 biography, 167–68
 illustrations by, 2, 55, 61, 63,
 70–72, 102
Detective Fiction, 20, 62
detective magazines, 55, 58, 175–76
Detective Short Stories, 58
Detective Story Magazine, 49, 55, 58, 59
Detective Tales, 61, 72
Dime Detective Magazine, 12, 71, 106
Dime Mystery, 12
Dime Western, 12
Doc Savage, 52, 53, 80, 104
Doc Savage Magazine, 52, 53, 68–69,
 105
Doctor Chu Lung, 108
Doctor Yen Sin, 105, 108
Dold, Elliott, Jr., 26
Donenfeld, Harry, 97, 102
Dragons of Chang Ch'ien, 106
Drew, John, 120

economic factors, 4, 35, 51. *See also*
 Great Depression, The
Eggenhofer, Nick, 50, 51, 132–33
Elliott, Bruce, 57
Excitement!, 26
exhibits, 8, 21
Famous Fantastic Mysteries, 10, 42, 162
Fantastic Adventures, 27
Fantastic Novels, 25, 33, 36, 160
Fantastic Universe, 32
fantasy. *See* science fiction and fantasy
Feature Detective Cases, 75
Fiction by Volume essay debate, 10–11,
 14–16
Fiction Factory, The, 62

Fiction House, 13, 124
Fighting Aces, 5, 125, 126, 160
Finlay, Virgil, 33, 36
 bibliography on, 177–78
 biography, 169–70
 illustrations by, 10, 25, 33, 36, 42
Fire Fighters, 98
Flying Aces, 127
Foster, Hal, 87
Frandzen, Eugene, 127–28
Frontier Stories, 152
Future Fiction, 44

Galaxy, 35
G-8 and His Battle Aces, 108, 123, 126,
 140, 142
Gangster Stories, 98
Gang World, 20
Gernsback, Hugo, 28, 34, 157. *See also*
 Amazing Stories
Ghost Stories, 26
Gibson, Walter, 57
Gifford, 162
Giunta, John, 47
Goldsmith, Harold, 20
Graef, Charles, 14
Graves, Gladney, 51
Great Depression, The, 5, 6, 20, 34,
 52, 100, 129
Grefe, Will, 138
Gross, George, 13, 95
Guide to Aesthetics, 18

Harris, Robert G., 13, 138
Henneberger, Jacob, 109. *See also*
 Weird Tales
Herndon, Laurence, 51, 85, 87, 89,
 93–94
heroes, 48–75, 122
Hersey, Harold Brainerd, 34, 58, 62
Hines, Pop, 68–69
historical background. *See* pulp maga-
 zines, historical background
Hogan, Robert J., 107
Hogarth, Burne, 87–89
Homer, Winslow, 89, 123, 131, 134
Horror Stories, 9
Hoskins, Gayle, 13
Howitt, John Newton, 7, 13, 51, 55,
 121, 173–74

Jungle Book, The, 77, 80
Jungle Stories, 95

Kent, Rockwell, 30
Kipling, Rudyard, 77
"knight errant spirit," 48–75

Lacassin, Francis, 87
Laocoön, 84–85
Lariat Story Magazine, 150–51

Lesser, Bob, 21
Leydenfrost, Alexander, 130, 134
Leyendecker, J. C., 56
Lillis, Richard, 59
Lone Eagle, The, 127
Lovell, Tom, 9, 13, 30, 99
 bibliography on, 178
 illustrations by, 8, 49, 77, 106

Magazine of Fantasy and Science Fiction,
 35
Magazine Publishers, Inc., 127
Miracle, Science, and Fantasy Stories, 34
Morey, Leo, 26
Mowgli, 77
Munsey, Frank, 98
murals, 129, 130
Mysterious Wu Fang, The, 17, 107, 119.
 See also Wu Fang
Mystery Tales, 116

New Detective Magazine, 63, 102
New Story Magazine, 85, 92
New Story [Magazine], 78

Octopus, The 176

paintings
 buying, guidance on, 163–64, 165
 collector's guide, 163–66
 design and style of, 9, 12, 20–21,
 30–31, 50, 55, 57. *See also*
 individual artists
 fate of, 6, 8, 10, 21, 136, 137, 163
 letters to the editors on, 10–11,
 14–16, 157–62
 populist culture and, 3–7
 restoration, 165
 technique, 28, 29, 36–37, 58–59,
 80–81, 83, 136
 wildness of, 104–06
paper, 5, 34, 35, 51, 86–87
Parkhurst, H. L., 97, 102–03, 112–14
Paul, Frank Rudolph, 26, 27–29, 51,
 106
 bibliography on, 178
 biography, 168
 illustrations by, 7, 15, 27, 28, 29,
 38, 39
penny dreadfuls, 50
Pettee, Clinton, 76
Phantom Detective, 176
Planet Stories, 161–62
Popular Love, 99
Popular Publications, 6, 7, 9, 12, 13,
 20–21, 26, 54
populist culture, 3–7, 8
Private Detective Stories, 59
psychological factors, 8, 10
pulp, origin and use of term, 5, 10,
 17

Pulpcon, 21
pulp magazines
 ethical covers, 16
 genre niches, 8, 9, 50, 98
 historical background, 5–17,
 20–21, 34–35, 50–52, 56–57,
 98–100
 letters to the editors, 10–11, 14–16,
 157–62
 reputation of, 8, 9, 10–11, 14–17
 weaknesses and strengths, 8–9
Puppi, Lionello, 22

racism, 103–04, 134
Railroad Stories, 126
Ralston, Henry, 52
reprints, 104
restoration, 165
Return of Tarzan, The, 77, 78
Reynolds, Quentin, 68
Rogers, Hubert, 154
Rozen, George, 13, 51, 53, 55, 105
 biography, 169
 illustrations by, ii, 6, 54, 62, 65–68,
 129, 155
Rozen, Jerome, 51, 55, 105, 107
 biography, 169
 illustrations by, 17, 107, 119

samurai warriors, 49, 54
Sarnoff, Arthur, 137–38
Saturday Evening Post, The, 51, 137
Saunders, Norman, 13, 55, 105, 108
 biography, 171–72
 illustrations by, 58, 73–74, 101,
 115, 116
Schuyler, Remington, 56
science-fact art, 25, 27, 33
science fiction and fantasy, 5–6,
 24–25, 27–29, 31–47, 176
Science Wonder Stories, 34, 157
Scientific Detective Monthly, 34
Scorpion, The 176
Scott, H. Winfield, 51, 134, 149
Scott, John, 51
scratchboard art, 36
Secret Agent X Detective Mysteries, 64
sexual factors. *See* women, depiction
 of
Shadow, The, 49, 52–54, 57, 80, 104
Shadow [Magazine], The, ii, 6, 48, 49,
 65–67, 105, 54, 164
Sky Birds, 127
Sky Fighters, 127, 129
Soare, W. F., 64
sociological factors, 15–16, 99. *See also*
 war
Spicy Adventure Stories, 97, 112
Spicy Detective [Stories], 9, 97, 103, 172
Spicy Mystery [Stories], 18, 97, 100, 101,
 114, 172

Spicy Western Stories, 97, 113, 172
Spider, The, 105
Spider, The, 54–55, 70, 104, 105, 176
St. John, James Allen, 51, 78, 79, 80–85
 bibliography on, 178
 biography, 167
 illustrations by, 24, 81, 84, 88, 90, 91
Stahr, Paul, 14, 37, 135
Standard Magazine, 13
Startling Stories, 46
Star Western, 12, 155
Steeger, Harry, 12, 20–21
stipple art, 36
Stoops, Herbert Morton, 11
Strange Detective Mysteries, 100
Street & Smith, 6, 12–13, 52, 68–69, 127, 135
Submarine Stories, 98

Tarzan, 76–85, 87–89, 92–93. *See also* Burroughs, Edgar Rice
technology, 4, 25, 33
Ten Story Detective, 73–74, 115
Terror Tales, 121
Thrilling Adventures, 99, 146–47
Thrilling Wonder Stories, 41
Tinsley, Frank, 127
Top Notch, 26
Torment in Art, 22
Triple-X, 98
Trojan Magazine Company, 103
Tuttle, W. C., 135

Unknown Fantasy Fiction, 37, 45

war
 bibliography, 175
 depiction of, 123–28, 130–31, 133–34, 146–47
War Birds, 123, 144
Ward, H. J., 18, 97, 100, 102, 103, 111
Watson, Emmett, 14
Weird Tales, 26, 29, 36, 85, 104, 109–10
 illustrations, 43, 47, 90, 91, 109, 117–18
Wellman, William, 125
Wentworth, Richard, 54
Wessolowski, Hans Waldemar, 26
Western Rangers, 20
westerns, 132–33, 135, 139–40, 148–55, 176–77
Wild West Weekly, 139, 149, 153–54
Wings, 123, 127, 145
Wittmack, Edgar Franklin, 96
women, depiction of, 50, 55, 97–121, 138
Wonder Stories, 7, 28, 29, 34, 35, 158, 159
Wright, Farnsworth, 85, 109–10. *See also* Weird Tales
Wu Fang, 103, 106–08. *See also* Mysterious Wu Fang, The
Wyeth, N. C., 30, 56, 76, 78–79, 85, 92, 148
Wyn, A. A., 11, 14–15

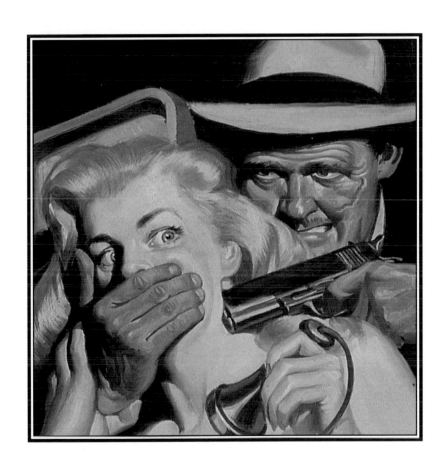